FABERGÉ AND THE
RUSSIAN CRAFTS TRADITION

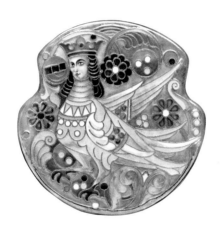

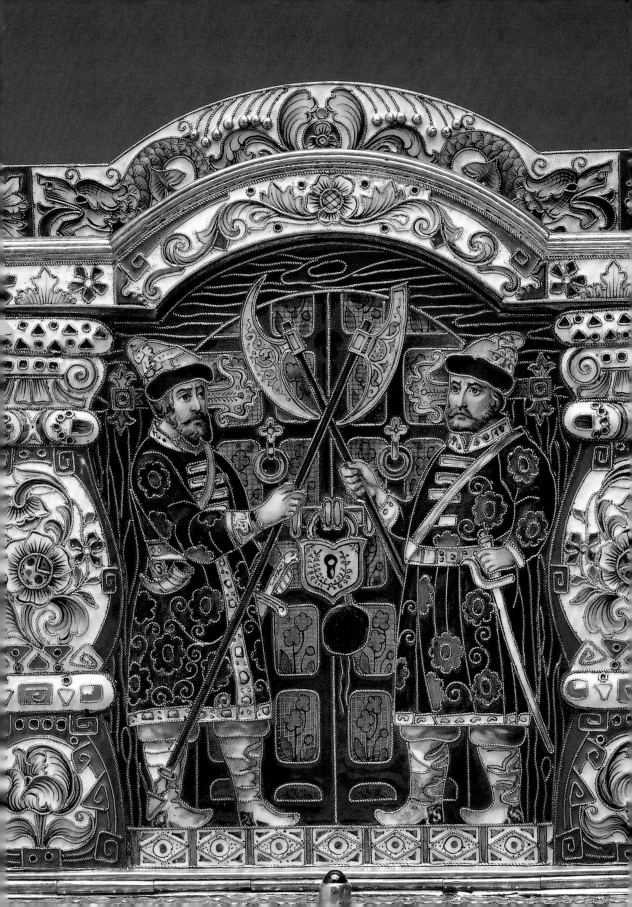

FABERGÉ AND THE
RUSSIAN CRAFTS TRADITION
An Empire's Legacy

Margaret Kelly Trombly

with

William R. Johnston
Karen Kettering
Robert Mintz
Diana Scarisbrick

Thames & Hudson THE WALTERS ART MUSEUM

This publication accompanies the exhibition
'Fabergé and the Russian Crafts Tradition: An Empire's Legacy'
at the Walters Art Museum, Baltimore,
from 12 November 2017 to 27 May 2018

First published in the United Kingdom in 2017
by Thames & Hudson Ltd, in collaboration with
the Walters Art Museum.

Fabergé and the Russian Crafts Tradition: An Empire's Legacy
© 2017 The Walters Art Museum/Thames & Hudson

Text and photographs © 2017 The Walters Art Museum
Design and layout © 2017 Thames & Hudson
Designed by Maggi Smith

Frontispiece: Detail of cat. no. 37,
Letter stand, 1899–1908

Note: Dimensions of works are given in
inches and centimeters; height precedes
width or diameter; and width precedes
depth.

British Library Cataloguing-in-Publication Data

A catalogue record for this book is available
from the British Library.

ISBN 978-0-500-48022-9

Printed and bound in China by C&C Offset Printing Co. Ltd

To find out about all our publications, please visit
www.thamesandhudson.com. There you can subscribe
to our e-newsletter, browse or download our current
catalogue, and buy any titles that are in print.

Contents

Foreword

JULIA MARCIARI-ALEXANDER

Fabergé and the Russian Crafts Tradition celebrates two transformative gifts to the Walters Art Museum: that of the museum's founder, Henry Walters, whose visionary acquisitions extended to what was then contemporary Russian art and included the first examples of Peter Carl Fabergé's jeweled masterpieces in an American collection; and a group of some two hundred Russian enamels brought together more recently by Mrs. Jean M. Riddell, who through an extraordinary act of generosity has made the Walters a leading repository of late 19th- and early 20th-century Russian decorative arts.

America's fascination with Russian art and culture dates to the early 20th century, and the Walters Art Museum has been at the forefront of this engagement, with respect to both its collection and its exhibitions. Over the last two decades, the Walters has brought remarkable examples of secular and religious art to the United States in such exhibitions as "Gates of Mystery: The Art of Holy Russia" (1992), "The Origins of the Russian Avant-Garde" (2001), and "Sacred Arts and City Life" (2005). Explored through different lenses, many of the objects featured in the present exhibition appeared in two past shows organized by the Walters: "Russian Enamels: Kievan Rus to Fabergé" (1996) and "The Fabergé Menagerie" (2003).

This project would not have been possible without Benjamin Zucker, a longtime friend and supporter of the museum, whose research brought to light the remarkable story of how Alexandre Polovtsoff—Russian diplomat, ethnographer, and collector with ancestral and political ties to the nation's ruling dynasty—facilitated the acquisition of many of the treasures now

in the Walters' collections. Margaret Kelly Trombly's profound knowledge of Russian decorative arts shaped both the exhibition and this book. It has been a pleasure and privilege to work with her and her fellow authors: William R. Johnston, Karen Kettering, Robert Mintz, and Diana Scarisbrick. The contributions of the late Anne Odom to the understanding of the Walters' collection of Russian art are inestimable, and much of her work is published here for the first time. We are indebted also to Anne Benson for information regarding Alexandre Polovtsoff's lineage, life, and career, and to Preban Ulstrup for his insights into the Romanov miniatures.

The Walters has contributed its tremendous expertise in bringing this project to fruition, especially Eleanor Hughes, Deputy Director for Art and Program; and Amy Landau, Director of Curatorial Affairs and Curator of Islamic and South Asian Art, and Jo Briggs, Associate Curator of 18th- and 19th-Century Art. Charles Dibble sensitively shepherded the publication at the Walters in collaboration with our partners at Thames & Hudson, Julian Honer, Susannah Lawson, Susanna Ingram, Sarah Yates and Maggi Smith.

Finally, the exhibition and publication have been generously supported by an anonymous donor, The Bernard Selz Foundation, William A. Bradford, Dr. Karen Kettering, and contributors to the Gary Vikan Exhibition Endowment Fund. Thanks to all those listed here—and many others—we delight in bringing this project to Baltimore so that our collections may inspire people to connect with each other through experiences with art from across the globe and throughout time.

Julia Marciari-Alexander
Andrea B. and John H. Laporte Director

OPPOSITE
Detail of cat. no. 42, Easter Egg, 1899–1908

Introduction

ROBERT MINTZ AND WILLIAM R. JOHNSTON

In 1917, the Romanov family's three centuries on the throne of the Russian Empire ended. Russian culture and the decorative arts had flourished under the patronage of the Romanov emperors (tsars) and their court, who supported the production of extraordinarily beautiful and technically sophisticated works of art, made from the most exquisite materials. From carefully faceted and ingeniously set gems to precisely chased silver and intricate gold work, artists created some of the most opulent objects that Russia and the world had ever seen. First among these were Imperial Easter Eggs exchanged as gifts by the royal family between 1885 and 1916; they were the crowning achievement of the workshops of Peter Carl Fabergé (1846–1920). These objects brought together the artistry of the metalsmith, enameler, jeweler, and stonecutter, the culmination of centuries of Russian craft expertise. The legendary status of these eggs and their "surprises" (their equally elaborate contents) has endured to the present, and they are perhaps the most famous pieces of decorative art ever created. Referenced in the lyrics of pop songs and the work of contemporary artists, they are powerful metaphors for the fanciful and doomed excesses of the Romanovs.

The beginnings of the international fame of Russian works of art can be found in the late nineteenth and early twentieth centuries, when Henry Walters (1848–1931; fig. 1) was collecting art to found what is today the Walters Art Museum in Baltimore. Toward the end of the Romanovs' long reign, the elite families of Russia forged relationships with the aristocratic families of Western Europe and with the newly wealthy and powerful families of North America's commercial cities. Boston, New York,

Philadelphia, and Baltimore all saw their share of elite Russian visitors interacting with, befriending, and sometimes marrying those whose names featured prominently on the social registers. As a result, an awareness of Russia and the products of its modern culture spread widely among the families who were most active in collecting art at the turn of the twentieth century.[1] Travel to Russia during the decades around 1900 was a popular adventure for those seeking the most innovative and elegant music, dance, theater, and art.

The efflorescence and extinction of the Russian Empire, and the subsequent movement of some of the magnificent works of art produced there to collections in Western Europe and America, lie at the heart of this story and are the motivation for the accompanying exhibition. The works recall a lineage of rulers and their close relatives whose aristocratic station lent meaning to a host of beautiful things. Their manufacture, exchange, and preservation form a complex story tied closely to the individuals who made the Walters Art Museum's collection a prime repository of Russian Imperial treasure. Drawing on these collections, which encompass both the revivalist and the innovative traditions in Russian decorative art popular during the later years of the Romanovs' rule, we are now celebrating the moment one hundred years ago when the Russian Empire's final artistic creations were made and then saved through the efforts of people dedicated to preserving the material culture of tsarist Russia.

To begin a discussion of the extraordinary Russian art that today makes up an important part of the Walters Art Museum's collections, perhaps paradoxically we must start with several *endings*. The first is that of the museum's

OPPOSITE
Detail of fig. 8 and cat. no. 61, Rose Trellis Egg, 1907.
The Walters Art Museum, acquired by Henry Walters,
1930.

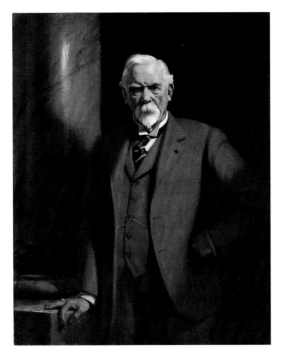

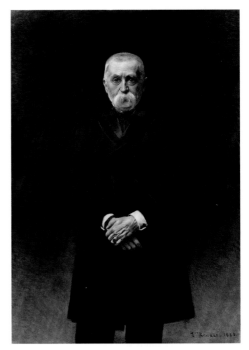

Fig. 1 Frank O. Salisbury (English, 1874–1962). *Henry Walters*, 1947. The Walters Art Museum, partial gift of Mrs. Frederick B. Adams, Miss Laura Franklin Delano, Mrs. George Harold Edgell, and Mrs. John Russell Pope, 1947.

Fig. 2 Léon Bonnat (French, 1833–1922). *William T. Walters*, 1883. The Walters Art Museum, commissioned by William T. Walters, 1883.

founder, who died in New York on November 30, 1931. Henry Walters' death marked the end of an art-collecting career that, through the guidance of his father, William T. Walters (1820–1894; fig. 2), effectively spanned the greater part of his eighty-three-year life. Even at the end, Walters was actively acquiring works of art to add to his treasury of more than 20,000 objects. He had built an Italian palazzo-style museum in Baltimore (fig. 3), dedicated to the memory of his father, and filled its galleries, arranging the art according to his taste, his ideas, and his understanding of the world. Even after his gallery opened to the public in 1909, he continued to seek out magnificent works of art worthy of inclusion, sending crate after crate of treasures to be stored in the basement for some future installations of the collection. Among the very last pieces he sent to this storehouse of art were two prime examples of the very finest late Imperial Russian artistry and craftsmanship: two Imperial Easter Eggs made by Peter Carl Fabergé's master craftsmen Mikhail Evlampievich Perkhin (1860–1903) and Henrik Wigström (1862–1923; cat. nos. 60, 61).

Henry Walters first became familiar with the work of the Fabergé artisans when he traveled to St. Petersburg, Russia, in the summer of 1900 aboard his steam yacht, *Narada* (fig. 4). Having crossed the Atlantic by ocean liner, Henry boarded the yacht in Southampton, England, with his sister Jennie, her husband, Warren Delano, and his close friends J. Pembroke Jones and Jones's wife, Sadie (who later married Walters). They then proceeded across the English Channel, visited Belgium and the Netherlands, and steamed through Germany, into the Baltic Sea.[2] Their itinerary for the trip included a meeting in St. Petersburg with an old friend, Princess Julia Dent Grant Cantacuzène-Speransky (1876–1975), the eldest granddaughter of President Ulysses S. Grant.[3]

Princess Cantacuzène-Speransky guided Henry and his fellow passengers to Fabergé's newly opened headquarters on Bolshaia Morskaia Street, where they encountered the refined and exacting work of the Fabergé craftsmen. Henry purchased an array of hardstone carved animals and several elegant jeweled parasol handles intended as gifts for his nieces (cat. nos. 57–59).[4] His taste

Fig. 3 The Walters Art Gallery, ca. 1909. The Walters Art Museum Archives.

for Fabergé's designs and the Russian artisans' skills had begun a few months earlier at the Exposition Universelle of 1900 in Paris. There, Fabergé displayed several of his Russian Imperial Easter Egg commissions and other jeweled works to the great interest of the press and collectors of decorative objects. Like his fellow Americans the industrialists, art collectors, and yachtsmen J. P. Morgan and Cornelius Vanderbilt, Henry had his first real taste of Russian decorative art at the turn of the twentieth century, but three decades would pass before he acquired his Imperial treasures.

Through the first seventeen years of the century, the extraordinary objects that Fabergé's workshop produced for the Romanovs remained within the confines of the Imperial palaces. The only opportunity the public had to see these works were the expositions at which the Fabergé company showed off examples of its most notable commissions.[5] The works presented in Paris in 1900 helped to inform the art-collecting world outside Russia about Fabergé's potential. During the early years of the century, the House of Fabergé grew steadily to become a major force within the European luxury trade. Expanding from its St. Petersburg headquarters, it opened branch offices in Moscow, Odessa, Kiev, and London. The prominence of the Fabergé name remained closely tied to Tsar Nicholas II (r. 1894–1917) and his court. When the tsar abdicated early in March 1917, the Fabergé company found that it was unable to disentangle itself from the Romanovs and the elite Russian society that had both represented it and funded its success. The company was nationalized by the Bolshevik government in 1918, and echoes of it appeared

in Paris in 1924, as Fabergé et Cie, under the guidance of Fabergé's sons, Eugène and Alexander, but the finest works were by that time creations of the past.

As the upheavals of the revolution ended, the ownership of the Imperial works that had been shown in Paris was suddenly upended as the Bolshevik government seized the possessions of the former Imperial family and the aristocracy. Among the mechanisms employed to do so were the nationalization of the Hermitage in St. Petersburg and the appropriation of the other tsarist palaces in and near the city, including the Gatchina Palace, the Anichkov Palace, and the Pavlovsk Palace. Each of these and many other Romanov residences housed the treasures that had been synonymous with Russian elite society. The precious works of art were part of the wealth of the nation (both financially and symbolically), and they sat as contested property claimed by both the new Soviet government and the anti-Communist forces trying to maintain the last vestiges of the Imperial state.

Alexandre Polovtsoff (1867–1944; fig. 16) was among those who played an important role in the preservation of the Imperial treasures. He was the son of Alexander Polovtsov (1832–1909), who served as Senator and Secretary of State to Tsar Alexander III (r. 1881–94). The elder Polovtsov was married to Nadezhda Mikhailovna Iuneva (1843–1908), the foster daughter of Baron Alexander Stieglitz (1814–1884), first governor of the State Bank of the Russian Empire. In 1878 Stieglitz, through his generous philanthropy, had established a school of industrial arts in St. Petersburg as an independent educational institution and funded the creation of

Fig. 4 S.S. *Narada*, ca. 1903. Mystic Seaport, Rosenfeld Collection, Mystic, Connecticut.

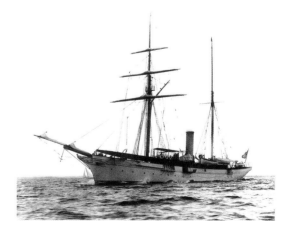

Fig. 5 The Museum of Applied Art of the Stieglitz State Academy of Arts, winter 2016.

the adjacent Stieglitz Museum in 1881 to benefit the students of the school (figs 5 and 6). In 1885 and 1886, the elder Polovtsov contributed greatly to the formation of the Stieglitz Museum by securing valuable collections of Persian, Italian, and French works of art.[6] He was in Paris shopping for additions to the museum's collections when William T. Walters, the father of Henry Walters, was there finalizing the purchase, through the assistance of the American art consultant George Lucas, of Eugène Delacroix's *Christ on the Sea of Galilee*.[7] This coincidence of collecting was the first moment of intersection between the Walters and Polovtsov families; it presaged a much more fruitful convergence between Polovtsov's and Walters' sons forty-five years later.

The younger Polovtsoff was appointed to the Stieglitz Museum in 1890 as a member of the school's board.[8] During this time, he also served as an officer in the Ministry of Foreign Affairs, which afforded him the opportunity to travel widely in the lands that bordered the empire. He amassed for himself, and purchased for the Stieglitz Museum, substantial collections of art, and developed close ties to many prominent art dealers who were actively searching out and offering works from cultures both near and far. Through the early years of the twentieth century, the museum collection grew even as

the economic and political climate of the Russian Empire suffered through some of the first of the struggles that would eventually lead to its end.[9] In 1905, following the realization that schools across the empire were hotbeds of revolutionary unrest, the Stieglitz Museum and Institute were closed as part of an attempt to quiet the civil disturbances spreading across the country. While initially the closure was intended to last for only a few months, it continued for four years, although the museum staff and structure remained in place. In 1907, the elder Polovtsov retired from his position on the school's board, and his son became the chief coordinator for the Stieglitz Museum. Through his collecting activity, the younger Polovtsoff developed ties to Florine Ebstein-Langweil, whose Paris shop specialized in imported Chinese and Japanese antiques. He also became acquainted with Jacques Seligmann, who facilitated major purchases for the Stieglitz Museum, even while its doors were closed, and figured prominently in Henry Walters' own purchases. These connections in Paris would become Polovtsoff's lifeline later in life when the Russian Revolution resulted in the Empire's collapse. They would also serve as the conduit through which Polovtsoff and Henry Walters would become associated as dealer and patron.

When the revolution arrived, the Stieglitz Museum, like the other vestiges of tsarist rule, came under the control of the new centralized state. Many of the works of art that Polovtsoff acquired were sent to the Hermitage, where the State Treasury was being consolidated. In 1917, Polovtsoff was named director of the Stieglitz Museum by the Soviet state. The following year he was named commissar of the Pavlovsk Palace Museum. Both of these institutions were important repositories of art, and Polovtsoff strove to protect their holdings from potential sales of tsarist heritage to support the Soviet state. By 1918, the Stieglitz Museum and Institute found itself without a reason for continuing in its role as an educational institution. The buildings had been largely neglected during the civil war. In the face of this challenge to the heritage he had longed to preserve, Polovtsoff left his position in that year and walked across the Finnish border, leaving his

homeland forever. He settled in Paris among the remaining dealers of fine art whom he had known as a younger collector and museum representative.

It is unclear whether, when he crossed the border into Finland, Polovtsoff carried with him any of the Imperial Russian works of art that he would sell a decade later to Henry Walters. He may have taken some of the holdings from the Stieglitz Museum or the Pavlovsk Palace Museum. He also may have had access to works within the Hermitage collection, to which much of his personal collection was added when the Soviet government began its campaign of consolidation. Although the means by which Polovtsoff acquired Imperial objects remains unknown, he would eventually bring to Henry Walters' attention and send to Baltimore a collection motivated by his impassioned understanding of the importance of these works of art.

Fig. 6 The Museum of Applied Art of the Stieglitz State Academy of Arts.

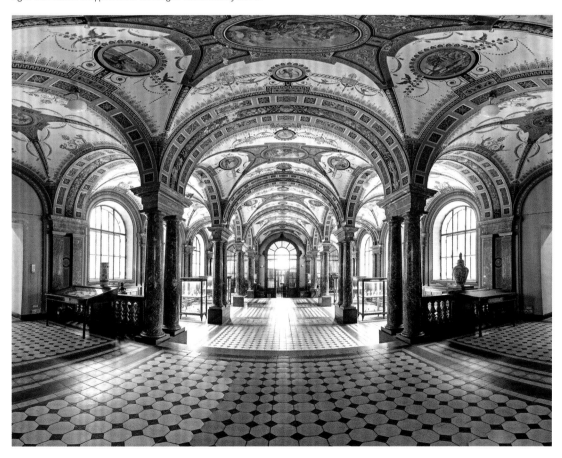

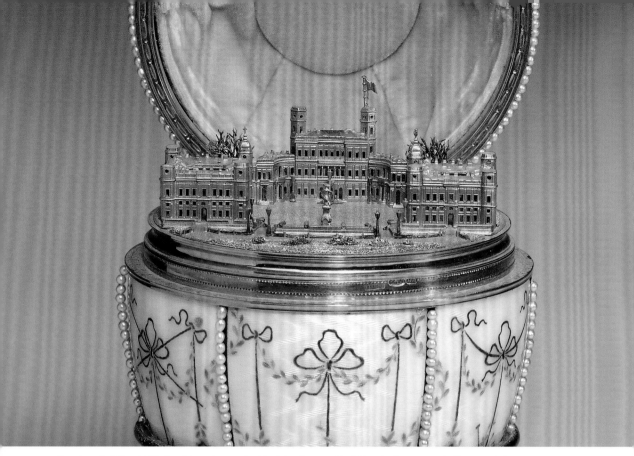

Fig. 7 Peter Carl Fabergé, Mikhail Perkhin, workmaster. Gatchina Palace Egg, 1901. The Walters Art Museum, acquired by Henry Walters, 1930.

By the time Polovtsoff offered his treasures to Henry Walters in 1928, there were many rumors in Europe and the United States of the potential sale of important art works from the Russian Imperial collections at the Hermitage in support of the Soviet state.[10] These rumors created a renewed awareness in the West of the valuable and rare items that might become obtainable as the Empire passed into historical memory. A notable sale in 1927 to Emanuel Snowman, who worked with the London jeweler Wartski, resulted in nine Imperial Easter Eggs being sent to London and eventually entering the British Royal Collection. Sales to Armand Hammer in 1930 resulted in another twelve of the Imperial Eggs moving from the Russian state into the Western market.[11]

Polovtsoff privately brought to this marketplace a range of treasures. He had been living in Paris for nearly a decade, and the time must have seemed right for him to find a buyer for what he had acquired of the old Empire during this period. He contacted Henry Walters, who was by that time reaching the end of his collecting

career. Walters was living out the early Depression years in his New York home. The Walters fortunes survived the stock market crash of 1929, but these were not the days of elegant adventure that they had enjoyed three decades earlier.

Although the exact purchase date and provenance of Henry Walters' art acquisitions are often hard to determine, it is fairly certain that he bought eighty objects from Polovtsoff largely between 1928 and 1931 (one, a very large icon dating from around 1600, cat. no. 5, was apparently purchased as early as 1922). Once he had located what he considered to be a trustworthy source, buying a large number of objects en masse was not an uncommon tactic in Walters' approach to collecting.

Walters' most spectacular acquisitions from Polovtsoff were the two Imperial Eggs made by Fabergé as gifts for the Easter holiday within the Romanov family. The Gatchina Palace Egg was made in 1901 by Mikhail Evlampievich Perkhin (fig. 7 and cat. no. 60) for Tsar Nicholas II to give his mother, Maria Feodorovna. It opens to reveal as

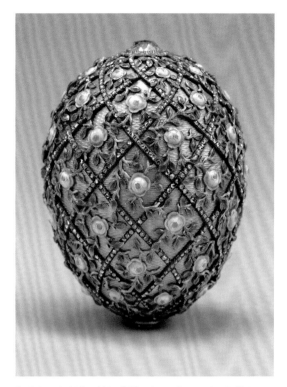

Fig. 8 Peter Carl Fabergé, Henrik Wigström, workmaster. Rose Trellis Egg, 1907. The Walters Art Museum, acquired by Henry Walters, 1930.

a surprise a miniature gold replica of the Gatchina Palace. Built for Count Grigori Orlov, the palace was acquired by Tsar Paul I (r. 1796–1801) and served as the winter residence for Nicholas II's parents, Alexander III and Maria Feodorovna. So meticulously did Perkhin execute the miniature palace that one can discern the tiniest details, including cannons, a flag, and the statue of Paul I. At the top and the bottom of the egg, portrait diamonds (diamonds cut in thin slices) cover small flat spaces where the date and perhaps the monogram of the tsar appeared. Around the opening and along each of six longitudinal bands, tiny seed pearls are set in gold channels.[12]

The second of the Imperial Eggs bought by Henry Walters is the Rose Trellis Egg (fig. 8 and cat. no. 61), made by Henrik Wigström for Fabergé as a gift from Nicholas II to his wife, Alexandra Feodorovna. On April 22, 1907, the tsar presented it to commemorate the third birthday of the tsarevich, Alexei Nicholaievich. Because of the challenges brought about by the Russo-Japanese War (1904–5), no Imperial Easter Eggs had been ordered for the tsarevich's first two birthdays. The egg contained as a surprise a diamond necklace with an ivory miniature portrait of Alexei.[13] The transparent portrait diamonds at the ends of this egg also reveal the date and a space that once may have held the empress's monogram. The removal of the monograms on both of these eggs may indicate that they were spirited out of Russia, or may have been an act of desecration directed at the Romanov family at the time of the transfer of the eggs from the Anichkov Palace to the Kremlin Armory in 1917.

Although these two Imperial Easter Eggs are today the most famous of Henry Walters' acquisitions, this publication and the accompanying exhibition allow us to focus again on the scope and ambition of Henry's acquisition of Russian art. From Polovtsoff he also purchased numerous icons, silver drinking vessels, enameled pieces, ivory, and hardstone objects, including two jeweled nephrite boxes by Fabergé that likely have Imperial

or court provenance. A further treasure, on a par with the Fabergé purchases, is a group of letters written by Empress Catherine the Great (r. 1762–96), purchased by Walters in 1930 (acc. no. 15.25.46). The earliest object is a Byzantine bone plaque depicting Apollo, which dates from the third or fourth century AD (acc. no. 71.43). It is also interesting to note that at an unknown date Walters purchased from the dealer Cornuau of Paris the Suchtelen Hours (Ms.W.176), an illuminated manuscript from Flanders dating to around 1500 that had previously passed through Polovtsoff's hands. Perhaps recognizing Polovtsoff's pedigree in the museum world, and his undoubted, possibly unrivaled, knowledge of and taste in the Russian decorative arts, Walters decided to make Polovtsoff his guide in assembling a broad and comprehensive selection of Russian artifacts for his encyclopedic museum in Baltimore.

A second significant group of Russian artistic treasures came to the Walters Art Museum in 2010 with the generous gift of Jean M. Riddell's collection of Russian

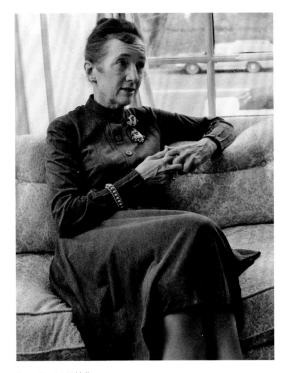

Fig. 9 Jean M. Riddell.

enamels. Jean Montgomery Riddell (fig. 9) was born in 1910 in St. Louis, Missouri. She was raised in New York City and attended the Spence School in Manhattan. Later, she enrolled in the Art Students League and became a pupil of Thomas Hart Benton (1889–1975). Summers were spent in Vermont, where Jean took flying lessons, barnstorming with her instructor while her anxious father played golf below. In 1933, President Franklin Roosevelt appointed her father, John Flournoy Montgomery (1878–1954), as United States Minister to Hungary, a position that he would hold during the critical years leading to World War II. Jean met Richard John Riddell at the embassy in Budapest. They married in 1934, and after the war the couple resided briefly in Baltimore, but eventually settled in Washington, D.C., with their three daughters and a son. Richard Riddell established a realty company, and, as a side venture, opened an antiques shop in Georgetown.

Richard Riddell had collected a few examples of Russian enamels, and it was after his death in 1966 that Jean developed a particular interest in the genre, concentrating on the Russian Revival wares made in Moscow between 1870 and 1917. While traveling abroad in 1970, she bought, at the shop Juvel og Kunst in Copenhagen, a pair of richly enameled caddies by the Eleventh Artel, the most accomplished of those trade co-operatives in Moscow (acc. nos. 44.951 and 44.952), and part of a tea service by Maria Semenovna (acc. nos. 44.826, 44.827, and 44.828), one of two women silversmiths in the city at the turn of the century. She continued to collect, relying on two New York antiques firms in particular, Leo Kaplan Ltd. and A La Vieille Russie. Kaplan, who was her chief source, not only sold to her directly, but he represented her at auctions, particularly at Christie's, Geneva. The Riddell collection, which includes works by both major and lesser-known firms, excels in specific areas. Jean, from the start, was drawn to the wares of Pavel Ovchinnikov's firm, the largest silver manufactory in Moscow (cat. nos. 31, 35, 40, and 43). It pioneered the introduction of the Russian Revival style and the adoption of the plique-à-jour enamel technique. Ovchinnikov is represented by a selection of fifty-eight works ranging from the champlevé enamels of the 1870s to the later filigree work, and to its feats in plique-à-jour enamel. Following on from her 1970 purchase, Jean continued her interest in women silversmiths, collecting twelve examples of Maria Semionovna's enamels (cat. no. 43) and a magnificent early *teremok*-shaped casket by Maria Adler.

Perhaps the Riddell collection's greatest strength is the works by, or attributed to, the enameler Fedor Ivanovich Rückert (1840–1917; cat. nos. 37, 38, 39, 62, 64, 65, 66, and 72). Although his early pieces in the Russian Revival style (evoking the empire's Russian, Slavic, and even Byzantine roots) scarcely differ from those of Ovchinnikov, Rückert developed a distinctive style exploiting the decorative potential of wire filigree and adapting the influences of international Art Nouveau and Austrian Secessionism to his own version of Art Nouveau, known thereafter in Russia as *stil moderne*. What appears to have fascinated

Jean in particular were the miniatures, often painted in matte enamel, on the faces of his boxes and on his *kovshi*, replicating paintings by contemporary artists. Anne Odom, curator at the Hillwood Estate, Museum, and Gardens in Washington, D.C., shared Jean's interest; after searching for images in early twentieth-century copies of the Russian illustrated magazine *Niva*, she managed to identify many of the original sources. Rückert not only sold his works independently but also provided them to Fabergé, in particular, and to other silversmiths in Moscow, including Bolin and Kurliukov, and to the jewelry house of Marshak in Kiev.

Although focusing on Russian Revival-style enamels, Jean Riddell, intending from the outset to donate her collection to a public institution, strove for comprehensiveness and sought pieces illustrating the various phases in the history of Russian enameling. Her pre-nineteenth-century purchases were carefully chosen. For example, the floral motifs and filigree work on a late seventeenth-century bowl (acc. no. 44.716) and a perfume flask (acc. no. 44.715) from Solvychegodsk were of the type that inspired the decoration found on late nineteenth-century Moscow revival pieces. Other antecedents that drew her attention were the enameled wares produced in Velikii Ustiug, a northern city with a large German population. A particular rarity, a small snuffbox from 1768, is inscribed with the name A. G. Popov, whose factory operated only from 1761 to 1776. In silver gilt and with characteristic Russian niello decoration, it is engraved inside the lid with an image of Justice under *en plein* enamel.

When the opportunity arose, Jean selected examples of Russian Revival wares that were directly copied from early prototypes. They included a rare Ovchinnikov teacup enameled in white and decorated with enameled silver appliqués, simulating in appearance her eighteenth-century Velikii Ustiug cups. Likewise, an unidentified late nineteenth-century wooden *bratina* (fig. 10) with enameled strapwork must have been inspired by a

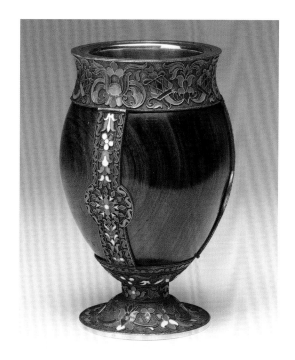

Fig. 10 Unknown maker. *Bratina,* 1896–1908. The Walters Art Museum, gift in memory of Jean M. Riddell, 2010.

seventeenth-century coconut-cup *bratina* similar to one that was shown in a 1904 exhibit of decorative arts at the Stieglitz Museum and that Henry Walters acquired for his collection from Polovtsoff in 1929 (cat. no. 9).

Although they were antithetical in style to her Moscow holdings, Jean acquired a selection of works produced by Fabergé (fig. 11) in the rococo and neoclassical styles at his St. Petersburg headquarters. Fabergé's technical mastery is further exemplified by a gold and nephrite *kovsh*, also by Perkhin (44.974), and by three enameled *kovshi* from the workshops of Anders Nevalainen (44.975 and 44.976) and Julius Rappoport (44.972).

The plique-à-jour enamel technique was very much in vogue internationally at the end of the nineteenth century. In Paris, it had been promoted since the early 1890s by André-Fernand Thesmar (1843–1912), who exhibited his little cups and mosque lamps at the annual salons. Among Jean's major early purchases, in 1972, was a spectacular Art Nouveau stemmed dish by Gustav Gaudernack, the Bohemian chief designer for the silver firm of David-Andersen in Oslo (fig. 12). Its upper

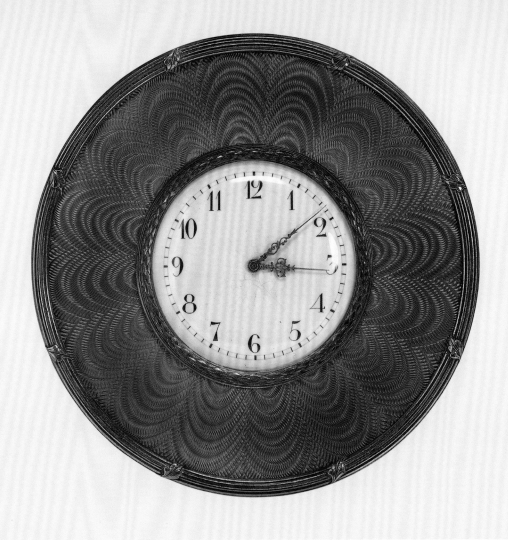

Fig. 11 House of Fabergé, Mikhail Perkhin, workmaster. Circular clock, 1888–96. The Walters Art Museum, gift in memory of Jean M. Riddell, 2010.

bowl-shaped section, formed of overlapping plique-à-jour peony leaves, is supported by two stems arising from an enameled base. Given the scale of this piece—it is 8 inches (20.32 cm) high—Gaudernack enameled the sections separately and then assembled them. Although it represented a departure from her area of collecting, Jean was so taken with this tour de force that she retained it long after she had disposed of another Gaudernack piece and several Swedish plique-à-jour long-boats. She also kept as an example of Art Nouveau a gilt-bronze mirror with a scene in plique-à-jour enamel of a pair of swans swimming among waterlilies. It had been made as a luxury item for the perfume house Lubin Paris (fig. 13).

While attending the Washington Crafts Fair in 1995, Jean encountered the contemporary enameler Valeri Timofeev (1941–2014). A native of Riga, Latvia, Timofeev had moved to Moscow. There he studied the techniques of the pre-revolutionary Moscow silversmiths, which he revived in a thoroughly modern idiom. He had begun to participate in American craft shows in 1991, and immigrated to America five years later. Jean was so impressed by his mastery of plique-à-jour enameling and his innovative designs that she added a goblet and four champagne flutes by him to her collection (fig. 14).

Jean Riddell assumed an advocacy role for Russian enamels and willingly shared her collection by publishing

it and lending from it to exhibitions. Like Henry Walters, then, she collected both for her own pleasure and for the benefit of the public. Through their gifts, we can today appreciate the heights that Russian artisans reached, sustained by the apparently limitless resources and patronage of the Romanovs and their circle. They created works of art that would endure beyond the revolution as milestones in the European decorative arts.

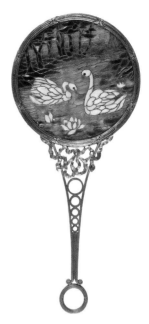

Fig. 13 Unknown maker. Plique-à-jour mirror, ca. 1900–1905. The Walters Art Museum, gift in memory of Jean M. Riddell, 2010.

Fig. 12 Gustav Gaudernack (Bohemian, 1865–1914), designer; firm of David-Andersen (Norwegian, founded 1876), manufacturer. Art Nouveau dish with stem, 1904–5. The Walters Art Museum, gift in memory of Jean M. Riddell, 2010.

Fig. 14 Valeri Timofeev (Latvian, 1941–2014). Champagne goblet, after 1993. The Walters Art Museum, gift in memory of Jean M. Riddell, 2010.

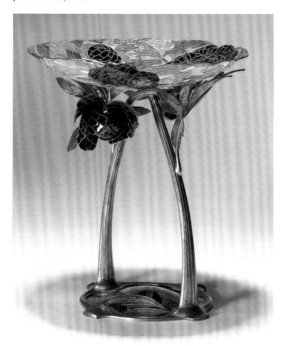

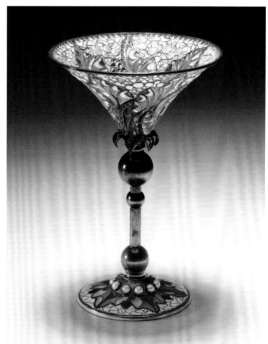

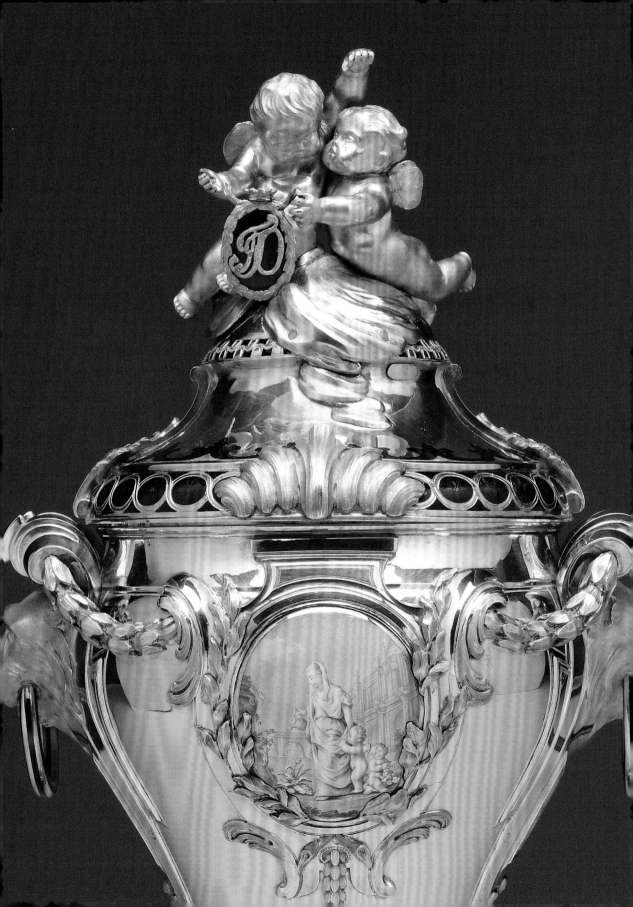

Baron Stieglitz, the Polovtsov Family, and the Pursuit of Art

KAREN KETTERING

The Baron Stieglitz Museum (now the Museum of Applied Art of the Stieglitz State Academy of Arts) in St. Petersburg, named for its founder, Baron Alexander Stieglitz (1814–1884), was an innovative and dynamic enterprise nurtured by several generations of his family until the revolution. Most notable among them was his son-in-law Secretary of State Alexander Polovtsov (1832–1909; fig. 15), whose organizational and diplomatic skills allowed him and his family members to create one of the most significant museums in Russia in only a few years. The last guardian was Alexandre Polovtsoff (1867–1944; fig. 16), a brilliant linguist and diplomat who, like his predecessors, was deeply devoted to improving Russia's trade and manufactories. Their aim was to prepare the skilled draftspeople necessary for industrial production, as well as artist–designers whose skills would allow the nation to remain competitive in the age of international expositions. This was a series of recurring, usually European, exhibitions beginning with London's Great Exhibition of the Works of Industry of All Nations in 1851, in which countries spent lavishly to construct pavilions or exhibits within which their nation's arts and manufactures could be judged against competitors, and find new buyers, from around the world.[1] With the change of regimes in 1917, the younger Polovtsoff gave up his roles as diplomat and educator, plunging ever deeper into the preservation of Russia's artistic treasures. Eventually forced to flee, he settled in Paris where he supported himself as a writer, lecturer, and art dealer, as discussed in Diana Scarisbrick's essay (pp. 31–41).

When Polovtsoff met Henry Walters in Paris in 1922, it was not immediately clear that the two men would create America's first important collection of Russian art.[2] Walters worked with only a few trusted dealers, including Jacques and Germain Seligmann. The Polovtsovs had enjoyed a fruitful collaboration with the Seligmann firm of dealers for many years before the 1917 revolution and it is probably they who made the introduction. It seems likely also that the two men would have recognized in each other similar backgrounds and sympathies. (Language would not have been a barrier, as Polovtsoff was fluent in English and French in addition to Russian and the various South Asian languages he had mastered during his diplomatic career.) The Polovtsov family's wealth, like that of Walters, was by no means "old money," and indeed its origins could be found in the previous generation's entrepreneurial ability to take advantage of technological developments such as the railroad. In the end, both men would try to use that wealth, and the family's collections, for the public good.

Polovtsoff's father was born into a minor noble family that traced its roots to the seventeenth-century Cossack leader Semion Polovets. While several of his uncles distinguished themselves as scholars or engineers, the elder Polovtsov was one of the leading personalities of Russia during the reigns of tsars Alexander III (r. 1881–94) and Nicholas II (r. 1894–1917), as a member of government, organizer of the Russian Imperial Historical Society, and publisher of the *Russian Biographical Dictionary*.[3] As a young man, Polovtsov was able to find a place in the prestigious Imperial Institute of Jurisprudence, founded in 1835 to prepare the sons of the nobility and other worthy candidates for the elite civil service. Its standing was equal to that of the Imperial Alexander Lyceum, the

OPPOSITE
Detail of cat. no. 21, Potpourri vase with classical figures, 1768. The Walters Art Museum.

Fig. 15 Louis Tallait (French, 19th century). *Alexander Polovtsov*, 1870. State Hermitage Museum, St. Petersburg.

Fig. 16 Alexandre Polovtsoff, undated photograph. Archives of the Stieglitz State Academy of Arts, St. Petersburg.

more prestigious educational institute founded in 1811 to prepare the sons of nobles for higher government service. Distinguished graduates of the Institute of Jurisprudence included Peter and Modest Tchaikovsky, the government minister and adviser Konstantin Pobedonostsev, and Vladimir Nabokov, the politician and attorney who became a close associate of the elder Polovtsov and whose eldest son became the well-known novelist of the same name.

A deciding factor in the elder Polovtsov's future was his marriage in February 1861 to Nadezhda Mikhailovna Iuneva (1843–1908; fig. 17), foster daughter of the financier Baron Alexander Stieglitz (fig. 18). According to family tradition, the Stieglitzes had been childless when, on June 10, 1844, a six-month-old infant girl was discovered in the garden of their country house. The infant was dressed in a shirt of fine linen and a christening cross of amber beads; a note gave her name, and her date of birth as December 10, 1843. While the baron was not sure if he wanted to raise the foundling, it was said that Tsar Nicholas I (r. 1825–55) personally requested that the

Stieglitzes adopt her as their ward and that "he knew who her father was" (reputedly the tsar's brother Grand Duke Michael Pavlovich).[4] The Lutheran Stieglitz agreed to raise the child as an Orthodox Christian. While the elder Polovtsov never commented on his wife's origins in his writings, Polovtsoff the younger recorded this information in his memoirs, a copy of which the historian Petr Zaionchkovskii had access to when he prepared the 1966 publication of the elder man's diaries. Zaianchkovskii included it in his introduction, touching off a series of debates that continue to this day. The younger Polovtsoff was clearly convinced of the story, noting his mother's uncanny resemblance to a young Empress Catherine II (the Great; r. 1762–96), her putative great-grandmother. Writing in 1934, Polovtsoff recalled that his father had acquired one of Marie-Anne Collot's marble busts of the empress. When Polovtsoff installed it in his home, he reported that visitors often remarked that it was a lovely bust of his mother.[5]

Whether it was the baron's connections or her own (rumored) Imperial relations, Nadezhda Mikhailovna

Iuneva offered Polovtsov entrée to the most exclusive court circles in addition to the vast wealth inherited from her adoptive father. Having come to Russia from Germany, the Stieglitz family converted from Judaism to Lutheranism. In 1826, Alexander Stieglitz's father, Ludwig Stieglitz (1779–1843), was granted the hereditary noble title of Baron of the Russian Empire and Russian citizenship in recognition of the many successful enterprises he had founded within Russia that had brought the nation wealth and advanced the development of industry. The firm Stieglitz & Co., one of the first joint stock companies in Russia, essentially functioned as court bankers.[6] Their promissory notes funded most of the Russian government's foreign transactions, and their name was as well recognized as that of the Rothschilds.[7]

By 1870, Alexander Stieglitz had amassed extraordinary wealth and was searching for a worthy project that could harness this resource to the advantage of the nation that had made this possible. Stieglitz had already spent six years as head of the Russian State Bank and

was therefore at the apex of his knowledge of the Russian economy, including all of its strengths and weaknesses. International expositions held in London, Paris, and Vienna demonstrated that Russian industry needed talented designers fully conversant with historical styles and contemporary developments in order to compete in an international market.

According to the younger Polovtsoff's memoirs, copies of which are held in Yale University's Beinecke Library and in the Russian State Archives, the Polovtsovs convinced the baron, who was a talented banker and industrialist but had little interest in the arts, to found an educational institution that would strengthen and improve Russia's industries and her economy.[8] When Alexander Stieglitz presented his plan for a new school of industrial arts to the Imperial government in 1876, Russia had only three such schools, and they could hardly fulfill the vast nation's needs. Stieglitz cited these other institutions, particularly Moscow's Stroganov Institute of Technical Drawing, as excellent models for the institution

Fig. 17 Charles François Jalabert (French, 1819–1901). *Nadezhda Mikhailovna Polovtsova*, 1860s. State Hermitage Museum, St. Petersburg.

Fig. 18 Carolus-Duran (French, 1837–1917). *Baron Alexander Stieglitz*, 1876. State Hermitage Museum, St. Petersburg.

he hoped to establish.[9] As articulated in its charter, the Stieglitz Institute had "the goal of educating draftsmen, painters, and sculptors required for artistic–industrial production and the preparation of [male and female] instructors of drawing and painting for middle and lower schools."[10] Significantly, the institution was open to women from the opening of its doors to students in 1879.

The new institution was given space in the central St. Petersburg neighborhood of Salt Town, located across the Fontanka River from the Summer Garden and named for a large salt warehouse built there in the eighteenth century. In the second half of the nineteenth century it was becoming a locus for new institutions intended to improve Russia's industrial capacity, technological literacy, and contemporary art industries. The rebuilt salt warehouse housed the 1870 All-Russian Manufacturing Exhibition that included displays of the latest works by Russia's porcelain manufactories, jewelers, and bronze foundries, as well as a show organized by prominent painters and sculptors. Within these same few blocks, the Imperial Russian Technological Society's facilities, including a Museum of Applied Sciences, and the Ministry of State Property's Agricultural Museum were being built.

Stieglitz and the Polovtsovs might have found this location less than satisfactory despite its proximity to a number of Imperial palaces and grand noble residences. Polovtsoff the younger complained rather bitterly about the spot in his memoirs:

> This public land was assigned to the Baron, who built there one of the most significant private educational institutions [in Russia], and it did not cost the Treasury a single penny. It was the envy and inertia of those bureaucrats who ruled Salt Township which drove it into an overlooked corner where there was little else of interest and, because of this, the public hardly knew it.[11]

It is possible that the family felt slighted by their placement among industrial museums and technical organizations, especially in comparison to the Society for the Encouragement of Artists (later the Imperial Society for the Encouragement of the Arts). This, the other school in St. Petersburg, offered limited technical drawing courses and was equipped with a small applied arts museum, but its goals were more oriented to the fine arts than to art in industry, and it enjoyed the patronage of a member of the Imperial family, Princess Eugenia of Leuchtenberg (1845–1925). At virtually the same time, in 1877, it was granted land by Tsar Alexander II at no. 38 Bolshaia Morskaia Street, a prime spot only minutes from the Polovtsovs' city residence at no. 52 and at the edge of the fashionable shopping district housing the firm of Fabergé, among others. Whether or not the elder Polovtsov believed that his wife was the child of an Imperial family member, he certainly was close enough (beyond his governmental duties) to the Imperial family, including a number of the grand dukes, to be frustrated at the lack of support they gave to the Stieglitz Institute and Museum. He dined several times each week at the home of Grand Duke Vladimir Alexandrovich and his wife, Maria Pavlovna, themselves voracious collectors and connoisseurs. The Secretary of State advised both the grand duke and his brother, the future tsar Alexander III, on acquisitions and frequently presented them with objects he had purchased during his travels.

The Stieglitz Institute was not entirely a private institution as we would understand the term today. The family's decisions had to be approved by the tsar or the Ministry of Finance, of which the school was officially part. The situation probably presented few difficulties for Stieglitz and Polovtsov the elder, both of whom had proven themselves masters of negotiating the Russian Imperial bureaucracy. But the subtle snub they had received in comparison to the Society for the Encouragement of Artists obviously rankled. The elder Polovtsov's published diaries offer hints

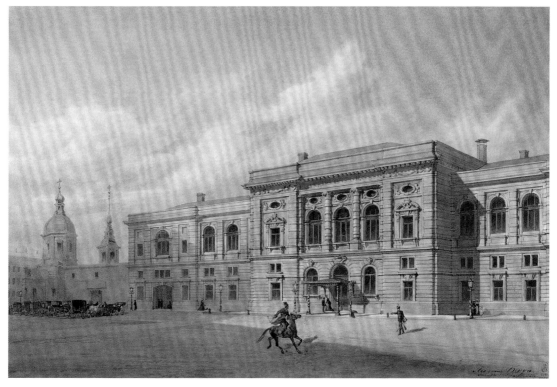

Fig. 19 L. N. Benois and N. P. Krakovskii (Russian, 19th century). *The Baron A. L. Stieglitz Central Institute of Technical Drawing*, 1880.

of the mutual and competitive antipathy with which he and Dmitry Grigorovich, the Secretary of the Society, viewed each other.[12]

Whatever the dissatisfaction with the location, the modern, two-story building in the Neo-Renaissance style at 13 Salt Lane by the architects Alexander Krakau and Robert Gödicke (fig. 19) was purpose-built for educating young artists, designers, and teachers. When it fully opened in 1881 (after having admitted a smaller class to the completed parts of the building in 1879), students and teachers benefitted from classrooms with better light than could be had in the rebuilt private residence housing the Society. The prominent painter Kuzma Petrov-Vodkin recalled how airy and well equipped these rooms were, so much so that he found it difficult to work lest he somehow soil them.[13]

The school was administered by a Board of Trustees including Baron Stieglitz (until his death in October 1884) and Alexander Polovtsov the elder; the younger Polovtsoff was still finishing his own education, but

recalled that his parents felt that he was the only one of the four children who would be suited to taking over the institute after their deaths. The elder family members appointed as director the architect Maximilian Mesmacher, who had been teaching drawing classes at the Society.[14] At a meeting of the board early in 1878 the decision was taken to include a museum in which students could study three-dimensional objects at first hand; photographs and engravings were not considered an adequate substitute for the future designers and artisans.[15] When the school building fully opened in 1881, it included a space for a museum and a library. News reports tell us that these spaces were filled with items donated or loaned by prominent citizens, including the Polovtsov–Stieglitz family, wishing to contribute to the effort to improve Russia's manufactories.[16]

The elder Polovtsov and his wife energetically sought out exemplary European, Chinese, Japanese, and Persian objects for the school's museum. Winters were spent in the family's St. Petersburg mansion, but summers were

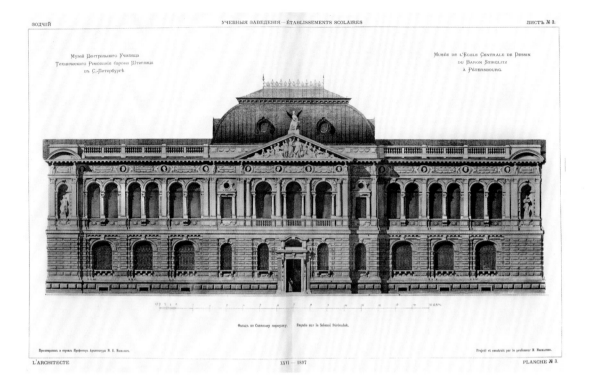

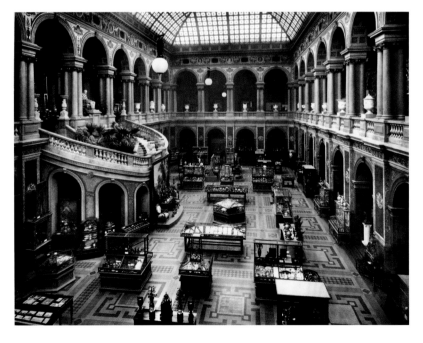

Fig. 20 Maximilian Mesmacher (Russian, 1842–1906). *Façade of the Museum of the Baron Stieglitz Central Institute of Technical Drawing*. Reproduced from *Zodchii (The Architect)*, 1907.

Fig. 21 Karl Bulla (Russian, 1855–1929). *The Great Hall of the Museum of the Baron Stieglitz Central Institute of Technical Drawing*, 1909.

taken abroad, usually in Paris or Biarritz. The younger Polovtsoff's memoirs are filled with the names of the important galleries and collectors he visited with his parents, trips he saw as part of their effort to prepare him to safeguard and develop the institute and museum on which the family had lavished their efforts and fortune.[17] Eventually the family would acquire a home in Paris, and that city served as a base for their travels to acquire art works for the museum, as well as books for the elder Polovtsov's 25,000-volume library and objects for their own collections. By the time the baron died in 1884, the museum had outgrown the space allotted to it. With the baron's passing, the school received an additional five million silver rubles to safeguard its work and develop its resources. It was now the wealthiest such institution in Russia. With nearly unlimited funds, the family set out to build a museum that would serve both the institute and the public as a whole.

When one stands on Salt Lane today and looks at the museum and the institute next to each other, it is possible to assume that the museum had assumed greater importance for the family. The museum dwarfs the institute in terms of both façade and footprint (fig. 20). In order that it be on a par with similar institutions in Europe, the Polovtsovs sent Mesmacher to London, Berlin, and Vienna to study similar institutions, including their decoration, organization, and facilities. The design he presented to the Board of Trustees on his return, and which greatly pleased Polovtsov the elder, was grandiose and announced the new building as a great repository of public learning. While the comparison might not be the first to occur to the viewer today, contemporaries frequently cited similarities with Jacopo Sansovino's sixteenth-century Biblioteca Marciana in Venice, one of the earliest public manuscript depositories.[18]

The museum's interiors were organized as a canonical history of art essential to future designers and decorative artists as it was understood in the period. At the center is the Grand Exhibition Hall (fig. 21), a vast two-story space enclosed by a glass roof, the largest in Russia at that time. On the first and second floors, students and visitors could progress through thirty-two rooms representing periods spanning antiquity to the Baroque; walls were painted with complex decorative schemes designed by Mesmacher (fig. 22) and rooms furnished with historically appropriate objects from the collection, which numbered 15,000 objects by the time the museum was completed in 1896. The institute's students participated in the museum's decoration, transferring Mesmacher's

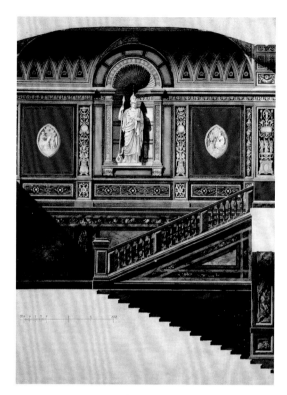

Fig. 22 Maximilian Mesmacher (Russian, 1842–1906). *Design for the North Wall of the Roman Staircase, Museum of the Baron Stieglitz Central Institute of Technical Drawing,* ca. 1890. Collection of the Stieglitz Museum of Applied Arts.

designs to the walls and installing the plaster, bronze, and gilt-leather fittings. The grand opening on April 30, 1896, was an international event, attended by representatives from museums throughout Europe and presided over by Nicholas II.

The museum seemed poised to surpass great European public collections of applied arts and to do so in a space that far exceeded its competitors' "exterior splendor."[19] The family acquired several important collections en bloc via purchase or donation.[20] According to Polovtsoff's memoirs, the annual budget for the museum's acquisitions was 100,000 rubles, an extraordinary sum for the period that makes clear his family's ambitions.[21] Best known is a group of 632 items purchased from Aron Zvenigorodskoi, who would go on to form an important collection of Byzantine enamels now in the Metropolitan Museum of Art, New York.[22] Large acquisitions were also made from dealers and antiquarians specializing in diverse fields, including Julius Goldschmidt,

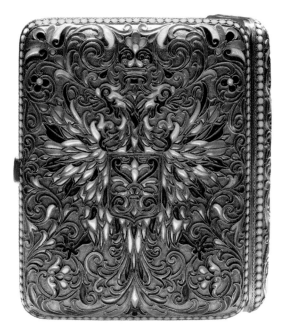

Fig. 23 Alexander Liubavin (Russian, 19th/early 20th century). Cigarette case in plique-à-jour enamel and gilded silver, 1899–1908. The Walters Art Museum, gift in memory of Jean M. Riddell, 2010.

Seligmann et Cie, and Siegfried Bing. Polovtsoff and his parents were all serious students of the international expositions, their visits to which enriched the museum with the latest technical developments and trends in design. Nadezhda Polovtsova assembled a large collection of contemporary glasswork by Salviati, J. & L. Lobmeyr, and Philippe-Joseph Brocard at the 1878 Paris Exposition Universelle that was subsequently donated to the museum. The latest jewelry and glass, by the firms of Falize, Gallé, Lalique, and Tiffany, and ceramics by Rookwood Pottery's Albert Valentien similarly found their way to the Stieglitz Museum.

Of Nadezhda and Alexander Polovtsov's four children, only Sasha, as Alexandre Polovtsoff was known among family members, showed interest in shouldering the burden of overseeing and developing the institute and museum. With this in mind, the young man's education, already the best that could be obtained in late Imperial Russia, was supplemented accordingly. Polovtsoff recalled that his father began to bring him along on his visits to some of Europe's best private collections as well as to the most influential dealers then at work.[23] Under the influence of his parents' work,

Polovtsoff recalled that "aesthetics became the guiding interest of my life."[24] Those aesthetic interests were deeply bound to the late eighteenth century, the period of Catherine II, his presumed great-great-grandmother and a patron who used her wealth and power to amass one of Europe's greatest collections of art. Polovtsoff's affinity for the era is clear from his extensive writings on the woman and her court, but they are also reflected in some of the finest objects he sold to Walters and by doing so protected from Russia's cultural maelstrom.

With his father's death in 1909, responsibility for the institute and museum fell squarely on Polovtsoff's shoulders. It is possible that the family was facing some financial difficulties. A great sale of the elder Polovtsov's property, at the Galerie Georges Petit in Paris from December 2 through 4, 1909,[25] was followed by a number of smaller, specialized sales throughout 1910.[26] The 244-lot sale in 1909 included important jewels, silver by Juste-Aurèle Meissonnier, paintings by Jean-Baptiste Greuze and Charles-François Daubigny, and tapestries, porcelains, and *objets de vertu* that all would easily have fit the mission of the St. Petersburg museum. Sergei Witte, who dictated his memoirs shortly after Polovtsov's death, wrote that the elder Polovtsov "sold, bought, and speculated to such an extent that he speculated through his wife's entire fortune."[27] The Polovtsov children may have had no choice but to sell rather than to further enrich the museum.

The institute's programs were well established, and the period before World War I is one of success building on success. Students were required to complete what today might be called an internship: all graduates had to work for some period in an active workshop or manufactory. This often resulted in students quickly finding permanent positions. The list of Stieglitz graduates who worked at the Imperial Porcelain Factory is astonishingly long and includes well-known names such as Rudolf Vilde, who distinguished himself as a ceramics designer and graphic

artist in both the late Imperial and Soviet periods, and Alexandra Schchekotikhina-Pototskaia, whose folk-influenced designs are some of the most original of the early Soviet period. The firm of Fabergé also benefitted from the program: numerous designers and miniaturists were graduates of the Stieglitz Institute.[28] After graduation from the Stieglitz Institute, Vasili Zuiev went on to become one of Fabergé's best miniaturists and painted the miniatures on the 1912 Napoleonic Egg (Matilda Geddings Gray Foundation), the 1913 Tercentenary Egg (Kremlin Museums), and the 1914 Catherine the Great Egg (Hillwood Estate, Museum & Gardens). Other graduates found work at manufactories and workshops such as the Meltser Furniture Workshops, at the Imperial theaters, and at the firm of Liubavin, the producer of the striking plique-à-jour case now in the collections of the Walters Art Museum (fig. 23).

With the outbreak of the war in 1914, the museum's exhibition work came to a sudden halt. The collection was packed in crates in order to free space so that the great central hall could be utilized as a hospital for treating the wounded. Collecting, on the other hand, hardly slowed. The war years saw an explosion in antiques trading, and Polovtsoff and other trustees continued to acquire new works for the collection, including medieval enamels from southern Russia and sixteenth- and seventeenth-century Russian silver vessels from the collection of the painter Konstantin Makovsky.[29] The fall of the Imperial government in February 1917 resulted in a sharp increase in donations, as collectors sought to shield pieces from the looting and destruction of the first stages of the Russian Civil War (1917–22). When Alexandre Polovtsoff fled across the Finnish border in 1918, he left behind his personal collection in the Stieglitz Museum.

Unfortunately, this extraordinary collection is not one that can be visited today. Financial constraints and Soviet museological policies necessitated creating the museum as a branch of the Hermitage in 1923. The

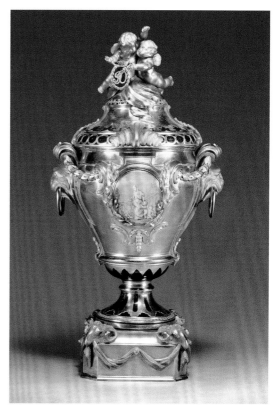

Fig. 24 Jean-Pierre Ador (Swiss, 1724–1784). Potpourri vase with classical figures, 1768. The Walters Art Museum, acquired by Henry Walters.

collections were transferred there in several campaigns, a process completed as the first bombs fell on the city during the German invasion in 1941. The logic of early twentieth-century cultural policy gave little importance to the Imperial or noble provenance of objects, and the outlines of the Stieglitz Museum's collection remain to be established. Whether all of the transferred items are now in the Hermitage is unknown; curators at both institutions have collaborated on a number of exhibitions and publications tracing their whereabouts and provenance.[30]

The museum's existence in the form that the Polovtsov family had wanted was all too brief, but the influence of its founders lives on in the impact the last director had on Henry Walters. By assembling a collection of items ranging from an eighteenth-century potpourri vase (fig. 24) and early icons to Fabergé Imperial Easter Eggs, Walters became America's "first collector of Russian art" and preserved a tiny piece of that vision in America.[31]

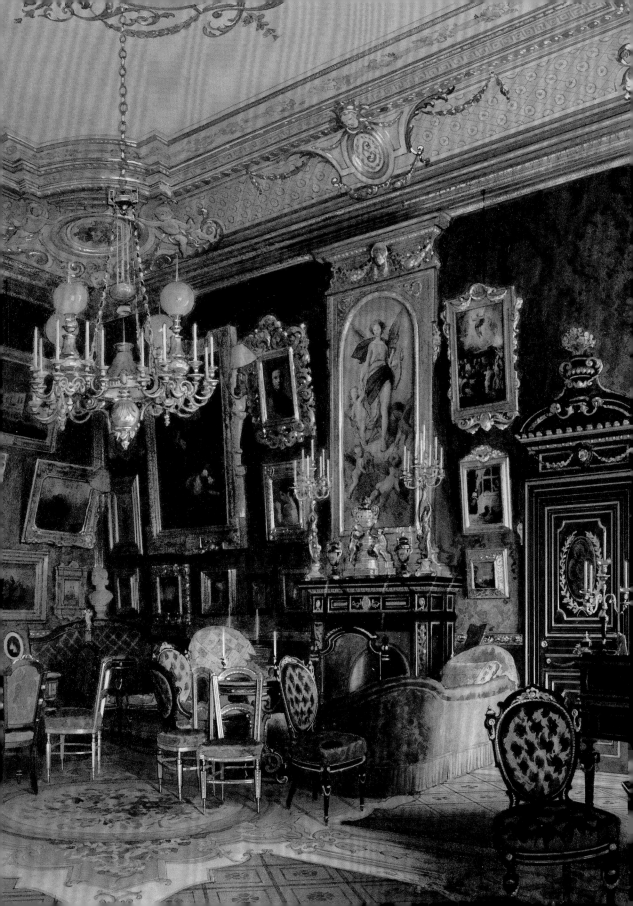

CHAPTER TWO

Alexandre Polovtsoff

DIANA SCARISBRICK

It is often said that behind every good collection lies a good dealer, and certainly Henry Walters (1848–1931) owed much to the expertise of Alexandre Polovtsoff (1867–1944), from whom he acquired the important Russian works of art that became part of the collection of the Walters Art Museum. Yet Polovtsoff never expected to become a dealer, having been born into a privileged world of Imperial courts, palaces, country estates, and cosmopolitan luxury.[1] It was only after losing his fortune and career as a result of the Russian Revolution in 1917 that, faced with the challenge of exile, he turned to the selling of antiques. All went well until the economic recession of the 1930s and then World War II, which destroyed all his hopes of recovery. Yet he came through all these vicissitudes sustained by his very Russian fortitude and by his passion for beauty, art, and history.

Polovtsoff was born into an art-loving family of wealth and political influence. As Karen Kettering's essay (pp. 21–29) describes, his mother, Nadezhda (1838–1908), rumored to be the "natural" daughter of Grand Duke Michael Pavlovich, brother of Nicholas I (r. 1825–55), inherited the huge fortune of her adoptive father, the banker and industrialist Baron Stieglitz, known as the Russian Rothschild. Polovtsoff's brilliant father, Alexander Polovtsov the elder (1832–1909), was not only a rich industrialist and landowner but also a high-ranking government official, a member of the State Council and of the Committee of Finance, and was appointed State Secretary by Alexander III (r. 1881–94) in 1883. The family lived on a princely scale in St. Petersburg (fig. 25) and at Rapti, the country estate south of the city, famous for its wolf and bear hunts. On show everywhere were works of

art: seventeenth-century Flemish tapestries, Renaissance sculpture, Vermeer's *Portrait of a Mistress with Her Maid*, a set of paintings by Giovanni Battista Tiepolo, and Chinese and Japanese ceramics. Determined that Russian craftsmen should learn from the best models, Alexander Polovtsov the elder also built, and then collected for, the new museum attached to the Stieglitz Institute. This patriotic institution had been founded in St. Petersburg by his father-in-law to give young people training in traditional skills so that they could be employed in the textile industry and in the porcelain and glass factories, as well as by silversmiths and goldsmiths such as Fabergé. A similar sense of duty impelled the elder Polovtsov to negotiate the acquisition of the collections of Petr Saburov and Alexander Bazilevskii for the Hermitage, and he was one of the founders of the Russian Historical Society.[2] Well known in France as a member of the Jockey Club and officer of the Légion d'Honneur, he had a home in Paris at 41 rue Cambon and a villa on the Riviera. With his parents, the young Alexandre had breakfast in Paris with the novelist Ivan Sergeievich Turgenev, visited the art collector Joseph-Louis Léopold Double at his apartment in Quai Voltaire, and enjoyed evenings at the Comédie Française.

In England the Polovtsovs were close to Lord Randolph Churchill, who with his wife had traveled in Russia. Years later, Alexandre remembered how their son Winston was given his political education aged twelve when after Sunday dinner Lord Randolph would call out "Winnie, make a speech," and the future prime minister would ask, "About what?" As soon as his father had given the subject the boy would then improvise,

OPPOSITE
Fig. 25 Luigi Premazzi (Italian, 1814–1891). *The Mansion of Baron A. L. Stieglitz: The Study of Baroness Stieglitz*, 1870? The State Hermitage Museum, St. Petersburg.

like an experienced public speaker. Invited everywhere, Alexandre danced with Princess Mary of Teck; she had "no grandeur, was timid, quiet and inconspicuous," and he never imagined that, as the wife of George V, she would be crowned Queen of the United Kingdom in 1911. Besides making friends—the eminent soldier Lord Kitchener, the statesman Arthur Balfour, the cultured and beautiful Lady de Grey, the lively socialite Margot Asquith, and the young diplomat John Gorham Ford— Alexandre attended Parliamentary sessions, where he heard Prime Minister William Gladstone's speech on home rule for Ireland, which he judged a masterpiece of rhetoric.

Thus, from an early age Alexandre grew up in palatial surroundings, traveled in France, England, and Italy, learned foreign languages, and met the outstanding personalities of European politics, diplomacy, and society. At home in St. Petersburg he immersed himself in his father's library, learned to paint and draw, developed a love of theater, ballet, and music, and, encouraged by his parents, became involved in the work of the Stieglitz Institute and Museum. At the age of twenty he impressed the Marquis de Breteuil, a family friend, who predicted that he would go far, having inherited the solid, serious interests of his father and the charm of his mother.[3] After legal studies and service in the Imperial Guard, he was employed from 1892 by the ministries of Internal and Foreign Affairs, which led him to western Siberia, to Russian Turkestan, and to India as Consul General in Bombay.

Travels to Greece, Sicily, Crete, Syria, Turkey, and Italy—and to France for the Expositions Universelles of 1878, 1889, and 1900—opened his horizons to the ancient and contemporary worlds, but for him Turkestan was "perfect heaven on earth." After his first visit in 1896, he wrote that he

*had finally pulled back the curtain that had al-
ways separated me from the fairy tale East, ...*

unconnected by rail to the Russian Empire ... it was still a dreamy, unique, incredibly beautiful kingdom—bazaars, holidays, dancers in caftans, turbans, beautiful horses in festive harness, local customs, women in long veils, camel caravans, the best fruit to be found nowhere else.[4]

Amazed that though Turkestan was part of Russia, no one had ever bothered to study it and connect it more closely with the fatherland, he determined to make this his own mission. With his camera he visited all the remotest provinces via the hair-raising passes of the Pamir Mountains, enduring the effects of the high altitude and attacks from hostile crowds. While there, he studied the local dialects and sought out nomads so as to compile a grammar and dictionary of the Ishkashimi language, which was published by the Academy of Sciences in 1909. After all these adventures, he revived the local handicrafts of wood carving and ceramics for the decoration of his house in Tashkent, where he remained very happily, studying and making a great collection of oriental carpets, until appointed Consul General in Bombay in 1905.

Polovtsoff's command of English and his connections in the Russian Ministry of Foreign Affairs smoothed his way in India. Since in a given year only one Russian ship entered the port at Bombay and no more than ten citizens called at the consulate, his mission was no more than that of a political observer. With his drive and his horror of an "unproductive life," he therefore set about studying Indian art, religion, and culture, and created a garden stocked with native plants unknown in Europe. Unfortunately, his plans were cut short after he fell ill with malaria and was obliged to resign his post in July 1907.

His career was not limited to the law, army, diplomacy, and administration but also included business: beginning in 1909, he developed the important

Fig. 26 The Polovtsov dacha on Kammenyi Island. Reproduced from *Zodchii* (*The Architect*), no. 12 (March 20, 1916).

Bogoslovosk metallurgy interests in the Urals, inherited from Baron Stieglitz. Successful though he was in all these various activities, in 1909, aged forty two, he admitted that "aesthetics were now the principal interest in his life" and devoted himself heart and soul to the Stieglitz Institute and Museum, of which he became director after the death of his father that year. His influence was felt immediately. Convinced by the experience of his travels and residence in Turkestan that the art of Russia had always been influenced by that of Asia, he steered the traditional Stieglitz acquisitions policy away from Western art to that of Russia and the East.

A man of the world, he was now related to some of the great names of Russian history, for both his sisters and his niece married into the nobility: Nadezhda, with Count Alexei Bobrinsky; Anna, with Prince Alexander Obolensky; and Nadezhda's daughter Sofia, with Prince Peter Dolgoruky, in 1907. Polovtsoff's own first marriage in 1890, to the heiress Sofia Panina (1871–1956), lasted six years before they divorced.[5] "Pol" married again, to another Sofia, and the couple made a great impression on his great-niece Sofia Skipwith (1907–1994):

he [was] … extremely intelligent, a wit, a connoisseur of art and antiques and a historian. Their houses were filled with exquisite things, and in Petrograd the drawing room had a ceiling brought from Greece. Aunt Sofka, surrounded by tangerine Persian cats with fur as long as Angora rabbits, a gay person and one of the leading lights of St. Petersburg, was always exquisitely dressed.[6]

They entertained at their Louis XV-style country mansion, Rapti, and in St. Petersburg at their grand house hung with rare tapestries in Bolshaia Morskaia Street. He was most attached to his dacha, Kammenyi (fig. 26), on the islands, said to be the place where his mother, Nadezhda, whom he believed to be a Romanov, had been left as a foundling for adoption by Stieglitz. There, although he put his own stamp on the property by creating winter gardens and a pavilion for gipsy choirs to entertain his guests, he kept the original atmosphere. It impressed a British diplomat, who, invited to dinner in the company of Grand Duchess Vladimir (the German-born wife of the second son of Alexander II) admired "the

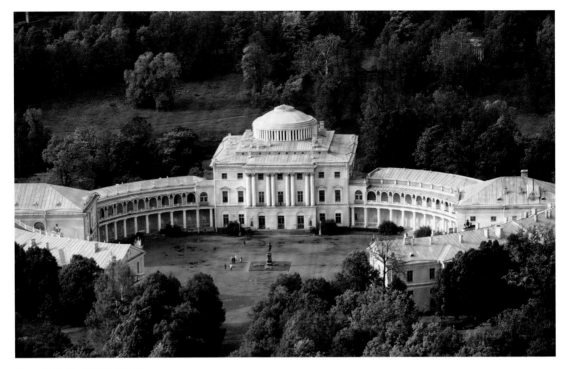

Fig. 27 Aerial view of Pavlovsk Palace.

classical style of the furniture, which like the architecture of the house, recalled the glory of [the] Liberation of Europe from Napoleon by Alexander I."⁷

In March 1917, as the revolution gathered momentum, Alexandre Polovtsoff resigned from the Ministry of Foreign Affairs and, aware of the dangers of looting and the destruction by the mob, joined a group of friends determined to save the artistic treasures of St. Petersburg and its neighboring districts. He told his enthralling story in a book, *Treasures of Art in Russia under the Bolshevik Regime* (1919).⁸ The Provisional Government commissioned Polovtsoff, with Count Zubov, a member of the Board of the Institute of the History of the Fine Arts, and P. P. Weiner, since 1907 publisher of the art journal *Starye Gody* (*Old Years*), to compile an inventory of the contents of Gatchina. This was the palace built for Grigori Orlov, named Prince of the Holy Roman Empire in 1772; it was subsequently occupied and enlarged by Paul I (r. 1796–1801), his son Nicholas I, and more recently the widow of Alexander III, Dowager Empress Maria Feodorovna. In June 1917, while Zubov and Weiner, assisted by students, concerned themselves with the collection of 4,000

paintings, Polovtsoff began listing the tapestries, lacquer, and porcelain in the Chinese Gallery, and the contents of the chapel, the armory, and the pavilions in the park. Meanwhile, on behalf of the residents of Pavlovsk Palace, Prince John Konstantinovich and his family, M. Smirnov, the palace's manager, appealed to Polovtsoff for help in making an inventory of the works of art it contained, a task which was now essential because of the very real possibility of pillage. Since he had virtually completed his work at Gatchina, Polovtsoff offered to undertake the work himself.

However, in September 1917, instead of being answerable to the sympathetic Provisional Government, Polovtsoff was now under the control of the local soviet boss, Alexander Kerensky, who, watchful and suspicious, made the work more difficult and caused unnecessary delays. Using his diplomatic skills, Polovtsoff established good terms with Anatole Lunacharsky, first People's Commissar of the Enlightenment. The latter appointed him commissar of Pavlovsk and charged him to turn the property into a museum. For Polovtsoff this was a sacred mission; as he explained,

I hoped not only to prevent profanation of a beautiful house, but also to prevent the dispersal of magnificent works of art. I wished above all to keep the sweet spectres of the past in their homes, to safeguard in its entirety this atmosphere of an elegant and refined period, full of illusions and allegories—as a pious and zealous priest to stir up sacred fire and save this subtle perfume that each bouquet of Pavlovsk gave off for other generations of artists. To gain this end I was ready to wear any disguise, and put up with any insults to let myself be called by any name (e.g., Commissar) and I shall be Comrade Polovtsoff ... nothing other than posthumous secretary to the orders of Her Imperial Majesty Marie Feodorovna.[9]

Built by the neoclassical architect Charles Cameron and given to her by her husband, Paul I, Pavlovsk had been Maria's favorite residence, and she lived there, adding wings and making improvements to the interiors, park pavilions, and landscape for forty years until her death in 1828. It was untouched by her heirs, who regarded it as a monument to her taste and artistry (fig. 27).

Perhaps thinking that if his mother was indeed the daughter of Grand Duke Michael, son of Maria Feodorovna, then he must be a great-grandson, Polovtsoff identified completely with the empress, whose taste he considered perfect (fig. 28). Every day his admiration increased: "the more I studied Pavlovsk the more I understood that it was there, a favorite residence of Maria Feodorovna that this princess, German by birth, French by her taste and education, Russian by ideas and activity, had collected all the souvenirs of her sentimental life, so rich in its manifestations."[10] Faithful to the memory of her husband, assassinated in 1801, she "kept his bed, with bloody sheets in a closet to which she possessed the only key and visited every day until she died."[11] Polovtsoff was also impressed by the range

of her artistic talents, for she could paint on frosted white glass, carve hardstone cameos, turn ivory and amber, and make mounts for vases and little columns for furniture. Soon he found himself so much in tune with her logical taste that he could discover the right plinths for each marble bust, chosen to match the decor of a

Fig. 28 Johann Baptist Lampi I (Austrian, 1751–1830). *Grand Duchess Maria Feodorovna*, 1795. Museum-Reserve Pavlovsk.

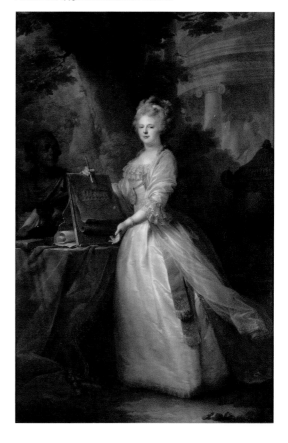

particular room, and even follow her thoughts as she reached out for the perfection of artistic effects in color combinations, draperies, picture hanging, and the placing of her furniture and objets d'art.

He marveled at the Italian Room, a "model of sober taste with 4 antique statues standing against [a] faux marble lilac colour" and the harmonious perfection of the Corinthian Grecian Hall.[12] The proportions of all rooms, large and small, were quite perfect, and he observed that "the more one remains in them more one feels this and one is seduced as much by their charm as if it were a human being."[13] Looking out at the park, also untouched, he felt transported into "another world," and sitting in her enclosed garden he "felt the summer air was impregnated with the talk of Maria Feodorovna and her literary guests."[14] Polovtsoff loved art not only for its own sake but also because it made the people of the past live again in his imagination.

The contents expressed the atmosphere of a palace. Pavlovsk was filled with the paintings and works of art acquired by the future Tsar Paul I and Maria Feodorovna during their Grand Tour of France, England, and Italy from September 1781 to November 1782. There were Louis XVI tapestries (notably a series after François Boucher's *Les amours des dieux*), marble busts, statues of exceptional beauty, alabaster urns, sarcophagi for ashes, chimney pieces, and a great mosaic of the Roman Colosseum, as well as paintings bought from the studios of artists—Jean-Baptiste Greuze in France, and Raphael Mengs, Angelica Kauffmann, Pompeo Batoni, and Hubert Robert in Italy. In her bedroom Maria kept three shuttles for making lace as souvenirs of Turin. The decorative arts were represented by the beautiful glass chandeliers and lanterns from the Imperial Crystal Works of St. Petersburg; Louis XV and Louis XVI wall sconces; fine Diréctoire-style furniture; porcelain from Sèvres, Berlin, Meissen, and Ludwigsburg; and a toilet service, vases, cups, and saucers from St. Petersburg, commissioned to

show that the Russian porcelain factory could equal the quality of the French. Using the inventories drawn up in 1802, 1811, 1818, 1848, and 1849 Polovtsoff could trace the history of each object and date it accurately, sometimes with surprising results.[15] His achievement as the savior of Pavlovsk was to protect the palace, its contents, and the park from the mob, and to persuade the Soviets not to destroy the Imperial residences but to transform them into museums for the benefit of the public; in his own words, the battle was a hard one, but "I had succeeded in instilling into the minds of the local people that the palace was national property and not merely booty offered by the revolution for plunder."[16]

While he was immersing himself in the glories of Pavlovsk, conditions became daily more difficult, and almost as soon as he began his inventory Polovtsoff advised Prince John Konstantinovich and his numerous family to leave, as he could not guarantee their safety. During the long winter from November 1917 to May 1918, he was obliged to work by candlelight in unheated dark rooms with windows boarded up, lost more than 40 pounds (18 kg) for lack of food, and suffered from frostbite and stress. Although the telephones were usually out of order, transport to and from Pavlovsk was very erratic, and there were thieves everywhere, he carried on. The hardest aspect was his relationship with the Bolsheviks, whom he described as "troupes of savage monkeys who had usurped power and abused it to destroy what made life acceptable."[17] After listening in silence to interminable speeches on the benefits of the revolution and the imminence of a new golden age, he made his requests as brief as possible and, if they were granted, then struggled to obtain a signed document. When, after a time, these papers became ineffective, he had to negotiate again with the person who was the most popular with the regime, and get his signature. In addition he was oppressed by a permanent feeling of insecurity, for there was always the danger of sudden arrest and imprisonment without

food or hope of trial, and then being shot "for having annoyed the world."[18]

At the end of October 1918, after a year of virtual slavery under the Bolsheviks, having lost his fortune and everything that had made life worth living, Polovtsoff and his wife left St. Petersburg in secret. This turned out to be even more difficult than they anticipated, for as they were about to slip on foot across the frontier into Finland they were approached by a stranger who asked them to take charge of three small children. Somehow they managed to walk 1¼ miles (2 km) across fields in the dark, she dragging a suitcase and he carrying one of the children, with the others holding onto their coats behind. On their arrival in Finland, relieved to find people waiting for the children—whose names they never discovered—the Polovtsoffs then proceeded toward Sweden and spent some time in England before finally making France their permanent home.[19] Besides speaking French well, they had highly influential friends such as the aristocratic de Ganays of Courrances and Maurice Paléologue, French ambassador to Russia from 1914 to 1917.

The Polovtsoffs became members of a colony of 100,000 Russians drawn to Paris, the political, artistic, and literary capital of Russia abroad. Few of these refugees were qualified to take up professional occupations. The greatest success stories came from the artists: the composer Igor Stravinsky; the dancers Serge Lifar and Boris Knyazev; the impresario Serge Diaghilev, director of the Ballets Russes; and the filmmaker Alexander Volkov and the actor Ivan Mosjoukine, both affiliated with the Albatros Studio, founded in 1922. The sense of national identity remained strong. At home there were icons and the samovar, and in the world outside Russian schools, tennis clubs, shops, clothing stores, drugstores, banks, real estate agencies, and the many hotels, restaurants, and cabarets clustered around Place Pigalle. The extraordinary atmosphere in such nightclubs as the Caveau Caucasien was described by Joseph Kessel in his novel *Nuits de princes* (1927) as

mixed up together, starving, disguised, colonels of the Guard, professors, ladies of the nobility, prostitutes, improvised artists, celebrated gypsies, exposed for sale, sometimes with ferocious sincerity, sometimes with vicious mummery, to couples stunned by the noise and the lights and the champagne, the wild, hopeless, often sublime breath that formless, boundless Russia has put into her songs, her dances and the hearts of even the worst of her children.[20]

The community was kept close by two newspapers and by the Orthodox clergy, centered on the church in the rue Daru and the Institut de théologie orthodoxe Saint-Serge, who supported aid organizations, necessary for so many refugees without money or training. Times were hard. Kessel described the poverty of "two sisters eking out an insecure living designing and making flower decorations," and so did George Orwell, in *Down and Out in Paris and London* (1933), with his description of the unforgettable Boris sleeping under the Seine bridges, existing on a meager diet of bread, potatoes, milk, and cheese, and employed as a dishwasher working eighteen hours a day, seven days a week. Other ex-officers worked as waiters, some drove taxis, and a few were dependent on women who had managed to bring money away from Russia and owned dancing halls or garages.[21] Today, a museum in Courbevoie records how splendidly the Cossacks succeeded in keeping their spirits high by living together in a residence of their own and maintaining the regimental traditions of horsemanship, brotherhood, and courage. For Orwell they were "a hardworking people who have put up with their bad luck far better than one can imagine the Englishmen of the same class doing."[22]

Fig. 29 Sergei Mikhailovich Prokudin-Gorskii (Russian, 1863–1944). *General View of the Shaykh-i Zindeh Mosque, Samarkand,* ca. 1905–1915. Library of Congress Prints and Photographs Division, Washington, D.C.

The émigrés' lively and exotic presence in the city influenced the leaders of Paris fashion who, for a few seasons, adopted Russian style—the brilliant clashing colors of the Ballets Russes costumes, the embroidered blouses, the fur-lined cloaks—and émigré Russian women found employment in couture houses such as Chanel. The celebrated Prince Felix Yusupov and his wife, Irina, gave the lead by opening IRFE (combining the first two letters of their names) in rue Duphot, and Sofia (Sophy) Polovtsoff followed them with her own dressmaking house on the Left Bank in rue Vaneau. As for her husband, the former commissar of Pavlovsk, aesthete, and collector, he now became a dealer in antiques, setting up at 154 Boulevard Haussmann near other well-known shops. From there he must have spent hours at the Hôtel Drouot, the Paris auction house, picking out fine examples of Western porcelain, glass, furniture, tapestries, painting, and sculpture; Chinese and Japanese ceramics and lacquer; and, above all, any items of Russian provenance that should come up for sale.

Polovtsoff's connoisseurship and breadth of knowledge soon came to the attention of the auctioneers, who engaged him as expert to catalogue a series of fifty-two sales from 1923 to 1933. He did more than write sale catalogues covering his favorite period of European decorative arts: the elegant classicism of the reign of Louis XVI (r. 1774–92), King of France, so well represented at Pavlovsk. He also bought examples for the shop and on commission for his clients. He was therefore particularly active at the sale of some of the beautiful possessions of his old friend Grand Duke Paul (youngest son of Alexander II), formerly at Tsarskoe Selo, near St. Petersburg, seized by the Soviets and sold to a syndicate of dealers who sent them for auction at Christie's on June 6 and 7, 1929. His many acquisitions included Sèvres porcelain, ormolu-mounted Louis XVI candlesticks, a French Empire perfume burner, a clock by Gaston Jolly, and some fine furniture, notably a suite comprising a sofa and eight armchairs covered in Aubusson tapestries illustrating Aesop's *Fables,* with children and flowers.

As his mind and eye were not exclusively concerned with Western achievements, he would have enjoyed cataloguing Persian manuscripts and miniatures, and glass, bronzes, arms, lacquer, textiles, and carpets for the Hôtel Drouot. While in Turkestan in 1903–4 he had discovered the beauty and originality of Islamic art, declaring that "those who have been admitted to a taste of her enchantments are her slaves for ever." He remembered walking up to the Shaykh-i Zindeh mosque in Samarkand (fig. 29) "like a dream. … one feels caught up in the meshes of a spell, and each step brings one to a new vista of beauty which encompasses one all around."[23] Describing a sixteenth-century Persian carpet, he enthused about "the native Persian inspiration which was so enamoured of the tangible beauty of the world that it has known how to interpret the grace and the splendour of flowers and blossom with a perfection no other human civilisation has ever touched."[24] Similarly, in cataloguing the Far Eastern objects, he must have drawn on his own experience as a collector, buying before the 1917 revolution

from the celebrated dealer Florine Ebstein-Langweil in Paris and remaining close to her after settling in the city.

By the time Henry Walters made his purchases of Russian art between 1928 and 1931, Polovtsoff was already established as an authority and had catalogued sales of icons, silver, textiles, mid-nineteenth-century Peter Loukoutine lacquer, St. Petersburg porcelain, books, lithographs, and landscapes by the painters Alexei Bogolyubov and Vasili Khudiakov. Goods were limited to what émigrés had managed to bring out with them, but the supply increased from 1925, when the Antikvariat was set up by the Soviet state for trading in antiques, chiefly Church property, expropriated on the pretext of helping the hungry. The main outlets were the Berlin auction house of Rudolph Lepke and other dealers, either combined into syndicates or operating individually.[25] Although the French government would not allow auctions of sequestrated property to take place, dealers and museums could and did acquire these items through unofficial channels. Along with the former curator of the Hermitage picture collection, Alexandre Benois, who was in Paris after 1926, and the partners Jacques Zolotnitsky and his nephew Léon Grinberg of the shop A La Vieille Russie, Polovtsoff set about promoting interest in Russian art, especially icons, through exhibitions. They were able to show 103 objects formerly in religious institutions, such as icons, manuscripts, and crosses, at their first exhibition, *Art russe: ancien et moderne*, held at the Palais des Beaux-Arts in Brussels, from May through June 1928.[26] The devotion of the émigré community to the Church helped foster knowledge of icons and brought international recognition to this art form through traveling exhibitions in the late 1920s and collections including those of Joseph Davies, George Hann, Maurice-Léon Ettinghausen, and Armand Hammer. However, business became difficult after the international economic disaster triggered by Black Thursday (October 24, 1929), the first day of the stock market crash on Wall Street, New York, and only a

few clients, among them Henry Walters, could continue buying. According to Grinberg's handwritten diary, composed in Russian, it was during the five or six years preceding his death in the autumn of 1931 that Henry Walters bought, for millions of dollars, the many first-class Russian items now in the museum. Although these objects, among them silver items, snuffboxes, icons, crosses, miniatures, and enamels, were sold by Polovtsoff to the collector, they were supplied through A La Vieille Russie.[27]

From the 1930s, having time to spare, Polovtsoff published three books, *The Land of Timur: Recollections of Russian Turkestan* (1932), *The Favourites of Catherine the Great* (1940), and *The Call of the Siren* (1939), the last his love letter to the city of Naples, "one of the most delightful places on earth." He was also the motivating force behind the landmark exhibition of Russian art held at 1 Belgrave Square, London, from June 4 through July 13, 1935. His unrivaled connoisseurship and devoted enthusiasm were acknowledged by the exhibition committee, which felt that it was to him rather than to any other individual "that the successful encompassing of our object is due."[28]

In his introduction to the catalogue of that exhibition, he reveals his artistic credo: to "people his places as in a theatre," according to his conviction that the remnants of the past would acquire a new meaning if they were associated with the men and women who had possessed them. To this end, he selected nine objects and then linked them with biographical sketches of notable Russians. The series was introduced by the Gospel on which the Kievan princess Anna Yaroslavna swore her solemn oath at the coronation ceremony in Rheims Cathedral after her marriage to Henri I, King of France, in 1051.[29] This was followed by a bust by Bartolomeo Rastrelli of Prince Menshikov, the favorite of Tsar Peter the Great (r. 1682–1725), who, from his peasant origins, assumed great power until fate turned on him and he died in exile. Next, the luxurious tastes of Empress Elizabeth, who governed from 1741 to 1761, were represented by the diamond-and-jasper cane handle

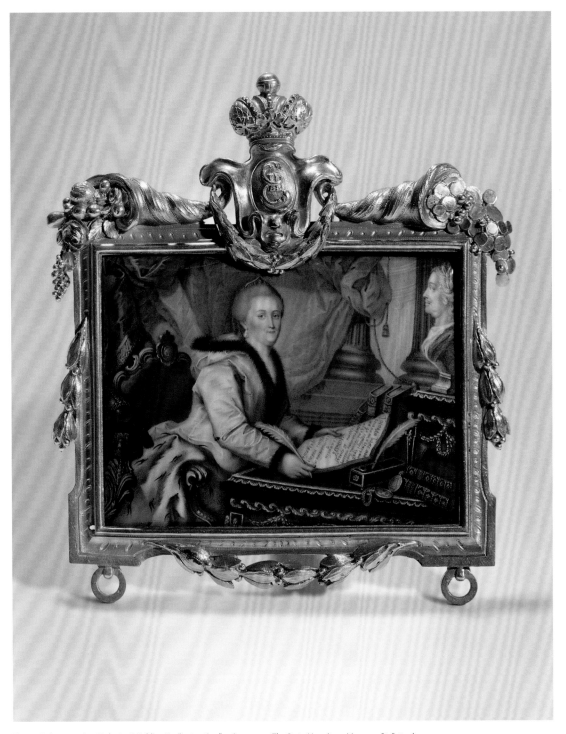

Fig. 30 Unknown artist. *Catherine II Holding Her "Instruction,"* 1760s–1770s. The State Hermitage Museum, St. Petersburg.

carved with her portrait, to be caressed by the fingers of her unofficial husband, Alexei, Count Razumovsky. The efforts of Catherine II the Great (r. 1762–96) to make Russia more prosperous and aligned with European culture were evoked by a portrait showing her working at her desk, starting each day at 7 a.m. (fig. 30). The most personal of the three works of art connected with Paul I and Maria Feodorovna was an onyx cameo portrait of their six daughters carved by their talented mother, who had mastered the difficult art of gem engraving.

We can be sure that every item on show—icons, gold and silver vessels, miniatures, jewelry, Fabergé enamels, and carved stones—would have met Polovtsoff's exacting taste and that he brought them to life when he escorted King George V and Queen Mary—his former dancing partner—around the exhibition. As a dealer in Boulevard Haussmann, Polovtsoff would have had the same approach to Henry Walters, offering him the best quality available and then explaining the significance. Since so little was known about Russian art in the first decades of the twentieth century, it was this gift for placing it in the context of the vanished periods, places, and people, based on deep knowledge and appreciation, that accounts for his success. Through his intellect, taste, and social graces he survived the hard years of exile, economic recession, and World War II. On his death in 1944, he was buried with his fellow émigrés in the cemetery of Saint-Geneviève-des-Bois in Paris's southern suburbs.

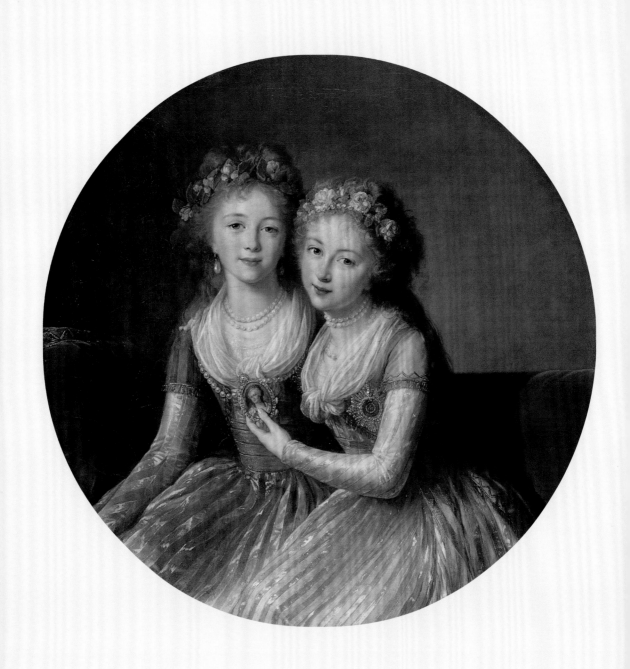

CHAPTER THREE

Imperial Russian Jewelry

DIANA SCARISBRICK

Madame de Staël, the French woman of letters, observed in 1810 that: "Magnificence is the character of everything one sees in Russia … what characterises this people is something gigantic of all kinds: ordinary dimensions are not applicable to it, boldness and imagination know no bounds, with them everything is colossal rather than well proportioned, audacious rather than reflective."[1] She might well have been describing the displays of jewelry worn at court in Moscow and St. Petersburg. Deeply rooted in national history, this distinctively Russian emphasis on magnificence and splendor stems from Byzantine art, evoking the legendary pomp and luxury of the palaces of Constantinople and the grandeur of the emperor, who "wears on his head either a diadem or a crown of gold decorated with precious stones of inestimable value. These ornaments and his purple garments are reserved for his sacred person alone, attracting the admiration of spectators."[2]

After the seizure of Constantinople by the Turks in 1453, this grand tradition did not come to an end but was continued in Russia by Ivan the Terrible (r. 1533–84), who claimed to be the sole heir of the Byzantine Empire. Having repulsed the Tartar invaders in 1547, Ivan, as the Grand Duke of Muscovy, assumed the Roman title tsar (Caesar) and was crowned Tsar of All the Russians. Like the Byzantine emperors, to signify his authority he also made a great display of the rare and precious stones bought from the caravans passing through Moscow on their way to Venice from India and the Far East. His sumptuous attire and imposing manner made a great impression on the enterprising British sea captain Richard Chancellor, who in 1553 recalled that:

our men began to wonder at the Majesty of the Emperour: his seat was aloft in a very royall throne having on his head a Diademe of Crown of gold apparelled with a robe all of goldsmiths work and in his hand a sceptre garnished and beset with pretious stones … there was Majestie in his Countenance proportionable to the excellencie of his estate.[3]

The political importance of jewelry was equally well understood by the Romanovs, who acceded to the throne in 1613. As a result of their patronage and that of the powerful Orthodox Church, the goldsmiths and enamelers established in the Kremlin workshops in Moscow flourished, reaching a peak of artistic creativity in the following decades. These craftsmen contributed to the beauty of the Orthodox liturgy by supplying precious vessels and attire for the clergy. The latter officiated crowned with tall globular miters embroidered with pearls and encrusted with gems and enameled plaques of angels and saints inscribed in Greek; they were clad in gold vestments hung with *panagia* (miniature icons or devotional medallions) and crosses of pearls, enamels, diamonds, sapphires, rubies, and amethysts. The much venerated icons of the Virgin were adorned with necklaces and crescent-shaped halos embossed with stylized plants bright with enamels, edged with pearls, and highlighted with precious stones. All this ecclesiastical splendor was matched by the rich jewelry of the Romanov monarchy. To Lord Carlisle, sent to Moscow as English ambassador in 1663, Tsar Alexis (r. 1645–76) and his court seemed like exotic characters from the *Tales of the Thousand and One Nights* in their

OPPOSITE
Fig. 31 Marie Louise Élisabeth Vigée-LeBrun (French, 1755–1842). *Grand Duchesses Alexandra and Elena Pavlovna*, 1796. The State Hermitage Museum, St. Petersburg.

flowing Byzantinesque caftans of gold and silver cloth trimmed with sable, colored stones, and pearls.[4]

This long historical tradition changed direction with the policy of Westernization initiated by Peter the Great (r. 1682–1725). After deciding to build the new city of St. Petersburg to replace Moscow as his capital, he moved his court there in 1712, and, from then onward, Western rather than Eastern influences became paramount, though the desire for luxury remained as strong as ever. Beards were forbidden, the nobility was compelled to adopt contemporary European dress, and foreign artists and craftsmen, including jewelers, were encouraged to settle in Russia. Attracted by important commissions from Peter the Great's three women successors, the empresses Anna (r. 1730–40), Elizabeth (r. 1741–61), and Catherine II (Catherine the Great; r. 1762–96), émigré jewelers brought the Parisian style of jewelry to Russia but adapted it to suit the Russian taste for splendor. In his *Memoirs*, Jérémie Pauzié (1716–1779), the most successful of these craftsmen, describes how as a youth he accompanied his father from Geneva to Russia and worked as apprentice to Benedict Gravero, a lapidary who cut precious stones, especially rubies, brought in from the Far East. Pauzié recalled that "the clothing of the ladies was very rich, as were their golden jewels. The ladies of the court wore amazing quantities of diamonds. Ladies of comparatively low rank may be wearing as much as 12,000 roubles worth of diamonds, but the gentlemen rival the ladies."[5] Recognizing the importance of the Russian Orders of St. Alexander Nevsky, St. Andrew, and St. Catherine—the last for women only—Pauzié won his first major commission by submitting a wax model of the star of the Order of St. Andrew set with diamonds for the Duke of Courland.[6] He also created court jewels: the cipher badge or diamond-crowned monogram of the empress, worn by maids of honor on a blue ribbon of the Order of St. Andrew on the left of the bodice, and a miniature of the empress framed in diamonds. Only a

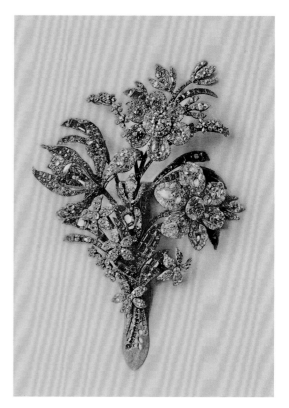

Fig. 32 Floral spray. Reproduced from Alexander Yevgenyevich Fersman, *Russia's Treasure of Diamonds and Precious Stones* (Moscow: Narodnyi kommissariat finansov, 1925), pl. 19.

few women—the Dames of the Portrait—were privileged to wear the latter jewel (fig. 31).

Besides these official badges, crosses, and stars, Pauzié and his colleagues created a series of asymmetric, polychrome rococo-style flower sprays and bouquets in diamonds, the stones backed with foil to give a light shimmer of pink, yellow, or green. There were aigrettes, or sprays, for the hair, dripping huge pearl or sapphire drops. Diamonds of the finest purity were strung into necklaces, hung as earrings, and mounted into sets of dress ornaments—designed to be pinned to give the appearance of glittering brocade—and a matchless group of floral and bowknot brooches.[7] Even the largest of these naturalistic bouquets, dating from the 1740s and considered the forerunner of Fabergé's flower studies, has a hook at the back, indicating that it could be worn with court dress (fig. 32). Pauzié's masterpiece was the new Imperial crown commissioned by Catherine II for her coronation in 1762

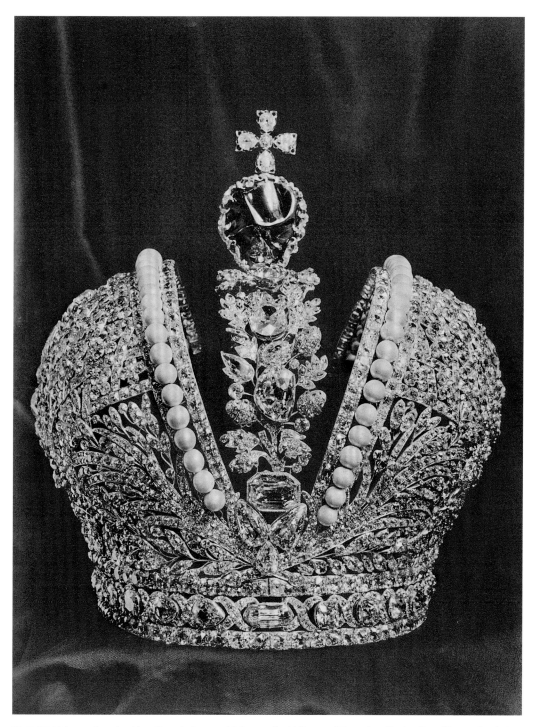

Fig. 33 Imperial crown. Reproduced from Alexander Yevgenyevich Fersman, *Russia's Treasure of Diamonds and Precious Stones* (Moscow: Narodnyi kommissariat finansov, 1925), pl. 2.

Fig. 34 Louis-David Duval (Swiss, 1727–1788). Cornucopia. Reproduced from Alexander Yevgenyevich Fersman, *Russia's Treasure of Diamonds and Precious Stones* (Moscow: Narodnyi kommissariat finansov, 1925), pl. 32.

and used in all later coronations. Inspired by the mitre-shaped crown made in Prague for the Habsburg Emperor Rudolph II in 1602, it replaced the old-style crown—a gold filigree cap lined with red satin and trimmed with sable—believed to have been a gift from the Byzantine emperor to St. Vladimir on his conversion to Christianity in 988. The new Russian version was set with 5,000 diamonds, outlined in rows of large pearls, centered on a magnificent octagonal diamond of 57 karats in the front, and surmounted by a great 389-karat spinel.[8] That Pauzié and his assistant J. F. Eckhart succeeded in creating this effect of magnificence, while ensuring that the crown would not weigh more than the empress could bear on her head during the five-hour ceremony, was a great achievement (fig. 33). Two years later, after creating this, the richest crown in Europe, and his other successes, notably the Imperial mantle clasp composed of diamond leaves tied with a bowknot, Pauzié returned to Geneva, worn out by a succession of fires, burglaries, and financial problems caused by clients who did not settle their accounts, unlike the empress, who paid promptly.

Aware that grand jewelry proclaimed her power and rank as ruler of a vast empire that stretched from Siberia to Poland, and also appealed to the Russian taste for sumptuousness, Catherine transformed the Imperial Bedchamber in the southeast corner of the Winter Palace in St. Petersburg into the Brilliant Room. The German visitor Johann Georgi described it thus:

Her room is like a priceless jewel case. … The regalia is laid out on a table under a great crystal globe through which everything can be examined in detail … the walls of the room are lined with glass cabinets containing numerous pieces of jewellery set with diamonds and other precious stones as well as insignia and portraits of her Imperial majesty, snuff boxes, watches and chains, drawing instruments, signet rings, bracelets, sword belts and other priceless treasures among which the Empress chooses presents for giving away.[9]

Throughout Catherine's long reign this collection was continually augmented through purchases and gifts, including diamonds, colored stones, turquoises from Persia, pearls, Chinese filigree, and Indian Mughal ornaments. All new acquisitions, which were supervised by two men, Glazumov and Aduarov, were either brought in from abroad or ordered from the colony of Russian and foreign jewelers and goldsmiths resident in St. Petersburg, notably Jean-Jacques Duc and Leopold Pfisterer.[10]

After Pauzié's return to Geneva in 1764, Louis-David Duval (1727–1788), his partner since 1754, became the most important of the court jewelers. His diamond cornucopia aigrette of ca. 1780, which is signed, illustrates his mastery (fig. 34). From London, the relatives of Duval established there sent a supply of aventurine snuffboxes, watches, étuis, gold, and pinchbeck. Other luxury items from the British court jeweler Rundell,

Fig. 35 Ring with a portrait of Peter the Great, after Jean-Marc Nattier (French, 1685–1766), beneath a heart-shaped portrait diamond, ca. 1720. Private collection.

Fig. 36 Medallion with an 18th-century miniature of Alexander I beneath a portrait diamond within a double-diamond border. Private collection.

Bridge, and Rundell were imported into Russia through their St. Petersburg agent. According to George Fox, employed by Rundell's, the empress was a "most excellent customer and many splendid examples of diamond work—necklaces, earrings, ornaments for the head, lockets, brooches—were purchased for her own use and as diplomatic presents, especially snuff boxes enriched with brilliants and with her miniature." There were also

> *rings of different sizes and values, generally set with brilliants and having small miniatures of Catherine covered with small thin flat diamonds commonly called pichere diamonds and for these diamonds large sums were obtained and consequently great profits made by them as Rundell, Bridge and Rundell were the only purchasers as they had a market for them.*[11]

This type of royal jewelry, in which the miniature was not only surrounded with diamonds but covered with a diamond, became a Russian specialty and continued to be popular with the Imperial family beginning with Peter the Great until the revolution of 1917 (fig. 35).[12]

There was no limit to what Catherine II, commanding huge revenues and the mineral wealth of the Urals, could afford, and the best diamonds and precious stones were acquired for the state collection during her reign,

some from French emigrants. In 1792, she decided to transfer her jewels for display in a new, more spacious Brilliant Room, decorated in classical Russian style, hung with paintings by Anthony van Dyck and with the celebrated Peacock Clock of James Cox in the center. But Catherine II did not concentrate all her interest in brilliant gem-set jewelry to the exclusion of other types of craftsmanship, and under her patronage the goldsmiths of St. Petersburg, Paris, and Berlin perfected their skills of enameling and chasing, producing innumerable exquisite snuffboxes for her pleasure. An inventory of 1789 lists a collection of some of the most exquisite jewels and objets de vertu created during the eighteenth century.

Catherine understood that "the important thing is that wherever we arrive people should see at once which one of us is the empress" and accordingly devoted time and thought to her public appearances as an enlightened benevolent autocrat. Escorted by her six pet greyhounds, she would choose jewels for a state occasion in the Brilliant Room and then proceed next door to her chambre de toilette. There a hairdresser might crown her piled-up hair with a Russian-style *kokoshnik* tiara, an aigrette, or jeweled pins, perhaps those designed as bowknots like the clasp of the necklace, which are still in the Kremlin. Afterward, dressed in her picturesque loose-sleeved Muscovite-style gown, she would proceed to a reception, a gala dinner, or a court ball. Even in her

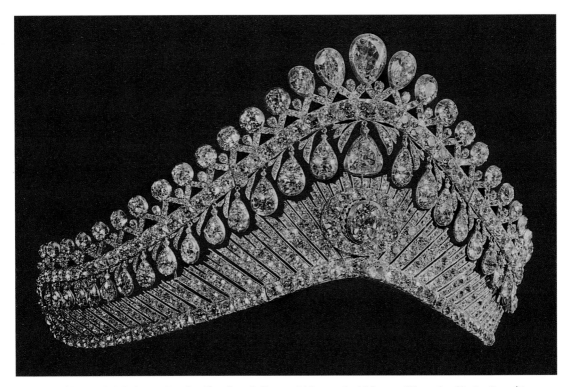

Fig. 36 Tiara of Empress Maria Feodorovna. Reproduced from Alexander Yevgenyevich Fersman, *Russia's Treasure of Diamonds and Precious Stones* (Moscow: Narodnyi kommissariat finansov, 1925), pl. 34. .

final years, her stately appearance continued to fascinate, as the French artist Elizabeth Vigée-LeBrun described:

> *although not tall, with her erect head, eagle eye and countenance so used to command, all was so symbolic of majesty that she looked as if she were queen of the world. She wore the ribbons of the three Orders over a dress of noble simplicity. It consisted of a red velvet dolman over a gold embroidered white muslin tunic with wide pleated sleeves, turned back in oriental fashion. Instead of ribbons, the most beautiful diamonds were scattered over the cap covering her white hair.*[13]

Catherine's son Paul I (r. 1796–1801), and his wife, Maria Feodorovna, and grandsons Alexander I (r. 1801–25) and Nicholas I (r. 1825–55) adopted the neoclassical style not only for architecture and furniture but also for jewelry. Designs became more symmetrical, using motifs, including cameos, derived from Greek and Roman art. The new

à *jour* settings meant jewels were lighter and easier to wear, and the parure—or set of tiara, earrings, necklace, stomacher (decoration for the bodice or corsage), and bracelets matching in design and stones—emerged for court festivities. Although in line with contemporary European fashions, the Russian versions were grander, the gems better quality, the scale more important. It was the sons of Louis-David Duval, Jacob David (1768–1844) and Jean François André (1776–1854), who succeeded most brilliantly in merging the Russian tradition with the latest European design. They supplied the jewels in the marriage caskets of the five daughters of Paul I and Maria Feodorovna.[14] For herself, and now that the tiara had replaced the aigrette as the most important jewel for the head, Maria Feodorovna bought from the Duvals two exquisite designs, one of classical ears of wheat and the other of Indian briolettes (fig. 36). Her excellent taste is also exemplified by a spray of pearl and diamond lilies made for Grand Duchess Alexandra Pavlovna, daughter of Paul I, on her marriage to Archduke Joseph of

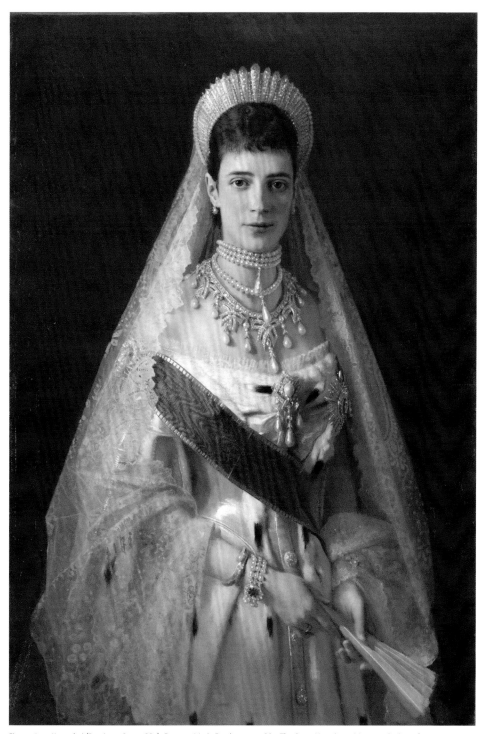

Fig. 37 Ivan Kramskoi (Russian, 1837–1887). *Empress Maria Feodorovna,* 1881. The State Hermitage Museum, St. Petersburg.

Austria in 1799, and by the pink topaz parures given in 1811 to Maria Pavlovna, Grand Duchess of Saxe-Weimar-Eisenach, and in 1818 to Maria's daughter, Princess Augusta.[15] These topazes were imported from Brazil, but soon afterward Russian jewelry received a great impetus from new discoveries in the Urals: platinum in 1824 and Siberian emeralds, aquamarines, amethysts, topazes, and alexandrite; the discovery of the last was announced on the coming of age of the future Alexander II (r. 1855–81) on April 17, 1834. There was no shortage of Golconda and Brazilian diamonds, white and fancy colored. The German traveler Christian Müller was overwhelmed by the sight of the valuable stones on the miraculous icon of the Mother of God at Kazan and by the lovely diamonds on the tiara made by Duval for Empress Elizabeth Alexeyevna, wife of Alexander I.[16] All these stones were beautifully mounted; the Comtesse de Choiseul-Gauffier, wife of the French ambassador, on receiving a jewel from Alexander I, declared that the St. Petersburg jewelers excelled all others in the art of setting diamonds.[17] Yet in spite of this expertise, these jewelers did not have an easy time. Clients delayed payments, and, by his own account, Duval had to juggle with the depreciation of paper money and fluctuations in foreign currency values before he could hope to make a profit.

With the wave of patriotism that swept across Russia after Napoleon's retreat from Moscow in 1812 came a revival of Russian traditions, expressed by the adoption of national costume by the court. It consisted of amply cut velvet robes over a white satin dress with train, long hanging sleeves heavily embroidered in silver and gold, liberally studded with stones of every color of the rainbow, and was completed by a halo-shaped, high *kokoshnik* over a lace veil falling behind. It was the Byzantine splendor of this attire, worn by so many, that made Russian court gatherings so picturesque (fig. 37).

Under Nicholas I and his successors, Alexander II, Alexander III (r. 1855–94), and Nicholas II (r. 1894–1917),

the pageantry of Imperial court life—balls celebrating name days, the New Year, and masquerades; weekly balls in the palaces of the nobility (held in the period between Christmas and Lent); and official ceremonies—amazed visitors. The spacious halls of the Winter Palace, with its immense windows, marble walls and columns, porphyry tables, malachite vases, and shining parquet floors, made a wonderful setting for the men in superb uniforms, glittering with orders and decorations, and for the women covered with diamonds.[18] In the diary he kept of his visit to St. Petersburg in 1836, the third Marquess of Londonderry wrote,

I give the palm to St. Petersburg for carrying the luxuries of fashion and magnificence to a higher pitch than any other capital I have ever visited: before I visited Russia and its treasures I knew not what was grandeur – let those who desire to understand it proceed to these palaces and then to the Kremlin at Moscow.[19]

The French writer Alexandre Dumas had the same impression of grandeur, which he declared was unrivaled by any other European court. At the ball for the name day of Nicholas I, the Marchioness of Londonderry admired Empress Alexandra Feodorovna in national costume, "her whole person one blaze of jewels but all arranged with such taste and perfection that their brilliancy struck you much more than their weight." Acknowledging that this imposing show put her own famous collection in the shade, the marchioness, through the wife of the foreign secretary, Count Nesselrode, met "the great jeweller and saw designs for remounting and resetting my jewels."[20]

Although unnamed, this jeweler is likely to have been Johann Wilhelm Keibel (d. 1862), who succeeded to the firm founded by his father, Otto Samuel Keibel (1768–1809), in 1797. He reworked the Imperial crown for the coronation of Nicholas I in Moscow in 1826 and

Fig. 38 Alexandra Feodorovna (1872–1918), Empress of Russia, ca. 1907.

coronations of emperors from 1826 to 1896. All the state regalia, including the insignia of the Orders of St. Andrew and of St. Alexander Nevsky, was used and, in addition, a new small crown for the empress was created by the court jeweler Leopold Zeftigen (1821–1888) for Maria Alexandrovna, empress of Alexander II. In the opinion of their daughter Grand Duchess Marie Alexandrovna, who married Alfred, Duke of Edinburgh, in 1874, the coronation ceremony in the Cathedral of the Assumption, the processions, the banquets, balls, and operas, and the plays were not to be missed, being "too grand for words." [24]

The Duchess of Edinburgh knew of what she spoke, for her own marriage and those of other members of the Imperial family were another pretext for a show of magnificence. For the long and majestic Orthodox ceremony in the chapel of the Winter Palace and the festivities that followed, the Romanov bride appeared wonderfully bejeweled, with the nuptial crown and the Indian briolette tiara on her head, the double-cherry earrings, the three-row *collier d'esclave*, and the ermine-lined mantle fastened with the Pauzié clasp. Because of her political importance, every bride was given her own treasury of jewels "calculated to inspire a deep reverence for the representatives of supreme majesty, ensigns of authority." At Clarence House, London, the Duchess of Edinburgh kept her great collection in glass cupboards lining the walls of the jewel room opening out of her bedroom. There, on velvet-covered shelves and stands were displayed sets of sapphires, emeralds, rubies, and diamonds, each with a huge tiara or crown, with necklaces, pendants, and stomachers. For formal occasions the jeweled stomacher, filling the bodice from the edge of the décolletage to the waist, was as essential as the matching tiara blazing out from the head and as the bracelets. There were iron shutters over all the cases, and watchmen kept guard over the jewel room day and night.

Fabulous parures were also presented to Dagmar of Denmark on her marriage to the future Alexander III; [25]

supplied Empress Alexandra with fine multirow diamond bracelets and, almost certainly, the rivière of twenty-five huge diamonds hung with seven pear-shaped drops, which in 1843 Nicholas I gave Alexandra to mark the twenty-fifth anniversary of their marriage and the births of their seven children. [21] Her collection contained no fewer than 500 bracelets, her favorite type of jewel, and in the Romanov gift-giving tradition she presented them as souvenirs and rewards for loyalty and achievement. She gave one with her miniature to Lady Londonderry and, in 1842, while the emperor was congratulating the ballet dancer Maria Taglioni on her farewell performance at the Hermitage, on stage the empress discreetly removed the bracelet from her own arm and placed it on the arm of the dancer, who pretended not to notice. [22]

According to Queen Sophie of the Netherlands, niece of Nicholas I, the Russian Imperial family believed they "belonged to another race of being from the rest of mankind," which consisted of "men, women and Romanovs." [23] Since jewelry was the most effective means of asserting this pre-eminence, the greatest displays were for the

to Alix of Hesse, bride of the future Nicholas II;[26] and to his sisters the grand duchesses Olga and Xenia in 1894.[27] Ironically, in these twilight years of Romanov autocratic rule the amount of jewelry owned and displayed by the women of the Imperial family reached epic proportions and designs were even grander than before. Outlined in bold diamond scrolls, fretwork, loops, or simple geometric shapes, and enclosing huge emeralds, sapphires, rubies, or pearls, these jewels, which made such uncompromising statements of authority, were admired internationally. In 1858, Alexandre Dumas declared that "the Russian craftsmen were the best in the world, unrivaled in their mastery of the art of setting diamonds, trained to excel in every process."[28] His opinion was shared by the leading Parisian jewelers Eugène Fontenay and Oscar Massin, who emphasized the importance given to the final polishing.[29]

Significantly, two of the most splendid events held before the revolution of 1917 commemorated Romanov achievements: the ball of the Costumes Russes, held in 1903 to mark the bicentenary of the founding of St. Petersburg, and the Romanov Tercentenary held in 1913, which was celebrated by a week of ceremonies and festivities. The importance of the historic first opening of the Duma, or Parliament, in 1906 was underscored by the appearance of the entire court, splendidly arrayed and led by the empress, resplendent in a magnificent diamond and pearl tiara, choker, and cluster necklace by the court jeweler, Bolin (fig. 38). Similarly, in 1914, in honor of the Franco-Russian alliance, the splendor of the banquet held at the Peterhof Palace, St. Petersburg, during the state visit of French president Raymond Poincaré impressed the French ambassador, Maurice Paléologue:

Thanks to the brilliance of the uniforms, the superb toilettes, elaborate liveries, magnificent furnishings and fittings, in short the whole panoply of pomp and power, the spectacle was such as no court in the world can rival. I shall long remember the dis-

play of jewels on the women's shoulders—it was simply a fantastic shower of diamonds, pearls, rubies, sapphires, emeralds, topazes, beryls—a blaze of fire and flame.[30]

These displays were not reserved exclusively for events in palaces, but were also visible at the Easter church service, the most important feast of the liturgical year. According to *Queen* magazine (1878) the ceremony at the Cathedral of St. Alexander Nevsky in Paris took place at midnight, and:

all ladies present were in full evening dress, low bodices and diamonds. The tsar's cousin, the comtesse de Beauharnais, wore pink brocade embroidered with silver flowers, a gold emerald-studded girdle, [and an] antique coronet consisting of three immense emeralds set in dead [matte] gold, her neck covered with row upon row of pearls which reached to [the] top of her low bodice, [and] many bracelets reaching up to [the] elbow. … Russians have quite a Byzantine style of wearing jewels, and put them everywhere. They interlace plaits of hair with precious stones, their necklaces consist of 20 rows of gems, one lady will wear as many as 20 bracelets at a time—when there is a large assemblage of Russian ladies in full dress [the] effect is most brilliant.[31]

Where the court led, the nobility and merchant classes followed, giving further stimulus to the jewelers. One of the great names was Bolin, founded in the early 1830s by Carl Edvard Bolin. By 1900, after several generations, Bolin was, with Dmitry Karlovich Hahn, the most important jeweler in St. Petersburg,[32] Other well-known jewelers were Fuldu and Tchitsheleff of Moscow, who showed in the international expositions in Paris and Vienna in 1868 and 1874 respectively; the English firm

of Nicholls and Ewing; the Swiss Friedrich Koechli, and Hahn, the latter two of St. Petersburg.

Hahn's great rival was the St. Petersburg firm founded in 1842 by Gustav Fabergé. Under his son Carl Gustavovich (Peter Carl) Fabergé (1846–1920), who took over in 1872, the name of Fabergé attained international pre-eminence. Appointed court jeweler in 1885, and employing 500 artists and craftsmen, notably Erik Kollin, Mikhail Perkhin, and Henrik Wigström, Carl Fabergé exercised total control over every stage of the production of a jewel or objet d'art. Famous for the superb quality of his enamels, especially in the guilloché technique, his unmistakable house style combines elements from the art of the Louis XV, Louis XVI, and French Empire periods with others from the Russian national tradition, executed in semi-precious stones—jadeite, amethyst, moss agate, aquamarine, bloodstone, and chalcedony from the Urals—mixed with precious rose diamonds, sapphires, and rubies. For Empress Maria Feodorovna, wife of Alexander III, he was an "incomparable genius" who from 1894 until 1917 delighted the Imperial family with a succession of fifty-six Easter Eggs. As the world's greatest maker of beautiful things, Fabergé set up branches in Moscow, Odessa, Kiev, and London. Such crowds gathered round his stand at the Paris Exposition Universelle in 1900 that even the Duchess of Edinburgh could not get near "his wonderful productions."[33] The key to the total perfection of Fabergé's work is provided by the memoirs of Franz Birbaum (1895–1917), the Swiss-born chief designer, discovered in 1990. Asked how young apprentices were trained to the exacting house standards, Birbaum related an anecdote concerning an elderly craftsman. When he delivered a complete set of jeweler's tools to a customer (a grand duke) who asked why it contained a leather strap, the old man explained, "Your Highness, it is the first and most important instrument. No pupil has ever learnt without one."[34]

Meanwhile, the great French houses were competing successfully for Imperial Russian custom. In 1898,

Boucheron opened a shop on the Pont de Marechaux in Moscow, while Cartier and Chaumet opted for showing their elegant and newest creations in exhibitions held periodically for charity in St. Petersburg. Although the future Nicholas II had given her a fan from Lalique and a coronet from Boucheron to mark their engagement in 1894, Empress Alexandra Feodorovna felt bound to patronize the Russian jewelers. Their clientele, which was a lucrative market, was drawn from other members of the Imperial family, such as Grand Duchess Vladimir; the nobility, led by Princess Yusupov; and the Shuvalov, Sheremetev, Stroganov, and Naryshkin families. [35]

As the destination of the finest jewels produced in Russia over two centuries, the Imperial collection was efficiently administered, recorded, and increased by successive generations of sovereigns. It was stored in the Brilliant Room of the Winter Palace until World War I, when, as the German army advanced toward St. Petersburg, it was removed in eight trunks for safekeeping in Moscow. These trunks were untouched for years until a commission was appointed to value the contents, and a catalogue with photographs of the 773 items compiled.[36] Most unfortunately, the Soviets, through the state institution of the Antikvariat, began a huge dispersal culminating in the sale of a large number of historical items to a syndicate, which sent them for auction at Christie's, London, on March 16, 1927. Jewels from this sale and others occasionally reappear on the market, though many will have been broken up and the stones used for more up-to-date jewelry. The remainder, now numbering 114 pieces, have been displayed by the Diamond Fund in the Kremlin since 1967. Together with photographs and paintings they tell the story of the Romanovs in jewels with such power that Mrs. Marjorie Post, founder of the Hillwood Museum (and then married to the American ambassador in Moscow, Joseph Davies), exclaimed on seeing them: "What a wonderful country is this Russia!"

Catalogue

Margaret Kelly Trombly

1 Temple pendant (*kolt*) with two birds

Kievan Rus', 12th century
Gold, cloisonné enamel
2⅛ × 1⅞ × ⅜ in. (5.2 × 4.6 × 1.5 cm)

Provenance: Henry Walters; The Walters Art Museum, 1931, by bequest, 44.297

In the construction of this *kolt*, the jeweler was drawing from Byzantine, Islamic and Kievan Rus' artistic traditions. *Kolty* adorned the hair and the elaborate headdresses of both men and women. Originally worn by Byzantine aristocrats, they hung from a loop near the cheek or the temple, hence the name temple pendant.[1] The fashion was later adopted by the wealthy of Kievan Rus', a powerful state that arose to the north of Byzantium. *Kolty* were enameled on both sides because they rotated as a person moved. The concave disks hid a perfumed cloth, which not only scented the air but may also have had amuletic properties. *Kolty* were most likely made in jewelry workshops attached to the Grand Ducal Palace in the Moscow Kremlin and share the same fine craftsmanship of earlier Scythian jewelry.[2]

This singular example features the motif of two birds facing each other with a stylized tree of life between them; other *kolty* depicted saints or mythical sirens. The birds are in brightly colored cloisonné enamel, a technique derived from Byzantium, their feet carved into the gold but not enameled. The spots or seeds on the birds' breasts represent fertility symbols. The boxlike construction of geometric enameled motifs on the reverse derives from Islamic designs.[3]

NOTES
1 Helen C. Evans, "The Arts of Byzantium," *Metropolitan Museum of Art Bulletin*, 58, no. 4 (spring 2001), 54, 56.
2 Tamara Talbot Rice, *A Concise History of Russian Art* (New York, 1963), 95.
3 Ibid.

2 St. Andrew Icon

Greece, 14th century
Tempera on wood with gilt
10¼ × 8 × ⅞ in. (26 × 20.5 × 2.2 cm)

Provenance: Alexandre Polovtsoff; Henry Walters, 1930; The Walters Art Museum, 1931, by bequest, 1931, 37.559

St. Andrew, one of Christ's twelve apostles and the patron saint of Russia and the Ukraine, is depicted here proffering a scroll, symbolic of holy wisdom. This panel may have been one of a group of saints flanking a *Deesis*, a trio of the Virgin Mary, Christ, and St. John the Baptist, whom worshipers venerated and supplicated. The *Deesis* is generally placed in the center of the most important tier of the iconostasis, a screen separating the sanctuary from worshipers in Russian Orthodox churches. This half-length portrait of the saint looking left toward the *Deesis* is set in a recessed portion of the small panel, suggestive of a "window to heaven." Icons, from the Greek word meaning "images," are considered "windows to heaven" because for true believers they give a glimpse of what awaits them in eternity.

St. Andrew has an arresting presence, newly characteristic of the late Byzantine style. Set against a plain ocher background, he mesmerizes the supplicant with his furrowed brow, riveting gaze, attenuated hands, and flowing hair. The outline of his halo is partially visible, and Greek letters in the upper corners identify him.

The figure is painted in tempera (a mixture of pigment and egg yolk), a common medium for Greek and Russian Orthodox icons. This medium cannot be manipulated on the panel surface, and consequently the red and green of Andrew's robes are bright and true. The outer frame shows traces of gilding, gold being symbolic of heavenly light.

3 Seven Days of the Week Icon

Russia, 16th century
Tempera on wood, silver filigree, cloisonné enamel
12⅛ × 10¼ × 1½ in. (31 × 26 × 3.6 cm)

Provenance: Alexandre Polovtsoff; Henry Walters, 1931; The Walters Art Museum, 1931, by bequest, 37.580

NOTES
1 Philippe Verdier, *Russian Art: Icons and Decorative Arts* (Baltimore, 1959), no. 14.
2 Alexandre Polovtsoff, "Memoirs," December 1934 (unpublished), trans. Olga Savin, 7. Sincere thanks to Anne Benson for arranging for the translation and providing a copy to the author and for her research on A. Polovtsoff.
3 K. Kozyrev, *Baron Stieglitz Museum: The Past and the Present* (St. Petersburg, 1994), 36, 37.
4 A. Polovtsoff, "The Exhibition of Russian Art," *Burlington Magazine*, 66 (June 1935), 297.

The days of the week are represented here by liturgical scenes in individual tableaux. They are laid out in three registers with a descending number of scenes in each, giving a distinctive rhythm to the panel.

The four scenes in the top register (from left to right) are the Harrowing of Hell (Saturday), symbolic of Christ's descent into Hell after the Crucifixion and before the Resurrection; the "Divine Powers" (Monday); the beheading of St. John the Baptist (Tuesday); and the Annunciation (Wednesday).

The center register recounts the story of Holy Week, with the risen Christ (Sunday) preaching from the Gospel of Matthew (25:34) "Come, O blessed of [my father]," flanked on the left by the washing of the feet (Thursday) and on the right by the Crucifixion (Friday). In the top and center registers, the figures are set in cityscapes and painted in a late Gothic style.

The base is composed of a celestial scene of the adoration of the Cross, depicted on an altar. A host of deceased bishops, saints, nuns, priests, and kings surround a group of souls, dressed in white, who were martyred for their faith. Taken in a larger context, the scene represents the moment when Christ ascends to the throne of God the Father and readies himself for the Last Judgment.[1] The frame is in cloisonné enamel in a pattern of leafy tendrils, characteristic of the sixteenth century.

Henry Walters' and Alexandre Polovtsoff's interests would have converged in this acquisition. Walters' goal was to build a comprehensive collection, and icons would have fit in this context. Polovtsoff had a lifelong interest in this Russian art form. It started in his youth when he accompanied his father on a diplomatic mission to Kiev, an ancient Slavic city, where he visited the holy sites.[2] One of the last exhibitions Polovtsoff organized at the Stieglitz Museum in March and April 1915 was one of "Church Antiquity."[3] In 1935, Polovtsoff mounted an exhibition of Russian art in Belgrave Square, London, where a room was devoted to icons.[4]

4 Triptych icon with the *Deesis*

Russia, 16th century
Tempera on wood, silver gilt
12 × 9 × 1¼ in. (30.5 × 23 × 3.3 cm)

Provenance: Alexandre Polovtsoff;
Henry Walters, 1930; The Walters Art Museum,
1931, by bequest, 37.1065

This triptych represents the *Deesis*, a pictorial convention developed in the Byzantine period that shows Christ flanked by the Virgin Mary and St. John the Baptist, who intercede with Christ on behalf of the faithful.[1] Their half-length figures are depicted atop silver-gilt altars. Christ, facing the viewer, is represented as the teacher with the book of the Gospel of John (7:24): "Do not judge according to appearance, but judge with righteous judgment."

Additional full-length figures join in prayer in the four quadrants of each panel. They strike supplicating poses, with heads slightly bowed and hands lifted in prayer. Many are identified on silver plaques and are recognizable by their carefully rendered garb. The Venerable Barlaam, St. George, and two others surround the Virgin, while St. Gregory the Theologian and the Venerable Sergius and two others join John the Baptist. The apostles Peter and Paul with the archangels Gabriel and Michael in the upper register give homage to the Christ figure.[2]

Imagine this icon in a chapel, home, or church with candlelight flickering off the *riza* (protective cover), composed of thin gilded silver sheets hand-hammered with elaborate foliate and scroll designs. The *riza* preserves the delicately painted figures, whose *repoussé* halos give dimension to the icon. The Archangel Michael retains his silver-gilt crescent-shaped collar, which serves as additional protection for the paint surface.

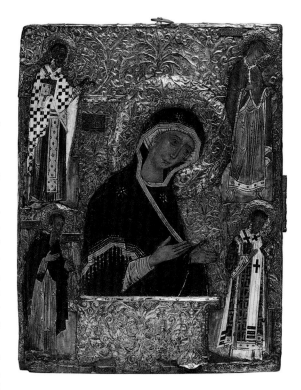

NOTES
1 Tamara Talbot Rice, *A Concise History of Russian Art* (New York, 1963), 44.
2 Philippe Verdier, *Russian Art: Icons and Decorative Arts* (Baltimore, 1959), no. 13.

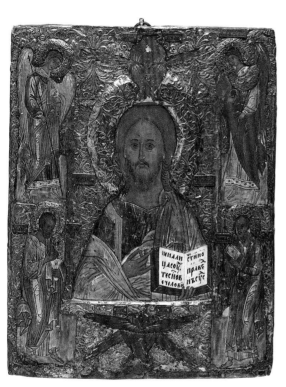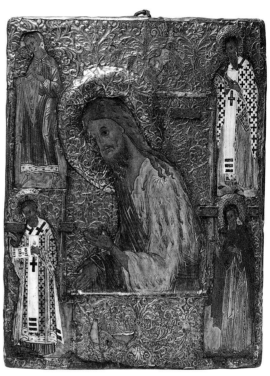

5 The Hospitality of Abraham Icon

Yaroslavl, Russia, ca. 1600
Tempera on wood, gilt
60½ × 50⅛ in. (153.6 × 127.3 cm)

Provenance: Henry Walters, 1922; The Walters Art Museum, 1931, by bequest, 37.1185

The icon's subject is stated in the inscription at center top, which reads: "The Holy Trinity." It recounts the story from the first book of the Bible, Genesis (18:1–15), in which Abraham welcomes three strangers at the Oak of Mamre, visible in the center background.

The visitors, three identical angels holding rods of divine authority, symbolize the Holy Trinity, or three persons in one God: the Father, the Son, and the Holy Ghost. The central angel blesses the vessels before him, foreshadowing the Last Supper and the sacrament of the Eucharist. Abraham and Sarah are smaller in scale and positioned in either corner, reminiscent of Renaissance donor portraits. The fanciful architecture, the umbrella-shaped oak, the wavelike rocky cliffs, and fabrics on the altar point to Asian artistic influences.[1] The biblical account ends with the visiting angels announcing that Sarah will soon be with child, a long-awaited miracle for the elderly couple. This monumental gilded panel would have served as the centerpiece of an iconostasis.

NOTE

1 Philippe Verdier, *Russian Art: Icons and Decorative Arts* (Baltimore, 1959), no. 16.

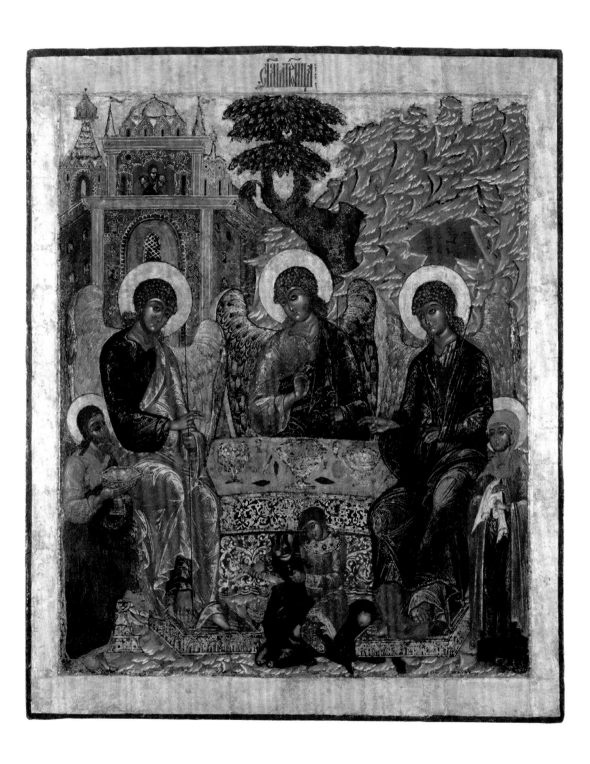

6 Triptych icon with Christ, St. Nicholas, and St. Blaise

Russia, 17th century
Tempera on wood, silver, silver filigree, enamel
2⅞ × 7 × ¾ in. (7.5 × 18 × 1.9 cm)

Provenance: Alexandre Polovtsoff; Henry Walters, 1928; The Walters Art
Museum, 1931, by bequest, 44.408

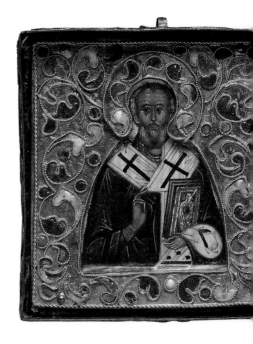

This three-part icon, known as a triptych, features half-length
figures of Christ, St. Nicholas the Wonderworker, and St. Blaise.
All have their right hand raised in a blessing. Nicholas (d. 343)
was a fourth-century bishop in Asia Minor. He was known as
the wonderworker because he rescued people from dire situa-
tions. He was a popular subject of icons and became known as
the patron saint of travelers. Blaise (d. 316) was an Armenian
bishop, renowned for healing human and animal diseases.
His intercession is most commonly sought for healing throat
ailments.

In rendering Christ and the saints, the icon painter was
faithful to an already established visual imagery, symbols, and
dress. Each holds a book of the Gospels; Christ's is open to a
passage that reads: "Come to me all who labor and are heavy
laden" (Matthew 11:28).

Each figure has an *oklad*, or protective cover. The filigree
enamel on the front and back is wrought in shades of brilliant
blue, green, ivory, and gold in a foliate pattern typical of the
seventeenth century.

This portable icon, with a clasp and hooks for a cord at the
top, could be folded and worn around the neck for divine pro-
tection and opened for private devotion as needed. The choice
of figures for the icon may have had particular significance to
the person who commissioned it.

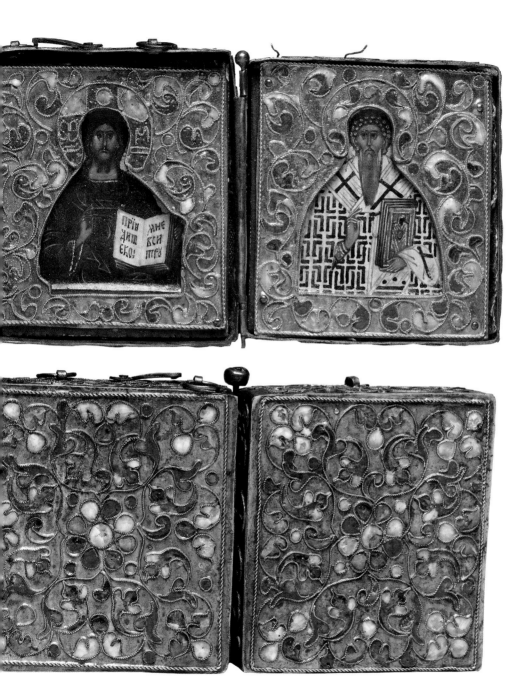

7 Casket

Russia, 17th century
Copper alloy, champlevé enamel
10¾ × 10⅞ in. (27.5 × 27.7 cm)

Provenance: Henry Walters; The Walters Art Museum, 1931, by bequest, 44.237

This casket is an example of Ustiug enamel ware, characterized by its color scheme of white, green, blue, and yellow, punctuated with distinctive black dots. The overall patterning of paisley shapes is reminiscent of Byzantine textiles. The town of Velikii Ustiug, located in the far north on the Northern Dvina River, was known in the seventeenth century for producing such everyday wares.[1]

The form of the casket may have been inspired by the Terem Palace, built in the Moscow Kremlin in the seventeenth century as a residence for the tsars. This casket is a miniature recreation of a *teremok*—the stepped-back upper floors of a palace or noble house reserved for women—and may have been used as a jewel case.[2] It opens in two places: at the midline and at the "roof" line, and the interior is divided into compartments. The front is fitted with copper rings, presumably part of a locking apparatus. The side handles aid with carrying this heavy object.

This casket is large in comparison to the nineteenth-century tea caddy, also in the form of a *teremok* (cat. no. 64), its design undoubtedly inspired by a seventeenth-century prototype. In the late nineteenth century, artisans working in the Russian Revival style were looking at antique objects such as this to impart a sense of authenticity to their work.

NOTES

1 Anne Odom, *Russian Enamels: Kievan Rus to Fabergé* (Baltimore, Washington, D.C., and London, 1996), 46–47.
2 Ibid., 50.

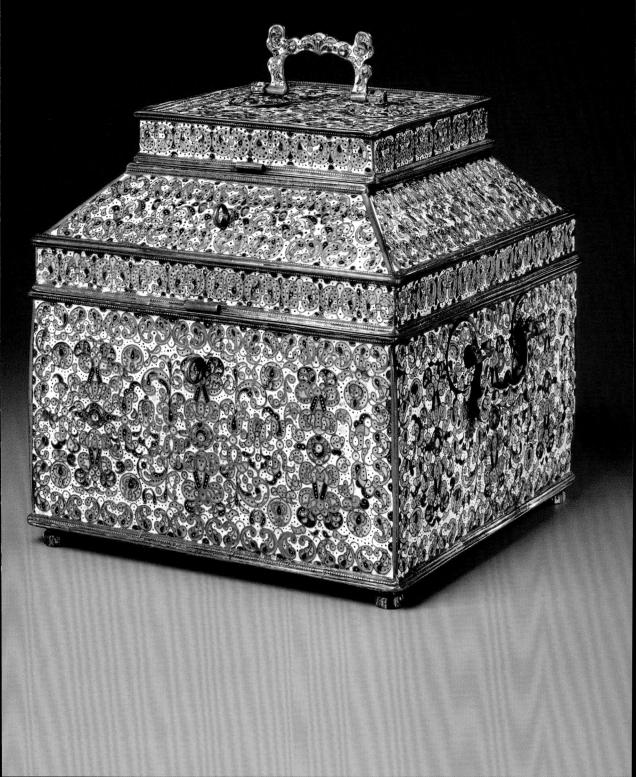

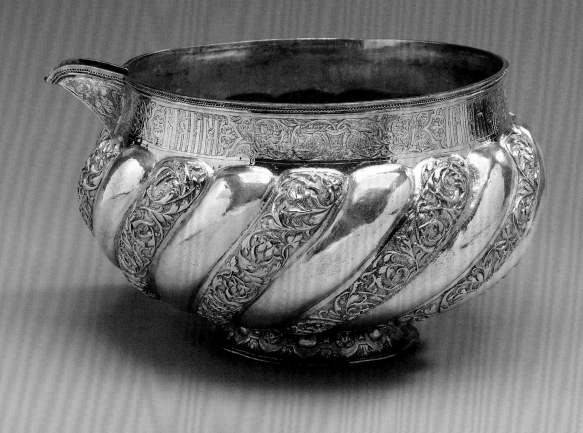

8 Fraternity drinking bowl (*endova*)

Russia, 17th century
Silver, parcel gilt
6 × 10⅜ in. (15.2 × 27.9 cm)

Provenance: Count Alexander Alexeevich Musin-Pushkin, St. Petersburg, before 1904; Alexandre Polovtsoff;
Henry Walters; The Walters Art Museum, 1931, by bequest, 57.794

NOTES
1 K. Kozyrev, *Baron Stieglitz Museum: The Past and the Present* (St. Petersburg, 1994), 34.
2 Sergei M. Gontar, "Alexander III's Reforms in the Decorative Arts," in *Maria Feodorovna, Empress of Russia*, exh. cat., Copenhagen: The Royal Silver Chamber (Copenhagen, 1997), 288.

This large, low vessel was used to pour individual servings of wine or mead. The alternating fluted silver and foliate gilded bands would have allowed the pourer to get a firm grip on it. A Cyrillic inscription in the scrollwork band around the rim reads: "Bratina of Jacob, son of Anicius Stroganov." The Stroganov family's power was centered in the northeastern Russian towns of Perm and Solvychegodsk, the latter known for its icon painting. Their wealth derived from salt and trading. Jacob Stroganov and his brother, Grigori, were instrumental in colonizing Siberia in the sixteenth century.

This *endova*, from the Musin-Pushkin collection, was shown at the 1904 exhibition in St. Petersburg under the patronage of Empress Alexandra Feodorovna, held to benefit soldiers wounded in the 1904–5 Russo-Japanese War (fig. 8.1). The exhibition was held for three months at the Stieglitz Museum, where the young Alexandre Polovtsoff served in a curatorial capacity.[1] That same year, the Russian Society for Decorative Arts was founded.[2]

In Paris after the revolution, Polovtsoff would have remembered this piece from the 1904 exhibition and understood its importance as a rare and early example of Russian metalwork. Henry Walters, whose fortune was built on the liquor trade, would have appreciated the *endova* for its history and association with liquor.

Fig. 8.1. *Endova* (right) as shown at the 1904 St. Petersburg exhibition, showing interior boss. Reproduced from Adrian Prakhov, *Album de l'exposition rétrospective d'objets d'art de 1904 à St.-Pétersbourg, …* (St. Petersburg, 1907), 141, fig. 54.

9 Drinking cup (*bratina*)

Western Europe and Moscow, ca. 1650–1670
Silver with gilt
H: 3⅝ × Diam: 4 in. (9.4 × 10.3 cm)

Provenance: Count Alexander Alexeevich Musin-Pushkin, St. Petersburg, before 1904;
Alexandre Polovtsoff; Henry Walters, 1929; The Walters Art Museum, 1931, by bequest, 57.814

The term *bratina* derives from *brat* (brother) and signifies fellowship. At traditional feasts, a *bratina* was filled with mead, an alcoholic beverage created by fermenting honey with water, and passed around the table.

One of the outstanding features of this handworked silver cup is the masklike repoussé scrollwork. This and its globular form contrast with the angularity of the Slavonic inscription etched on the lip. It reads: "Do not get drunk from the drink [and] do not brag of [your] table plate [but] guard it."[1] The cup was likely made in Western Europe, possibly in Hamburg, for the Russian market; the script was added later in Moscow. The idea of placing script on decorative objects had its roots in Islamic art, known in Russia through trade routes.

This *bratina* was included in the 1904 exhibition of Russian decorative arts held at the Stieglitz Museum in St. Petersburg. It was illustrated in a commemorative book with other antique silver vessels that belonged to Count Alexander A. Musin-Pushkin, a poet and essayist.[2] Alexandre Polovtsoff, whose family contributed loans to the exhibition, would have recognized this piece.

The *bratina* came to Polovtsoff through Jacques Zolotnitsky and his nephew, Léon Grinberg, who left Russia during the revolution to continue their antiques business under the banner of A La Vieille Russie in Paris. Polovtsoff sold the *bratina* to Henry Walters, who might have had an interest in antique drinking vessels because of the family liquor business.

NOTES
1 Philippe Verdier, *Russian Art: Icons and Decorative Arts* (Baltimore, 1959), no. 31.
2 Adrian Viktorovich Prakhov, *Album de l'exposition rétrospective d'objets d'art, de 1904, à St. Pétersbourg* (St. Petersburg, 1907), 141.

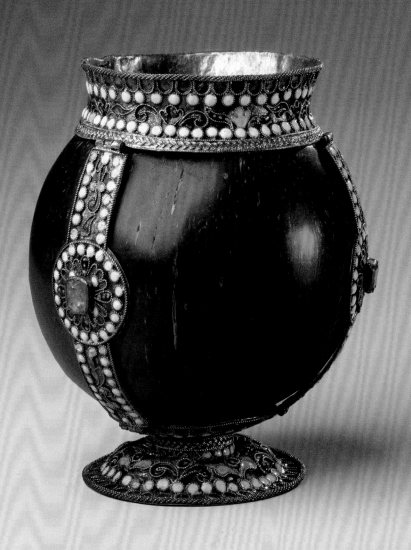

10 Drinking cup (*bratina*)

Moscow, 1660–90
Silver gilt, filigree enamel, coconut, colored stones
4⅝ × 3⅞ in. (11.8 × 10 cm)

Provenance: Count Alexander Alexeevich Musin-Pushkin, St. Petersburg, before 1904;
Alexandre Polovtsoff; Henry Walters; The Walters Art Museum, 1931, by bequest, 44.194

A *bratina* is a drinking cup, passed around and shared at feasts. This early cup is fashioned from a coconut, then a prized exotic fruit. It is embellished with silver-gilt filigree enamel strapwork, known as scan enamel, inspired by a Byzantine enamel technique seen on chalices. The bright blue and green enamels play against the colored stones in the center medallions. Tiny beads of white enamel, made to suggest pearls, outline the strapwork. The cup was a rare collector's item and a window onto a world beyond Russia.

This *bratina* once belonged to Count Alexander Alexeevich Musin-Pushkin, who had a collector's cabinet of antique Russian silver. It was showcased at the 1904 Russian decorative arts exhibition at the Stieglitz Museum in St. Petersburg, and a photograph of it was included in the commemorative catalogue, published in 1907 (fig. 10.1). The goal of this show was twofold: to raise funds to benefit soldiers who fought in the Russo-Japanese War (1904–5) and to provide a survey of Russian decorative arts to a wide audience, including the students at the Stieglitz Institute.

Early twentieth-century artisans looked to these antique prototypes and to the 1904 groundbreaking exhibition to create a similar cup (see p. 17, fig. 10). In this later version, richly grained and highly polished wood simulates a coconut. The strapwork is almost identical to the seventeenth-century example, and the filigree enamel copies the blue and green colors of the earlier version. The cup is in the Russian Revival style, which looked to the past for inspiration.

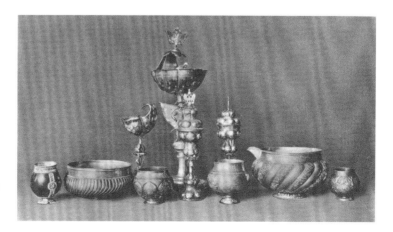

Fig. 10.1. *Bratina* (far left), as shown at the 1904 St. Petersburg exhibition. Reproduced from Adrian Prakhov, *Album de l'exposition rétrospective d'objets d'art de 1904 à St.-Pétersbourg, ...* (St. Petersburg, 1907), 141, fig. 54.

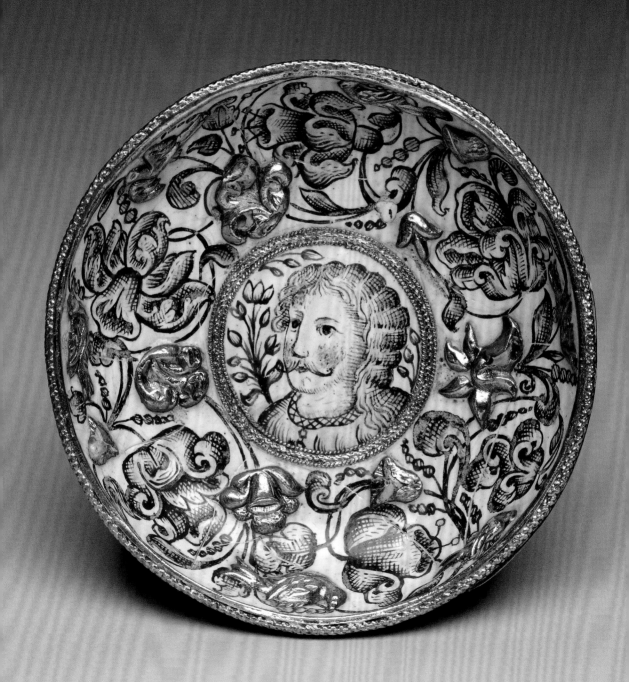

11 Bowl with portrait of a man

Usolsk (present-day Solvychegodsk, Russia), late 17th century
Silver gilt, painted enamel
1⅛ × 3⅜ in. (2.8 × 8.5 cm)

Provenance: Henry Walters, 1930; The Walters Art Museum, 1931, by bequest, 44.417

This bowl combines the skill of the miniature painter with that of the enamelist and silversmith. The form imitates Italian maiolica ceramic ware, with its center roundel featuring an enamel-painted portrait of a man encircled by a border of lilies and tulips, flowers that were first grown in the Ottoman Empire.[1]

This is an early example of filigree enamel, in which fine silver-gilt wires form flowers into which enamel is poured and then shaded. The cross-hatching gives depth and dimension to the blossoms and is a clear indication that fine prints, books, and engravings from Europe were available and being studied by the enamelist.[2] The border of flowers is enriched by the overlay of small silver-gilt flowers and the charming conceit of the gilded birds flying among them around the rim of the bowl.

The beardless man indicates that the piece dates to the reign of Tsar Peter the Great (r. 1682–1725) or later. Peter had banned the wearing of beards to effect the Westernization of his subjects. The man depicted may have been a royal personage or a victor in battle; bay laurel leaves, a symbol of kingship and victory, surround him.

The reverse (fig. 11.1) features a *kokoshnik*-shaped window set against a stone facade reminiscent of the Palace of Facets in the Moscow Kremlin. The window encloses the Cyrillic initials "LFM." It is an early example of personalizing an object, not dissimilar to the custom of inscribing the *kovshi*, *bratina*, and *endova* of the period.

This bowl is a precursor of late nine-teenth-century Russian Revival-style enamels, which often incorporated seventeenth-century devices such as filigree, painted enamel, and Ottoman-style flowers.

NOTES
1 Tamara Talbot Rice, *A Concise History of Russian Art* (New York, 1963), 157.
2 Ibid., 224. Peter the Great made printed books widely available.

Fig. 11.1. Cat. no. 11, reverse.

12 Drinking bowl (*kovsh*)

Moscow, 1710
Silver, parcel gilt
4¼ × 10⅞ in. (10.9 × 27.1 cm)

Provenance: Alexandre Polovtsoff; Henry Walters, 1930; The Walters Art Museum, 1931, by bequest, 57.797

The *kovsh* is a cherished Russian form, shaped like a swimming bird or a Viking ship.[1] In medieval times, it was carved out of wood and used by peasants for drinking or for serving food. By the early eighteenth century, *kovshi* were fashioned in precious materials such as silver and silver gilt, and presented as awards on behalf of the tsar to people who had rendered extraordinary service to the nation.[2] By the nineteenth century, the House of Fabergé and other makers made *kovshi* in precious hardstones, enamel, and silver with jeweled accents as bibelots for the home.

This *kovsh* is decorated with three Romanov ciphers of the double-headed eagle: one engraved in the center of the bowl, another flying at the prow, and a third applied to the handle in relief. This symbol of the Romanov dynasty, which looks both East and West, originated in Byzantium. Tsar Ivan III (r. 1462–1505) married a Byzantine princess in the fifteenth century and appropriated the double-headed eagle for the Russian Empire.

An elaborate inscription surrounds the bowl and continues in the cartouches, forming a strong decorative element. It reads:

> *Peter Alekseevich, by the grace of God great sovereign tsar and grand prince of all Great Little and White Russia, awarded with this kovsh Thedore Krukov's son Garaem, bailiff for the customs and tavern duties in the town of Orel, for having collected during the present year 1710 in partnership with the bailiff Ivan Oshchepkov 400 [?] rubles.*

Tax collectors played a critical role in keeping the government solvent, and with the gift of this gilded silver *kovsh* Peter the Great acknowledged Garaem Krukov's tenacity.

NOTES

1 Anne Odom, *Russian Silver in America: Surviving the Melting Pot* (Washington, D.C. and London, 2011), 222.

2 For more on *kovshi*, see Alexander von Solodkoff, *Russian Gold and Silverwork, 17th–19th Century* (New York, 1981), 84–87.

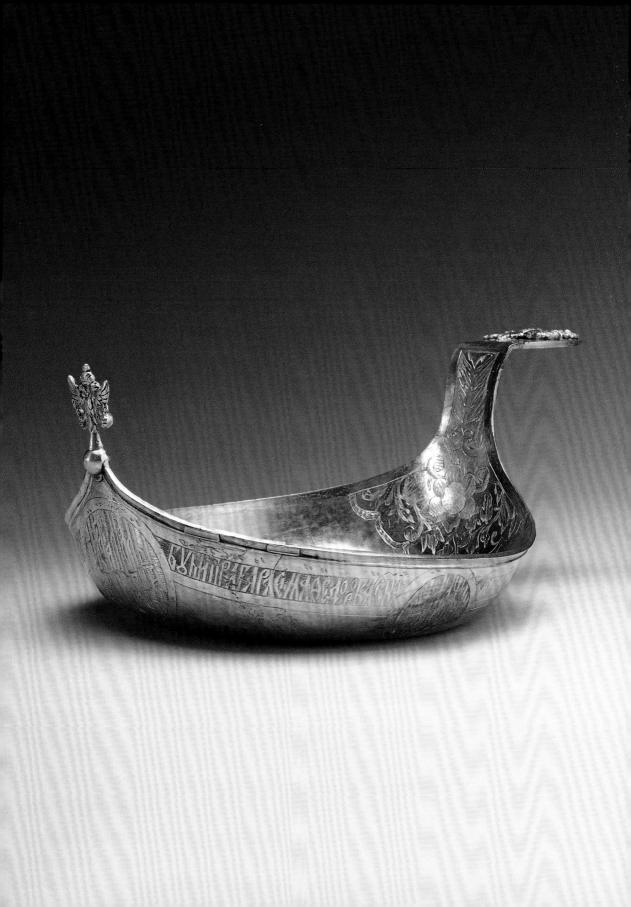

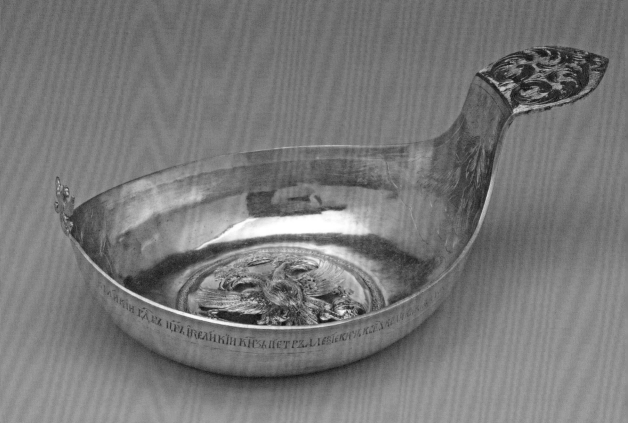

13 Drinking bowl (*kovsh*)

Moscow, 1712
Silver, parcel gilt
4½ × 10⅞ in. (10.9 × 27.1 cm)

Provenance: Alexandre Polovtsoff; Henry Walters, 1929; The Walters Art Museum, 1931, by bequest, 57.796

On his diplomatic tour or Grand Embassy of Europe in 1697–98, Tsar Peter the Great had his portrait painted in London by Sir Godfrey Kneller (1646–1723). In the painting, Peter cuts an elegant figure in a suit of armor with an ermine-lined cloak. The silversmith engraved the bust of this portrait on this presentation *kovsh*, faithfully rendering the subject. The presentation of Peter as a military figure was fitting: this *kovsh* had been presented to a commander of a Cossack troop. It is dated and inscribed as follows:

> *The great lord Tsar and Grand Prince Peter Alekseevich, sovereign of all Great, Little, and White Russia, presented with this "kovsh" the Cossack winter camp commander Axen Voloshenin for his many services.* AD 1712, *January 30.*

A bouquet of realistically engraved flowers, including the exotic tulip, is suspended from the handle. Peter may have encountered this flower, introduced into sixteenth-century Europe by Ottoman merchants, when he was in Holland surveying the shipbuilding trade. The skilled engraver had undoubtedly seen prints of both the Kneller portrait and the tulips, which also found their way onto late seventeenth-century enamel work (cat. no. 11). In the bottom of the bowl is a gilded repoussé double-headed eagle, symbol of the Russian Empire.

Fig. 13.1. Engraved portrait of Peter the Great on the *kovsh*'s prow.

14 Portrait medallion of Peter the Great and family

Grigori Semenovich Musikiiskii (Russian, 1670/71–1737)
Painted enamel on copper
3⅛ × 4⅛ in. (8.1 × 10.7 cm)
Inscribed: "Saint Petersburg 1720/Painted by G. Musikiiskii"

Provenance: Alexandre Polovtsoff; Henry Walters, 1930; The Walters Art Museum, 1931,
by bequest, 44.326

The composition of this enamel-painted medallion is based on the portrait con-
ventions of eighteenth-century Europe: Peter the Great and his wife, Catherine
(later Empress Catherine I), are seated against a swagged drape, with their daugh-
ters Anna, Elizabeth (the future empress), and Natalia, and young grandson,
the future Peter II, arrayed to their left. Following Western fashion, the tsar had
banned beards in 1698. Peter wears a European-inspired uniform that includes
a tricorne beaver hat of the Preobrazhensky Regiment, founded by him and
named for his childhood village.

Peter would have seen many court portraits and familiarized himself with
the art of miniature painting on his diplomatic tour ("Grand Embassy") through
Europe in 1697–98. The miniaturist, Grigori Semenovich Musikiiskii, trained in
the Moscow Kremlin Armory, before he was ordered to St. Petersburg in 1711 to
become court miniaturist. He captured a realistic likeness of Peter in the year
before he proclaimed Russia an empire.

The medallion is painted with exceptional details such as the ermine and lace
accents on the clothing, the women's jewelry, the delicate fans, and the marble
floor. Young Peter stands out in his emerald green European-style finery, and
holds a drawing and calipers.

Musikiiskii signed and dated the medallion, long separated from its original
mount, on the edge of the curtain and beneath Peter's seat.

Two other similar miniatures of Peter the Great's family exist in the artist's
hand, both of which are in the State Hermitage Museum.[1] These miniatures may
have been circulated as proclamations of dynastic succession.

NOTE
1 Philippe Verdier, *Russian Art:
Icons and Decorative Arts*
(Baltimore, 1959), no. 26.

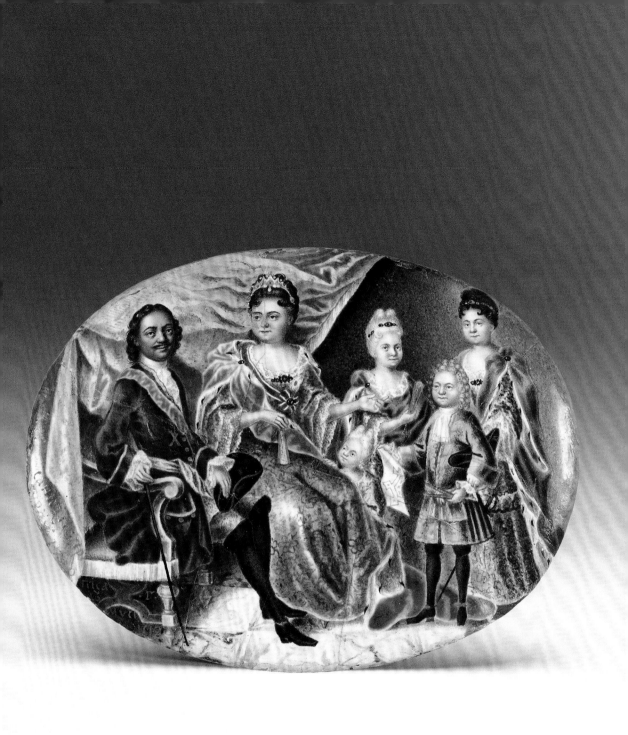

15 *Bokal* with royal portraits

Master A. D.
Russia, 2nd half of the 18th century
Mammoth ivory
12⅛ × 4⅛ in. (30.8 × 10.5 cm)

Provenance: Mouravieff-Apostol Collection; Alexandre Polovtsoff; Henry Walters, 1930;
The Walters Art Museum, 1931, by bequest, 71.477

This cup is divided vertically into thirds with finely detailed, three-quarter-length portraits of Empress Elizabeth; Peter III, whose reign was a short six months in 1762 before he was murdered and supplanted by his wife, later Catherine the Great, also pictured. Their likenesses were copied from sanctioned court portraits, disseminated through engravings. All three are set against a draped and tasseled background. The carver's practiced hand is evident in details such as the empresses' gowns, orders, and jewelry, and in Peter III's sword and his caliper propped on a Baroque side table.

The bottom border of the cup is festooned with trophies of flags, drums, and cannons, a reference to the importance of the military in sustaining the Romanov dynasty. A Renaissance-inspired soldier, dressed in armor, serves as the stem.

The cover is a conceit of a brick floor, divided into thirds, and carved with allegorical love themes, one of which is Apollo in pursuit of Daphne; another shows Cupid holding a bow and a plaque with three hearts. The theme of royalty is carried through in the finial, shaped like a crown. The base of the cup is carved with the Romanov crest.

Carvings such as this were generally no more than 1 foot (30.5 cm) tall, reflecting the size of the original tusk. These cups were regularly shipped down to St. Petersburg from Archangel'sk to be used as diplomatic gifts, and had the dual purpose of showcasing and promoting Russian decorative arts.[1] This *bokal* may have been intended for someone's beloved, whose portrait is in the locket on the cover.

NOTE
1 Philippe Verdier, *Russian Art: Icons and Decorative Arts* (Baltimore, 1959), no. 42.

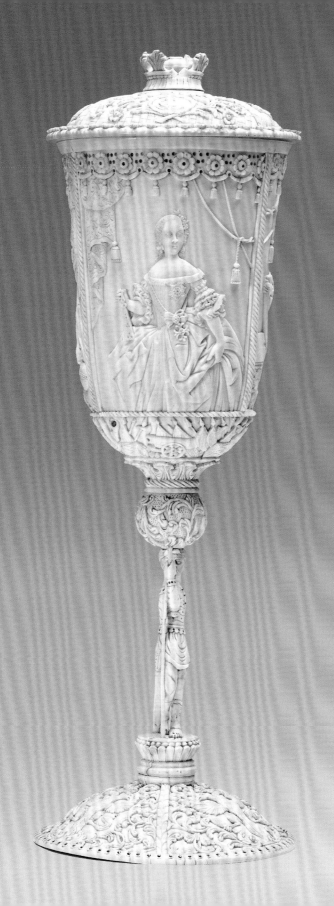

16 Covered cup

V. D., silversmith (Russian, active 1741–1753); Egor Ivanov, assay master
(Russian, active 1752–1758)
Moscow, 1753
Silver, parcel gilt
6¾ × 3⅛ in. (15.6 × 7.9 cm)

Provenance: A La Vieille Russie, Paris; Alexandre Polovtsoff; Henry Walters, 1929;
The Walters Art Museum, 1931, by bequest, 57.815

This covered cup is in the rococo taste, heavily patterned with flowers, leaves, and star-shaped motifs that suggest the heavenly firmament or Imperial Orders, bestowed on worthy recipients by the monarch. Cartouches decorate the center, one of which features Empress Elizabeth, shown in profile. The image was copied from a coin or medallion struck for her coronation in 1742.[1] Other roundels hold her crowned monogram "EP" (Elizabeth Petrovna), surrounded by a wreath of laurel leaves symbolic of royalty (fig. 16.1), and the Romanov double-headed eagle, symbol of the state. Elizabeth presented these covered cups to her guard corps, whose loyalty she enjoyed and who had helped engineer a coup d'état that put her on the throne.

Moscow was the center of silver production up until the revolution, and the silversmiths' guild was founded there in 1722. The silversmith of this piece, known only through his initials, V. D., hammered, embossed, and incised the silver and then gilded it in parts, giving the cup texture and richness. The assay master, Egor Ivanov, would have verified the quantity of pure silver used. This figure would have been used to levy a tax. Often, these silver pieces were a person's most valued possession, and they could be melted down in times of need and exchanged for cash.[2]

In 1935, Alexandre Polovtsoff devoted a chapter to Elizabeth in his book *Russian Exhibition Gossip*. He wrote, "EI was her monogram. She had it carved on her palaces, chiseled on her snuff-boxes, stamped on her bookbindings, gilt as centerpieces on her wrought-iron balcony gratings."[3]

NOTES
1 Anne Odom, *Russian Silver in America: Surviving the Melting Pot* (Washington, D.C., and London, 2011), 75.
2 Ibid., 12.
3 A. Polovtsoff, *Russian Exhibition Gossip* (London, 1935), 20.

Fig. 16.1. Cat. no. 16, detail of roundel with crowned monogram of Empress Elizabeth.

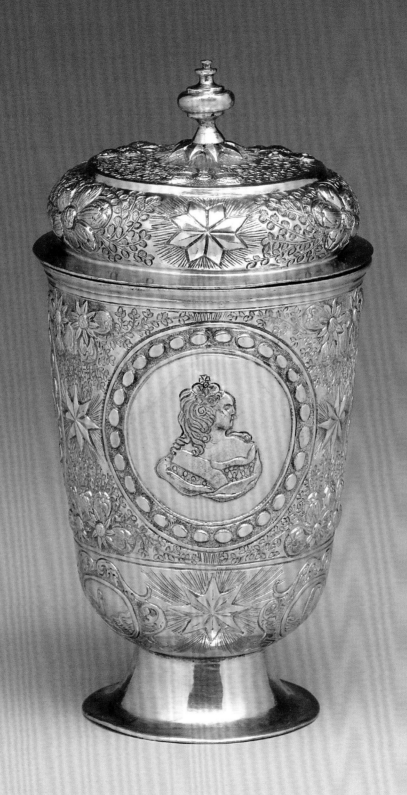

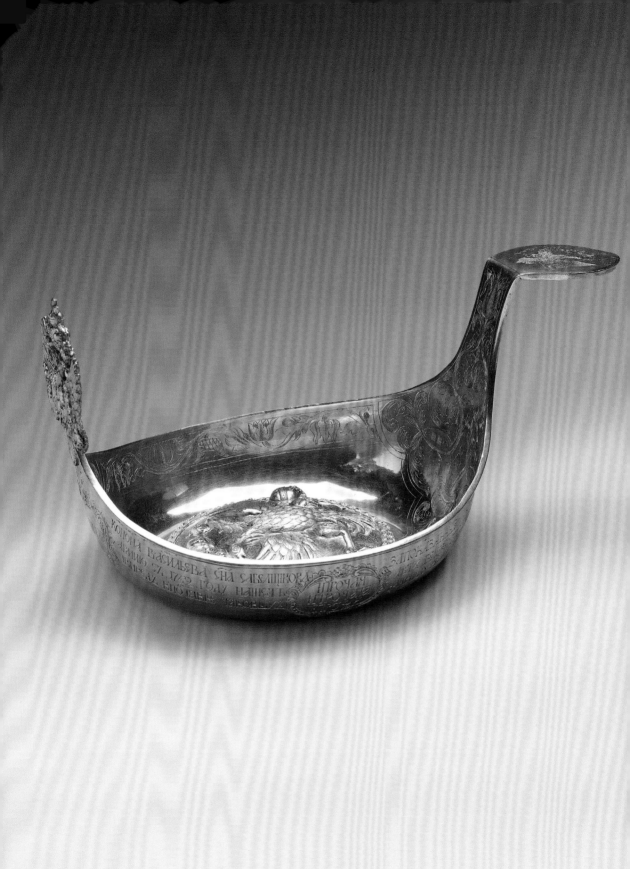

17 Drinking bowl (*kovsh*)

Vasili Matveev Kunkin (Russian, 1726–1762)
Moscow, 1758
Silver, parcel gilt
6½ × 13 in. (16.3 × 33.1 cm)

Provenance: Alexandre Polovtsoff; Henry Walters, 1928; The Walters Art Museum, 1931, by bequest, 57.799

By the mid-eighteenth century, a vocabulary had been established for presentation *kovshi* that included inscriptions, flowers, and the Romanov crest. Here, these devices are rendered in an ornamental style and reflect Elizabeth's penchant for opulence. An elaborately cast coat of arms of the city of Moscow featuring St. George slaying the dragon decorates the prow. The Romanov crest is embossed in the center of the bowl and engraved on the handle.

The inscription runs around the rim and continues in engraved cartouches surmounted with shell shapes. The inside rim has an exquisite running border of tulips that terminates in strapwork at the handle. The *kovsh* is richly gilded, with the exception of the base. The inscription reads:

We, Elizabeth the First by the grace of God empress and sovereign of all Russia … awarded with this "kovsh" the Moscow merchant of the first guild Konon, son of Basil Sabelshchikov, for the discounts he has been making for six years since 1752 to the advantage of our most high interest at the Main commissariat auctions for supplying our army, and so that he may in the future show zeal in providing such supplies for the army to the advantage of our interest.

During the Seven Years' War (1756–63), the Sabelshchikov family supplied the army and aided the war effort. This presentation *kovsh* literally expresses the hope that the family continue to discount their goods and services, and the gift may have been an inducement to do so.

Vasili Matveev Kunkin was one of the first masters in Moscow to set up a factory devoted solely to silversmithing. By 1752, seventy artisans worked there, specializing in church silver.[1]

These drinking bowls represented Imperial Russian heritage and would have been the type of pieces featured in the 1904 exhibition at the Stieglitz Museum and later sold through Antikvariat in the 1920s.[2] Alexandre Polovtsoff acted as agent for Léon Grinberg and Jacques Zolotnitsky of A La Vieille Russie in this and other sales to Henry Walters. Grinberg, Zolotnitsky, and Polovtsoff were all on the organizing committee for the exhibition *Art Russe* held in Brussels in 1928, the year this drinking bowl was purchased by Walters. Coincidentally, sales of Russian treasures orchestrated by the Bolsheviks peaked between 1928 and 1933. By 1938, the Russian government banned sales of Russian national treasures.[3]

NOTES
1 Alexander von Solodkoff, *Russian Gold and Silverwork, 17th–19th Century* (New York, 1981), 33, 214.
2 Anne Odom and Wendy R. Salmond, eds., *Treasures into Tractors: The Selling of Russia's Cultural Heritage, 1918–1938* (Washington, D.C., and Seattle, 2009), 11.
3 Robert C. Williams, *Russian Art and American Money, 1900–1940* (Cambridge, Mass., 1980), 266.

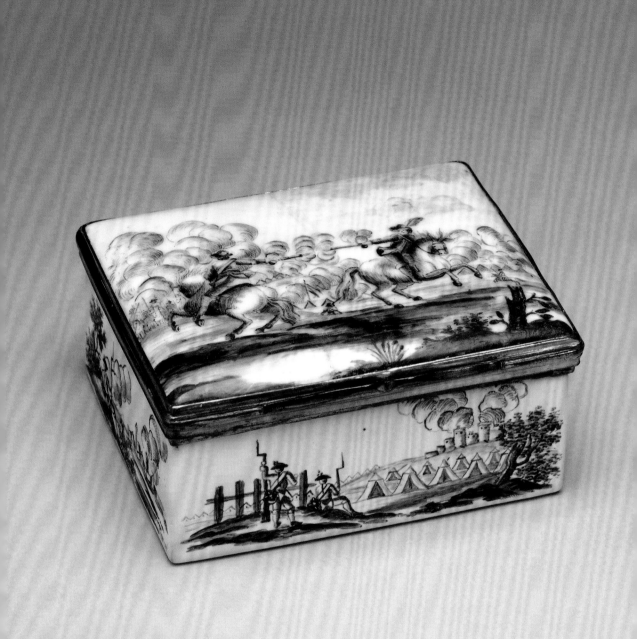

18 Snuffbox with portrait of Empress Elizabeth

St. Petersburg, late 1750s
Painted enamel, silver gilt
1½ × 3¼ × 2⅝ in. (4 × 8.1 × 6.5 cm)

Provenance: Sale, Sotheby's, New York, December 8, 1993, lot 631; Jean M. Riddell, 1993
(through Leo Kaplan as agent); The Walters Art Museum, 2010, gift in memory of Jean M. Riddell, 44.718

From the outside, this enamel snuffbox appears quite modest. The cover and sides are painted *en grisaille*. On the lid, armed combatants skirmish on horseback; the tree at lower right has been cut down, symbolic of human loss in war. The front panel depicts soldiers guarding an encampment.

When the box is opened, a copy of a formal court portrait of Empress Elizabeth is revealed (fig. 18.1), and the recipient would have been duly enchanted and honored. The idea of painting not only the exterior of a box but also the interior originated with porcelain factories such as Sèvres and Meissen. At first glance, the viewer might mistakenly assume that this enamel and silver-gilt snuffbox was made of porcelain.

Known for her extravagance and vanity, Empress Elizabeth is shown in full Imperial regalia with her crown and orb, a jeweled aigrette in her hair, a fashionable off-the-shoulder white silk dress with lace sleeves, and an ermine-lined cloak, draped with the Order of St. Andrew, the patron saint of Russia.[1]

Meant to imitate miniature painting, the unforgiving technique of enamel painting called for powdered enamels to be applied in layers to a silver ground and fired after each layer. Although somewhat naive, the portrait captures the likeness of the empress.

Elizabeth led Russia into two major European conflicts: the War of the Austrian Succession (1740–48) and the Seven Years' War (1756–63). This box may have commemorated one of these conflicts. Snuffboxes were typical gifts to retainers and diplomats. This example is particularly special because it bears the empress's likeness.

NOTE

1 Anne Odom, *Russian Enamels: Kievan Rus to Fabergé* (Baltimore, Washington, D.C., and London, 1996), 88.

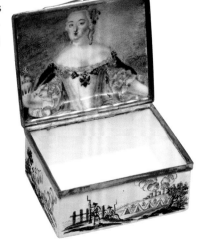

Fig. 18.1. Cat. no. 18, interior.

19 Standing cup with cover

Moscow, 1760
Silver, parcel gilt
15⅞ × 3⅞ in. (40.5 × 9.7 cm)

Provenance: Alexandre Polovtsoff; Henry Walters, 1930; The Walters Art Museum, 1931,
by bequest, 57.809

The cup is a marriage of a German Renaissance form with French rococo design.[1] German silversmiths came to work at the court of Peter the Great (r. 1696–1725) and his successors. The rococo style, with its naturalistic and supple curves, prevailed in France for most of the eighteenth century and quickly spread eastward as far as Russia through books, engravings, and artisans, who emigrated there.

The covered cup is related to the chalice in the way the cup blossoms from a long stem, anchored by a stable foot. Unlike a chalice, created for religious rituals, this example was made as a welcoming cup. The silver-gilt Romanov eagle finial may indicate it was a presentation gift given by the tsar to an unknown worthy recipient.

Six interlocked teardrop lobes worked in repoussé give this cup its voluptuous shape. The high relief of the teardrops is embellished with rococo scrollwork in low relief. Ribbons of silver curlicues sprout from the top, middle, and bottom of the cup.

The mythic figure of Atlas, standing on an earthly globe and holding up the vault of heaven, forms the stem. Atlas is commonly associated with single-handedly supporting a staggering weight, which here may be an allusion to the monarch's weighty burden of state.

Covered cups similar to this one are known to have been sold in the 1920s through the Antikvariat, the agency set up to sell art in exchange for foreign currency to be put toward the industrialization of Soviet Russia.[2]

Accession records indicate that Léon Grinberg of A La Vieille Russie may have had a hand in the sale of the cup to Henry Walters. Grinberg noted in his diary that: "He [Walters] came every year to Europe and spent millions of dollars on purchases. Five or six years in a row also we, through A. A. Polovtsoff, sold him first-class Russian items—silver, snuffboxes, icons, crosses, miniatures, etc.—each time for 100 to 300 thousand francs."[3]

NOTES

1 Philippe Verdier, *Russian Art: Icons and Decorative Arts* (Baltimore, 1959), no. 38.

2 Anne Odom and Wendy R. Salmond, *Treasures into Tractors: The Selling of Russia's Cultural Heritage, 1918–1938* (Washington, D.C., and Seattle, 2009).

3 Léon Grinberg, diary (unpublished), 1932, entry 33, courtesy of Alexander von Solodkoff to author, October 23, 2016.

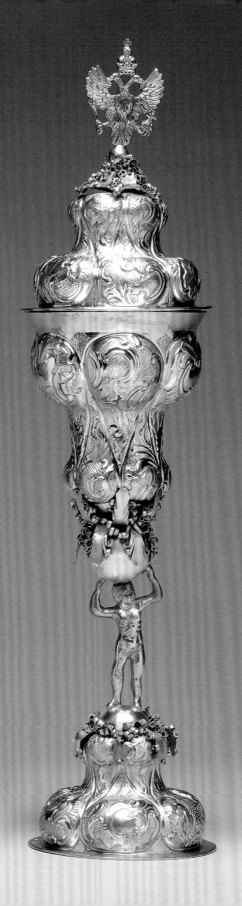

20 Snuffbox in the form of an envelope

Russia, 1765–85
Porcelain, gold
1⅜ × 3⅜ × 2½ in. (3.5 × 8.5 × 6.5 cm)

Provenance: Alexandre Polovtsoff; Henry Walters; The Walters Art Museum, 1931, by bequest, 48.769

This imaginative porcelain "envelope" is addressed: "To her Excellency my lady Praskovia Grigor'evna Butakova, lady-in waiting at the court of Her Imperial Majesty in St. Petersburg." As was the custom with correspondence, it is "secured" on the reverse with a heraldic trompe l'oeil red wax seal of a member of the powerful and wealthy Stroganov family (fig. 20.1). Lady Butakova was purported to be an illegitimate daughter of Empress Elizabeth, and she made a favorable marriage with Baron Sergei Nikolaevich Stroganov (1738–1777) in 1761.[1]

At court, these "packet" snuffboxes were intended as flirtatious mementoes, and the inscriptions often replicated the handwriting of the gift giver, lending the box a personal and meaningful touch.[2] This inscription is in Cyrillic, although other examples carry inscriptions in French, the language of the court.

Snuffboxes were a fashionable accessory throughout the eighteenth century. They became a necessity from the early 1700s onward, when it became acceptable for aristocratic men and women alike to take snuff in public. This clever porcelain example was undoubtedly made at the Imperial Porcelain Factory, founded in St. Petersburg in 1744. Early production pieces were small because porcelain making was still being refined.[3]

These boxes were made not only for snuff, but also to hold jewelry and small personal items.

NOTES
1 Karen L. Kettering, email to the author, October 21, 2015.
2 Tamara Vasil'evna Kudriavtseva, *Russian Imperial Porcelain* (St. Petersburg, 2003), 20.
3 Ibid., 9.

Fig. 20.1. Envelope from a group of autograph letters of Catherine II acquired in 1930 by Henry Walters from Alexandre Polovtsoff. The Walters Art Museum, 15.35.8.

Fig. 20.2. Cat. no. 20, reverse.

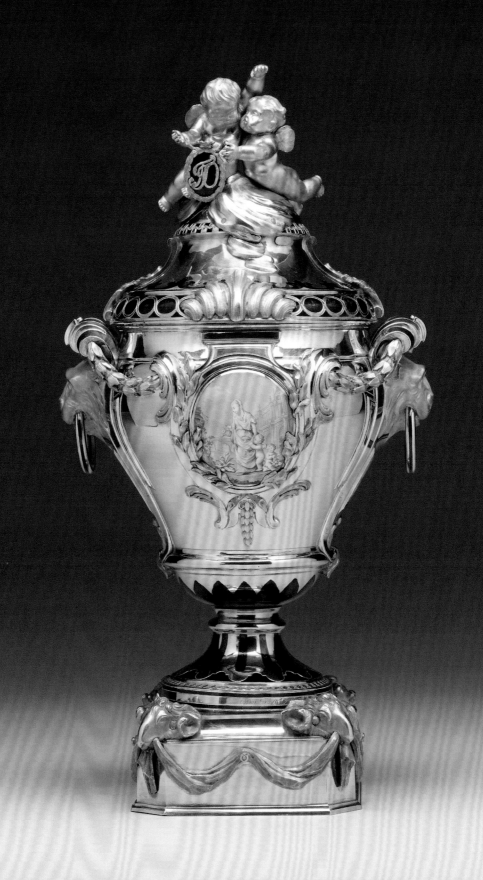

21 Potpourri vase with classical figures

Jean-Pierre Ador (Swiss, 1724–1784)
1768
Multicolored gold, *en plein* and *basse-taille* enamel
10⅞ × 5⅞ × 4⅝ in. (27.8 × 14.9 × 11.7 cm)

Provenance: Catherine the Great, St. Petersburg, 1768, by commission; Grigori Grigorevich Orlov, St. Petersburg, by gift; Orlov-Davidoff Collection; Henry Walters; The Walters Art Museum, 1931, by bequest, 57.864

In the eighteenth century, potpourri in specially made vases filled the air in aristocratic homes with scent created from a mixture of dried petals and spices that wafted through a pierced, fitted lid. Catherine the Great commissioned this gold potpourri vase as a gift for her lover, Count Grigori Orlov (1734–1783). An avid Francophile who invited the philosophers Voltaire (1694–1778) and Denis Diderot (1713–1784) to her court, the empress followed French taste in fashion and decor. This tulip-shape vase imitates Sèvres porcelain examples, which were popular in the French court of Louis XV (r. 1715–74).[1]

Plaques in *en camaïeu* enamel, imitating the look of a cameo, are set into elaborate four-color gold cartouches on the body of the vase. The rococo decorative scheme depicts Catherine the Great on one side as the goddess Flora, personifying youth and the joys of life, and on the other side as Ceres (fig. 21.1), emblematic of prosperity and abundance. In small plaques beneath the handles, as a subtle reminder of his rank, Count Orlov is represented as Hercules and Milon of Croton performing heroic deeds. In reality, his heroic deed was to secure the throne for Catherine the Great with the help of his brothers. Catherine, who was a student of ancient history and an enthusiastic collector of cameos, would have appreciated these symbolic elements.[2]

NOTES
1 Philippe Verdier, *Russian Art: Icons and Decorative Arts* (Baltimore, 1959), no. 43.
2 Ross, "A Golden Vase by I. Ador," *Gazette des Beaux-Arts* (November 1942), 122–24.

The cupids crowning the potpourri are a reference to the empress and Orlov. Only the deep blue enamel shield, with Count Orlov's gold cipher worked in Cyrillic letters, keeps the cupids from fully embracing. Gold swirls symbolic of clouds of scent rise from the pierced openings.[3]

Like so many artisans of the period, the Swiss-born goldsmith Jean-Pierre Ador was attracted to the court of Catherine the Great because of the opportunities it afforded him to give full expression to his artistic ideas. The use of four-color gold, burnished and matte, chased and chiseled, coupled with the *en camaïeu* enamel plaques and the regal lapis-color enamel accents, makes this the most luxurious of potpourri. It is dated the same year, 1768, that work was begun on Count Orlov's Marble Palace in St. Petersburg.

For three months in 1904, this golden potpourri was on loan from the Orlov-Davidoff collection to the decorative arts exhibition at the Stieglitz Museum in St. Petersburg. All of St. Petersburg society must have seen this exhibition, including Alexandre Polovtsoff's family, who also participated with loans of ancient sculpture, paintings, and antique lace.[4] It reverberated artistically, leading to the formation of the Russian Society for Decorative Arts, further inspired the four-color gold and *en camaïeu* enamel work of the House of Fabergé, and remained in the memory of Alexandre Polovtsoff, who placed this masterpiece in the collection of Henry Walters.

Polovtsoff was a great admirer of Catherine the Great from an early age. In his unpublished memoirs, he recounts spending a summer in the town of Tsarkoye Selo, where he explored the park and "absorbed the aesthetic principles of Catherine the Great, who had created and decorated it." He further wrote: "At that time aesthetics became the principal interest in my life."[5] The empress was the subject of his lecture at the May–June 1928 *Art Russe* exposition at Brussels' Palais des Beaux Arts.[6] He devoted a chapter to her in his *Russian Exhibition Gossip* (1935) and wrote an engaging book titled *The Favourites of Catherine the Great,* published in both French (1939) and English (1940). One of the last items that Polovtsoff sold to Walters during his last trip to Paris in July 1930 was a group of the empress's autographed letters.[7]

3 Asen Kirin, *Exuberance of Meaning: The Art Patronage of Catherine the Great* (Athens, Ga., 2013), 62.

4 Adrian Viktorovich Prakhov, *Album de l'exposition rétrospective d'objets d'art, de 1904, à St. Pétersbourg* (St. Petersburg, 1907), xxix. The potpourri was pictured on p. 215.

5 Alexandre Polovtsoff, "Memoirs," December 1934 (unpublished), trans. Olga Savin, 7. Sincere thanks to Anne Benson for arranging for the translation and for her research on Alexandre Polovtsoff.

6 *Art Russe: Ancien et Moderne,* exh. cat. (Brussels: Palais des Beaux-Arts de Bruxelles, May–June 1928). Broadside attached to catalogue listing lectures.

7 William R. Johnston, *William and Henry Walters: The Reticent Collectors* (Baltimore, 1999), 218.

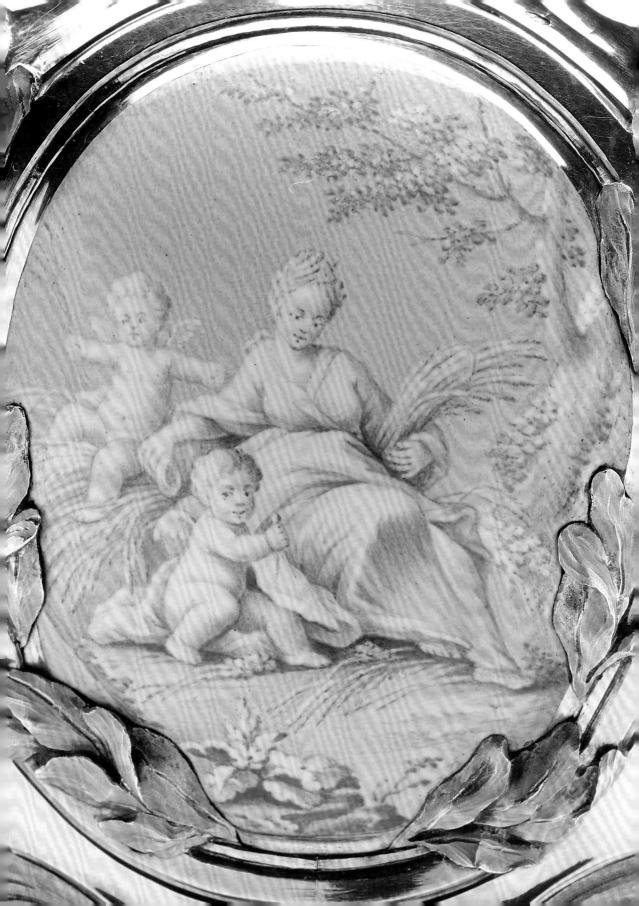

22 Cameo portrait of Catherine the Great

St. Petersburg, ca. 1780–90
Koshkul'dinskaia jasper, diamonds, gold
Cameo with mount: 1½ × 1⅛ in. (3.8 × 2.9 cm)
Visible cameo: 1¹⁄₁₆ × ¹³⁄₁₆ in. (2.7 × 2.1 cm)

On loan from a private collection

"Cameo fever" swept the Russian Empire during the reign of Catherine the Great, and the empress was not immune. She wrote to Friedrich Melchior (Baron von Grimm) that the Imperial collection was "made up of stones alone the number of which probably exceeds 4,000 not counting the pastes … God knows how much pleasure there is in touching all this every day; they contain an endless source of all kinds of knowledge."[1]

Passionate about cameos, Catherine was the subject of numerous examples herself. In this piece, copied from an officially sanctioned court portrait, she is seen in profile. The skilled anonymous carver suggested a light in her eye and roses on her cheeks, and even carved a realistic double chin. Her crown, the pearls entwined in her coiffed hair, and the collar of her ermine mantle point to her regal status.

This cameo, with an old mine-cut diamond surround, is carved from Koshkuldinsk jasper, an agate-jasper composed of three layers of green, black, and cherry-red banded stone, named after the small town of Koshkuld.[2] In 1779, Alexander Lanskoi, a favorite of Catherine's, urged the empress to use native stone from the Urals and Siberia in the fabrication of new gems. "A special decree was issued to search for sources of many-layered stones—during Catherine's lifetime this led to the appearance of the Yekaterinburg and Kolyvan Lapidary (or Grinding Works) 'for cameo arts.'"[3]

Throughout her lifetime, the empress actively encouraged the cameo arts, instructing the court engraver to teach her artistically gifted daughter-in-law, Maria Feodorovna. Maria carved not only Catherine, but also her husband, Paul I, with their sons (compare with cat. no. 23).[4]

This cameo may have been mounted on a snuffbox for the empress herself or on a presentation box to be gifted to a member of her court.[5] In a contemporary account of court life, J. Georgi records that Catherine had set up a "diamond room … from which the Sovereign chose whatever she wished to present as gifts."[6]

NOTES
1 Yulia Kagan and Oleg Neverov, "An Imperial Affair," in *Treasures of Catherine the Great* (New York: 2000–01), 98.
2 Karen L. Kettering, email to the author, April 14, 2015.
3 Kagan and Neverov, "An Imperial Affair," 98.
4 Tamara Rappe, "Catherine the Great and European Decorative Art," in *Catherine the Great: An Enlightened Empress* (Edinburgh, 2012), 125.
5 Ibid., 131. David Rudolph created a box made of Russian hardstones surmounted by a cut cameo of Catherine the Great with a chased gold laurel leaf surround. The box is thought to have been owned by her. It is in the State Hermitage Museum.
6 J. Georgi, *Description of Imperial St. Petersburg—the Capital of the Russian Empire* (St. Petersburg, 1794), I, 77, quoted in Rappe, "Catherine the Great and European Decorative Art," 130.

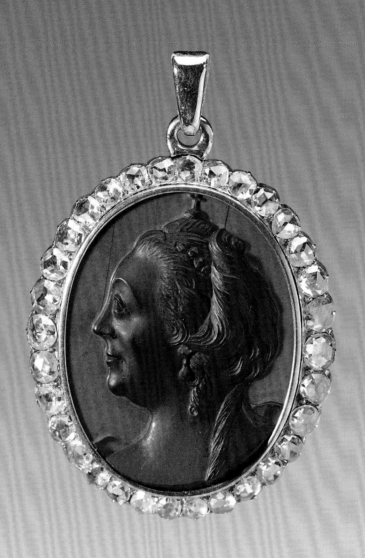

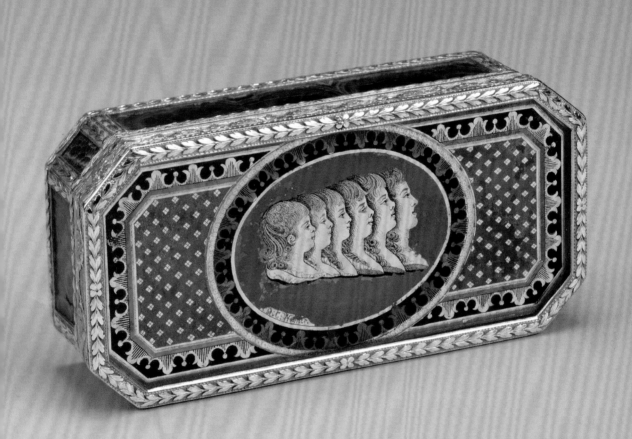

23 Box with profile images of six children of Tsar Paul I

Ditmar Kahrs (Norwegian, active ca. 1795)
St. Petersburg, ca. 1795
Gold, malachite, *verre églomisé*
1 × 3⅞ × 1⅞ in. (2.6 × 9.9 × 4.7 cm)

Provenance: Alexandre Polovtsoff; Henry Walters, 1929; The Walters Art Museum, 1931, by bequest, 57.45

Fig. 23.1. James Walker (English, 1748–ca. 1808), after a drawing by Maria Feodorovna. *Grand Dukes and Duchesses Alexander, Constantine, Elena, Maria, and Catherine*, 1790. Engraving, 7¾ × 6¼ in. (19.7 × 16.0 cm). The Walters Art Museum, 1976, gift of Marvin C. Ross, 93.65.

NOTES

1 Tamara Vasil'evna Kudriavtseva, *Russian Imperial Porcelain* (St. Petersburg, 2003), 58.
2 Anthony Cross, ed., *Engraved in the Memory: James Walker, Engraver to the Empress Catherine the Great, and his Russian Anecdotes* (Oxford and Providence, R.I., 1993), 41. In D. A. Rovinsky's 1889 inventory, the engraving is listed as: 1790 (ROV I/sap).
3 Antoine Chenevière. *Russian Furniture: The Golden Age 1780–1840* (New York, 1988), 97.

The six elder of the ten children of Maria Feodorovna and Tsar Paul I (r. 1796–1801) are pictured in profile on this snuffbox: Grand Dukes Alexander (later Alexander I) and Constantine, and Grand Duchesses Alexandra, Elena, Maria, and Catherine. Silhouetting, a representation showing shape and outline only, was popular in France from around 1750 to 1850. This new art form swept the courts of Europe. Catherine the Great was an enthusiast and ordered silhouettes of herself and her family.[1] Her daughter-in-law, Maria Feodorovna, must have been enchanted by this quick method of portraiture, which in its aesthetic suited the neoclassical taste. The portraits on this box are based on Maria Feodorovna's own miniature of her children from 1790 (fig. 23.1), which she presented to her husband.

The court engraver, the Englishman James Walker (1748–1808), rendered Maria Feodorovna's miniature in aquatint.[2] In turn, J. C. Wegner transferred the engraved image onto the box in a technique called *verre églomisé*, or reverse-painted glass. The portraits were engraved using an agate pencil, and decorative designs were added in gold against a dark green and black ground. The tableau was protected either with a second sheet of glass or by varnishing.[3] Wegner was rightly proud of this sentimental plaque, which he signed on the lower left.

The goldsmith, Ditmar Kahrs, made the snuffbox with canted corners using panels of malachite, a green ornamental stone found in Russia. These were mounted on the sides and bottom, supported by bands of chased gold laurel leaves.

A century later, the goldsmith Peter Carl Fabergé borrowed the motif of Imperial children seen in profile for his 1914 Imperial Mosaic Egg, in which the surprise is a miniature frame with the silhouettes of Nicholas II and Alexandra Feodorovna's five children.

After the 1917 revolution, Alexandre Polovtsoff, a great admirer of Maria Feodorovna's "exquisite natural taste," undertook an inventory of her carefully designed home, Pavlovsk Palace. He would have understood the sentimental and historic value of this box when he recommended it to Henry Walters for the latter's encyclopedic collection.

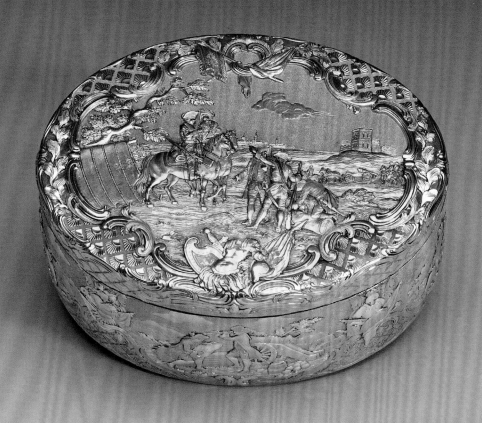

24 Snuffbox with military scene

Friedrich Joseph Kolbe (German, active late 18th–mid 19th century)
St. Petersburg, late 18th century
Multicolored gold
1¾ × 4 × 3⅛ in. (4.6 × 10.2 × 7.8 cm)

Provenance: Alexandre Polovtsoff; Henry Walters, 1930; The Walters Art Museum, 1931, by bequest, 57.261

Not a surface is left untouched in this large oval Louis XVI-style box by one *J F Kolb* [sic] *à St Petersbourg* as the signature on the box indicates. Many German goldsmiths, including a number of Kolbs or Kolbes, emigrated to St. Petersburg in the eighteenth century to work at the court of Catherine the Great.[1] The military subject, especially the type of soldiers' uniforms, and the profuse ornamentation of this box place it securely in the late eighteenth century. It may have been an early work of Friedrich Joseph Kolbe, who came from Würzburg to St. Petersburg in 1793, was made a master in 1806, and was awarded the right to use the Imperial Warrant between 1820 and 1825, when neoclassicism had long since supplanted the rococo style.[2]

Kolbe has "painted" the military scenes in *quatre-couleur* (four-color) gold. This is a complicated technique in which various metals can be added to gold in different proportions to produce colors such as white, yellow, green, or red gold. The process was first developed in France in the mid-eighteenth century, and became popular because it connoted luxury.[3]

On the front panel, a soldier in a rose gold uniform and white gold boots, leaning against a yellow gold cannon with white gold cannonballs, surveys the battlefield with a telescope while his compatriot consults a battle plan. On the cover, generals confer while the cannons pull out toward the city on the horizon. On the back panel, victory is confirmed by a monument wreathed with laurel leaves and crowned with the Romanov double-headed eagle (fig. 24.1).

Each tableau, set against a matte gold sky, is wreathed in elaborate scrollwork and flanked by military trophies with a quilted shell pattern filling the voids. The techniques of matting, chasing, tooling, and relief work, not to mention the lavish use of four-color gold, point to the skill of the goldsmith. The use of such costly materials, the laborious techniques, the idea that it celebrates a military victory, and the skill needed to produce this snuffbox suggest it was an important presentation piece.

A century later, Peter Carl Fabergé would revive the art of *quatre-couleur* gold in his bibelots, sought after by the court and high society of St. Petersburg (cat. nos. 39 and 40).

NOTES
1 Alexander von Solodkoff, *Russian Gold and Silverwork, 17th–19th Century* (New York, 1981), 219.
2 Ibid.
3 Philippe Verdier, *Russian Art: Icons and Decorative Arts from the Origin to the Twentieth Century* (Baltimore, 1959), no. 44.

Fig. 24.1. Cat. no. 24, detail of back panel.

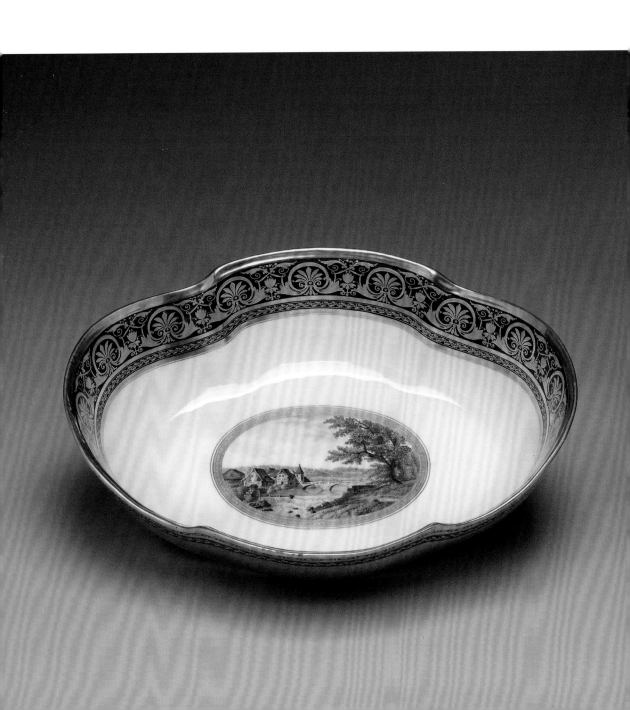

25, 26 Pitcher and basin

Imperial Porcelain Manufactory
St. Petersburg, 1800–1810
Hard-paste porcelain, gilt, painted enamel
Basin: 3⅝ × 13½ × 10⅜ in. (9.2 × 34.2 × 26.3 cm); pitcher: 11⅛ × 5½ × 4¼ in.
(28.2 × 14 × 10.8 cm)

Provenance: Alexandre Polovtsoff; Henry Walters, 1930; The Walters Art Museum, 1931,
by bequest, 48.964, 48.965

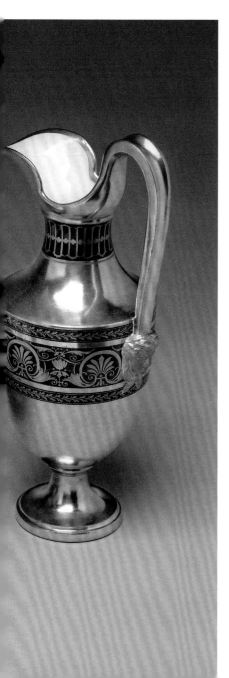

This pitcher and basin were made at the Imperial Porcelain Manufactory, established by Empress Elizabeth in 1744 to produce fine porcelain for the court. Before the advent of porcelain, wash basins and pitchers for the nobility were made of silver, and this set copies earlier silver forms. It is in the neoclassical taste, characterized by the use of Greco-Roman motifs, and was essential to the morning grooming ritual known as the toilette.

The pitcher is in the form of a Greek *oinoche*, or wine ewer, decorated with alternating bands of matte gilded palmettes and laurel leaves set against a deep blue border. The arching handle terminates in a woman's head. In contrast to its formal classical borders, the center of the basin is painted in enamel with a rustic landscape featuring a waterfall, most likely copied from a popular period engraving.[1] Scenic views had replaced the flowery decoration favored a generation earlier.[2] The basin is marked with an underglaze blue Cyrillic letter "P," surmounted by a crown, indicating the pieces were manufactured during the reign of Tsar Paul I.

There is a record of an 1801 Imperial commission of a toilette set made for Paul I's wife, Maria Feodorovna. Two choices were proposed, described as "painted decor in cobalt-blue with gold, and a light green with gold and overglaze painted decoration."[3] The green toilette was chosen and numbered over thirty pieces including powder boxes, trays, and brushes, typical of court sets of the period. The toilette was an occasion for conversation and a time to handle business matters, so even a morning tea service was included.[4]

The forms of the basin and pitcher in both sets are very similar, and there is a distinct possibility that they may have been made after sketches by Andrei Voronikhin (1759/60–1814), an architect and painter who also made sketches for applied arts.[5]

NOTES
1 Tamara Vasil'evna Kudriavtseva, *Russian Imperial Porcelain* (St. Petersburg, 2003), 79.
2 Laurent Thévenot, "La Manufacture Impériale de Saint-Petersbourg," *L'Estampille l'Objet d'Art*, 1994, 92–93.
3 Kudriavtseva, *Russian Imperial Porcelain*, 78.
4 Ibid., 78.
5 Ibid., 79, 265.

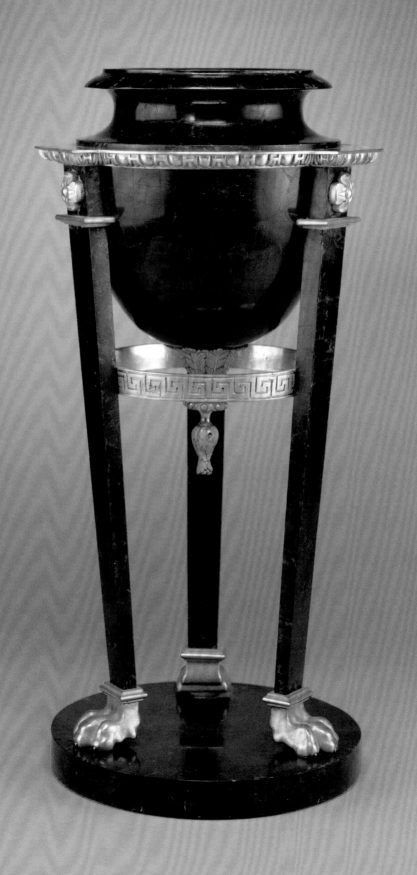

27 Bowl on tripod feet in the form of an incense burner

Probably Yekaterinburg Lapidary Factory, early 19th century
Lapis lazuli, gilded bronze
21⅛ × 10⅛ in. (53.6 × 25.9 cm)

Provenance: Henry Walters; The Walters Art Museum, 1931, by bequest, 41.239

This bowl on tripod feet, derived from classical antiquity, is designed in the form of an incense burner, intended to scent the rooms of a residence. Incense burners were immensely popular in France in the last quarter of the eighteenth century. As admirers of French taste, the Russians would have been quick to copy this luxurious accessory (fig. 27.1).

This example is constructed of sheaths of lapis lazuli, an intense ultramarine blue semi-precious hardstone, applied to a metal structure. Lapis is fragile, so a technique called "Roman mosaic," using a paste of lapis and cement, was employed to fill in and smooth out any imperfections, and the whole was highly polished.[1]

This decorative object was probably made at the Yekaterinburg Lapidary Factory, which was established in 1726 and became an Imperial manufactory in 1765. It was renowned for producing monumental hardstone pieces. In 1800, Count Alexander Sergeevich Stroganov (1734–1811) took the reins and required stonecutters to study sculpture at the St. Petersburg Academy of Arts. He also commissioned established architects to produce designs for decorative objects.[2] This bowl on tripod feet may have been one of a pair. Designs show very similar objects in the neoclassical taste expressed here in the gilded circular support with a Greek key design and in the paw feet.[3] The finely chased gilt *pendule* of acanthus leaves with seeds may have been copied from French examples.

NOTES
1 Antoine Chenevière, *Russian Furniture: The Golden Age 1780–1840* (New York, 1988), 260, 266, 269.
2 Ibid., 270.
3 N. M. Mavrodina, *Iskusstvo Ekaterinburgskikh Kamnerezov* (St. Petersburg, 2000), cover, 92–93.

Fig. 27.1. Boiserie from the Hôtel de Cabris, Grasse (Alpes Maritimes), France, ca. 1774 with later additions. Carved, painted, and gilded oak. The Metropolitan Museum of Art, New York, purchase, Mr. and Mrs. Charles Wrightsman Gift, 1972 (1972.276.1).

28 Bust of Tsar Nicholas I of Russia

Christian Daniel Rauch (German, 1777–1857)
St. Petersburg, 1834
Marble
24¾ × 15¼ × 10⅝ in. (63 × 38.9 × 27 cm)

Provenance: Alexandre Polovtsoff; Mary Churchill Humphrey; The Walters Art Museum, 1957,
gift of Miss Mary Churchill Humphrey in memory of Alexandre Polovtsoff, 27.554

Queen Victoria of the United Kingdom (r. 1837–1901) described Tsar Nicholas I (r. 1825–55) on his visit to England in 1844 as "a very striking man: still very handsome; his profile is beautiful … the expression of the eyes is formidable, and unlike anything I ever saw before."[1]

This characterization shines forth in this neoclassical portrait bust, sculpted during the tsar's reign. Christian Daniel Rauch trained in Rome and patterned this bust after classical examples of the Roman emperors. "Tsar" is a transliteration of "caesar," and the association with antiquity and the permanence of Imperial power are expressed in the luxurious pure white marble, Nicholas' carefully sculpted hair, and his regal profile. Classical-style busts were a fashionable part of palace decor, often displayed in libraries or studies, proclaiming dynastic lineage and a tangible link to history (fig. 29.1).

This bust was given to the museum by Miss Mary Churchill Humphrey in 1957. She was acquainted with the Polovtsoffs in Paris and hoped that the sculpture would "serve as a slight tribute to the erudition and taste of the late and much regretted Alexandre Polovtsoff."[2] His widow, Sophy, wrote that Mr. Walters was a "delightful friend … and he appreciated very much my husband's taste and knowledge."[3]

NOTES
1 Vanessa Remington, *Victorian Miniatures* (London, 2010), 2:518.
2 Mary Churchill Humphrey, letter to Edward S. King, Director, Walters Art Gallery, June 20, 1957. Walters Art Museum, accession folder, 27.554.
3 Mary Churchill Humphrey, letter to Marvin Ross, February 8, 1957. Walters Art Museum, accession folder, 27.554.

Fig. 28.1. Photograph in a Fabergé frame of Alexander II in his study, possibly showing the Rauch bust of Nicholas I on the desktop. Virginia Museum of Fine Arts, Richmond, bequest of Lillian Thomas Pratt.

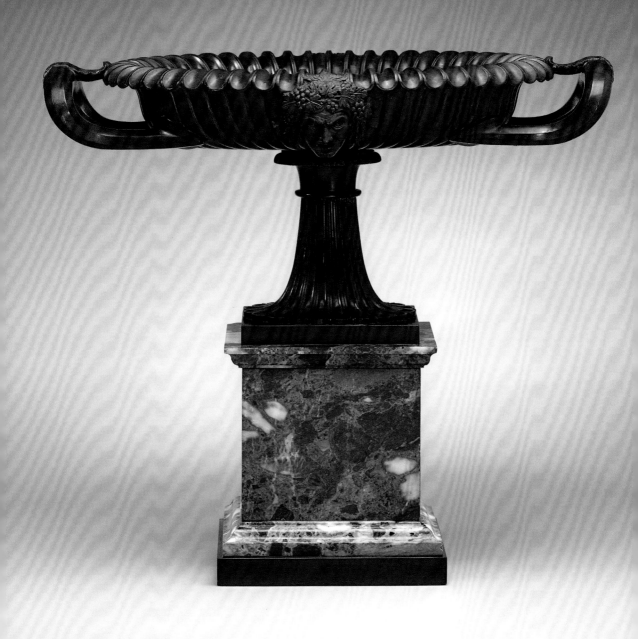

29 Tazza

St. Petersburg, mid-19th century
Red and mottled-green marble
13⅞ × 6⅛ × 9¾ in. (35.4 × 41 × 24.8 cm)

Provenance: William T. Walters or Henry Walters; The Walters Art Museum, 1931, by bequest, 41.267

This tazza, or footed dish, is patterned after an ancient Greek *kylix*, a ceramic drinking cup that has two looped handles on a shallow bowl, set on a slender foot. It may have been one of a pair. The bowl is ornamented on one side with the carved head of Dionysus, the Greek god of winemaking, identified by his wreath of leaves and bunches of grapes. On the other side is the likeness of one of his satyrs, identified by his pointed ears. Acanthus leaves secure the handles to the bowl and make up the central rosette inside. Before carving, meticulous drawings were made because the stones—an ovoid blood-red marble for the tazza and a mottled-green marble for the plinth—were expensive and difficult to mine.[1] The artist remains unknown. Many foreign artisans flocked to Russia for the opportunity to ply their craft and to help meet the demand for luxury goods.

Russia is known for its rich mineral, gem, and geological deposits. The first Imperial lapidary, or stonecutting factory, was established at Peterhof, near St. Petersburg, by 1721. Geological expeditions uncovered hardstones and marble in the Urals and Siberia, and lapidaries were established in 1726 in Yekaterinburg and in 1786 in Kolyvan in the remote Altai Mountains. The lapidaries made imposing decorative pieces for the palaces of the tsars and the nobility.

NOTE
1 N. M. Mavrodina, *Iskusstvo Ekaterinburgskikh Kamnerezov* (St. Petersburg, 2000), 106–07.

30 Wine carafe in the form of a griffin

Ivan Khlebnikov (Russian, 1819–1881)
Moscow, 1874
Silver gilt, champlevé enamel
8½ × 4⅞ × 3½ in. (21.6 × 12.2 × 9 cm)

Provenance: Jean M. Riddell; The Walters Art Museum, 2010,
gift in memory of Jean M. Riddell, 44.790

This carafe is shaped like a mythical griffin: the head like an eagle, whose sharp beak forms the spout; the rump like a lion, whose sinuous tail serves as the handle. The form may have been copied from a sixteenth-century covered cup made for Ivan the Terrible and known from an illustration in the *Antiquities of the Russian State*, published between 1849 and 1853 by Fedor G. Solntsev. These volumes became source books for artisans such as Khlebnikov who worked in the Russian Revival style to satisfy a clientele nostalgic for the past.

The griffin is suited in armor made of two-tone blue chevrons, with feathering showing through at the bottom and back. The elaborate belt, similar to the braiding found on a *shako* (military hat), covers the protruding stomach. This detail, coupled with the slightly tipsy crown, gives the anthropomorphic creature an air of satisfaction bordering on caricature. An apt Russian proverb is enameled around the breast in Slavonic script, an early form of the Cyrillic alphabet. It reads: "Drinking is not a hindrance but youth's diversion."[1] The griffin's taloned feet are silver gilt. The multicolored champlevé enamel mixed with chased silverwork is characteristic of Khlebnikov.

Ivan Khlebnikov's firm exhibited at international fairs, including the Philadelphia Centennial Exhibition of 1876, where a copy of this carafe was displayed. The *Art Journal* commented that among the exhibitors, "there is probably none more thoroughly distinctive of nationality than that of Russia."[2]

NOTES
1 Anne Odom, *Russian Enamels: Kievan Rus to Fabergé* (Baltimore, Washington, D.C., and London, 1996), 110.
2 "The Centennial Exhibition," *Art Journal* 2 (1876), 370.

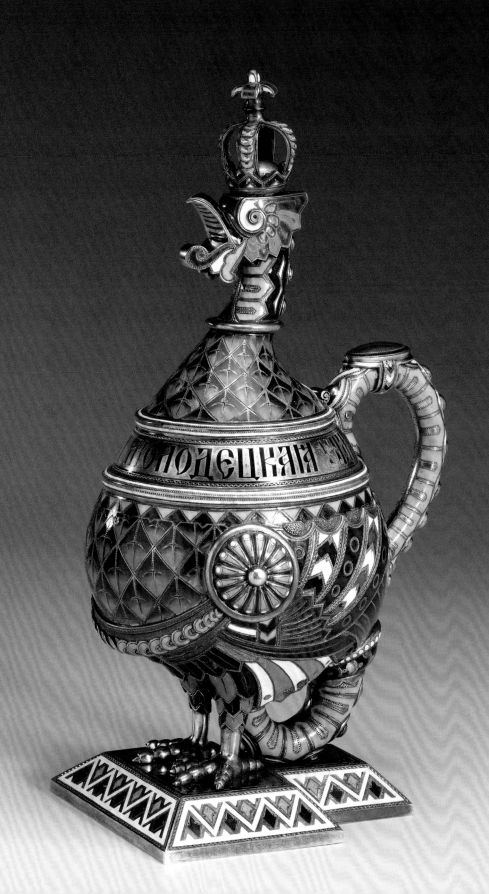

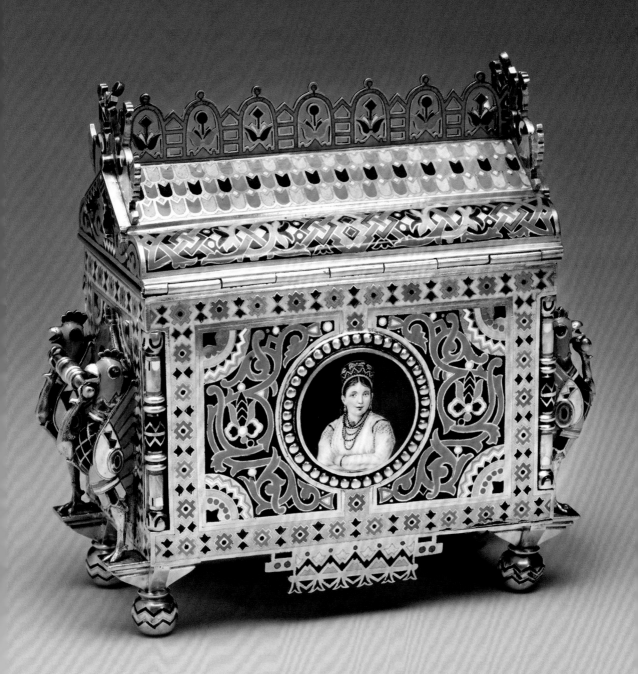

31 Casket in the form of an *izba*

Pavel Ovchinnikov (Russian, 1830–1888)
Moscow, 1876
Silver gilt, champlevé and painted enamel, velvet, composite board
6¼ × 6⅞ × 3⅜ in. (15.8 × 17.4 × 8.4 cm)

Provenance: Jean M. Riddell; The Walters Art Museum, 2010,
gift in memory of Jean M. Riddell, 44.730

Wooden *izby*, or peasant houses (fig. 31.1), often had detailed carvings along the roof line and around the window frames.[1] This champlevé enamel version, which displays Pavel Ovchinnikov's virtuosity as a designer and highly accomplished enamelist, imitates such work. The roof is "tiled" in alternating chevrons of red, blue, and green enamel terminating in Norse-inspired strapwork. The roof line sprouts flowers and boasts rooster finials. Three-dimensional roosters act as crowing guards on either end of the casket, which may have been used to store jewels.

The walls are inlaid with patterns suggesting a fusion of illuminated manuscript scrollwork with nineteenth-century motifs such as the fan-shaped spandrels and outer border. The repetition of bold colors unifies these disparate decorative elements. The designs were inspired by the influential *Histoire de l'ornament russe du Xe au XVIe siècle d'après les manuscrits*, collected and published by Victor de Boutovsky in 1870. It documented Byzantine and Russian manuscript ornamentation from the tenth century onward. The book had a significant impact on the arts, especially among artisans in Moscow. They used it as a design resource for their enamel work in the Russian Revival style.

Peasants, painted in enamel on separate enamel plaques, peer from the windows. Included are an accordionist, a balalaika player, and a wet nurse (a woman hired to suckle another woman's child). The wet nurse wears a headdress, indicating she is married; the musicians wear simple peasant shirts and hats.

NOTE
1 Alison Hilton, "The Peasant House and Its Furnishings: Decorative Principles in Russian Folk Art," in *The Journal of Decorative and Propaganda Arts*, Winter 1989, 15–16.

Fig. 31.1. *Izba* at the 1900 Paris Exposition Universelle, designed by Konstantin Korovin and fabricated by the *kustari* of Sergei Posad. Reproduced from *Mir Iskusstva*, 21–22 (1900).

32 Salt chair

Maria V. Adler (Russian, active ca. 1877–1897)
Moscow, 1878
Silver gilt, champlevé enamel
7½ × 4⅜ × 3¼ in. (18.5 × 11.1 × 8.3 cm)

Provenance: Sale, Christie's, New York, October 21, 1993, lot 54; Jean M. Riddell
(through Leo Kaplan as agent); The Walters Art Museum, 2010, gift in memory of Jean M. Riddell, 44.784

Offering bread and salt (an expensive commodity in early Russia) as a gesture of welcome is a Russian custom practiced in intimate domestic settings as well as on state occasions. This miniature throne-like chair, the seat of which is a salt container, would have been placed on top of a loaf of bread for presentation to guests.

The toylike chair, with its gay colors and riot of shapes, is in the Russian Revival style. The solidity of the columns that support the seat plays against the airy back splat made up of an elaborate *kokoshnik* form, topped by sea monsters abutting beneath a rising sun. Proud cockerels, facing outward, greet the dawn.

The pierced work on the back, suggesting the wooden lace carving on peasant cottages, gives the piece a lightness. The reverse of the back splat is heavily chased, making this object attractive from all angles.

From the beginning of the 1880s, Maria V. Adler had her own workshop in Moscow producing gold and silver pieces and enamel work.[1] The high quality of the champlevé enamel in deep blue, reds, and turquoise is a testament to her skill.

NOTE

1 Alexander von Solodkoff, *Russian Gold and Silverwork, 17th–19th Century* (New York, 1981), 206.

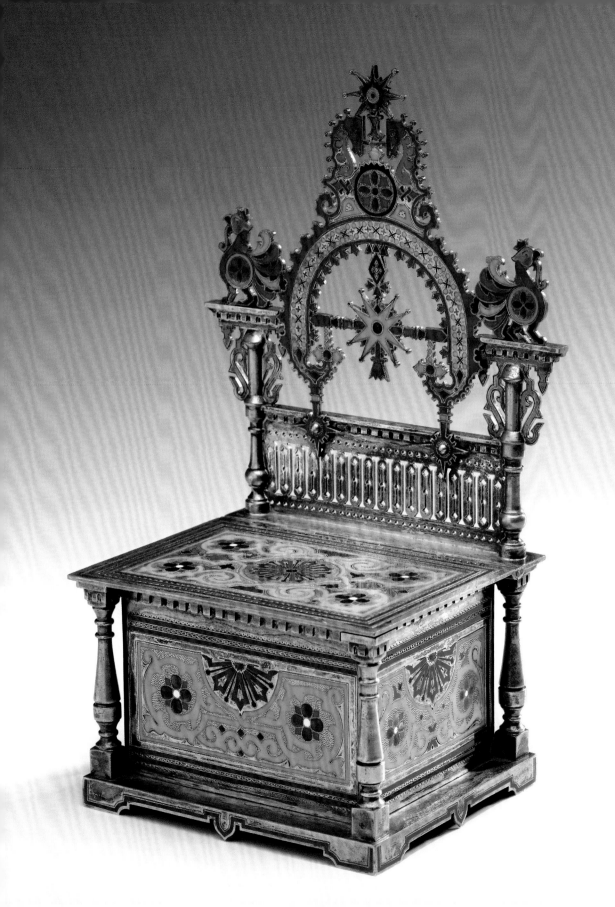

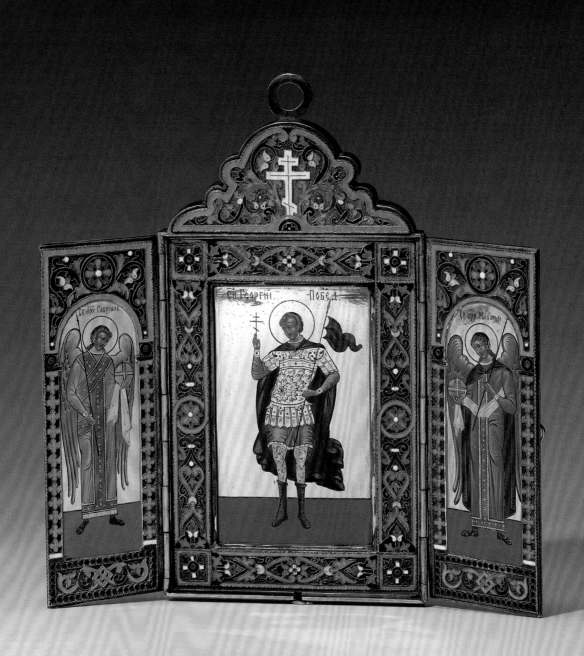

33 Triptych with saints and angels

Ivan Khlebnikov (Russian, 1819–1881)
Moscow, 1880
Silver gilt, filigree, painted enamel
With panels open: 6¼ × 6⅞ × ½ in. (15.8 × 17.5 × 1.5 cm)

Provenance: Jean M. Riddell; The Walters Art Museum, 2010,
gift in memory of Jean M. Riddell, 44.791

Icons, an art form derived from Byzantium, are a revered part of the Russian Orthodox tradition and were found not only in churches, but also in homes, stores, and offices in the late nineteenth century. Artists of the period studied antique icons to replicate them for the merchant class, who had a taste for the art of bygone Russia.[1]

This two portable icon and that shown in cat. no. 34 have an architectural quality, with miniature "church doors" surmounted with a *kokoshnik*-shaped arch. Both bear the Russian Orthodox cross, with an angled foot brace known as the balance of righteousness. In this version, the cross surmounts the doorway, whereas in cat. no. 34 the cross functions as a "doorknob." When considering the portals, both artists looked to earlier sources. The Khlebnikov doors are notably geometric and medievalizing in their design. Likewise the patterns of the interior archways seem to have been plucked from medieval manuscript borders. In contrast, Paikratev's doors are teeming with flowers and leaves and extravagantly flecked with silver-gilt balls, reminiscent of seventeenth-century enamel work (cat. no. 11).

The Khlebnikov triptych opens to reveal three warrior saints: St. George the Victorious and the Archangels Gabriel and Michael, identified by the inscriptions above their heads. The finely detailed figures are painted in enamel on silver in the Gothic style. The central wood panel in the Paikratev icon features the *nerukotvorenny obraz* or "holy image of Christ not made by human hand." In the Eastern Church, this image is venerated as the first icon; in the Western Church it is identified as "Veronica's Veil." In the archways on either side are St. Nicholas the Wonderworker and a guardian angel.

NOTE
1 Orlando Figes, *Natasha's Dance: A Cultural History of Russia* (New York, 2002), 11.173.

Fig. 33.1. Cat. no. 33, closed.

34 Triptych with Christ, St. Nicholas, and a Guardian Angel

Grigori Grigorevich Pankratiev (Russian, active 1874–1908)
St. Petersburg, ca. 1899
Silver gilt, filigree, painted enamel
With panels open: 7¼ × 8½ × ⅞ in. (18.3 × 21.6 × 2.3 cm)

Provenance: Jean M. Riddell; The Walters Art Museum, 2010,
gift in memory of Jean M. Riddell, 44.971

Fig. 34.1. Cat. no. 34, closed.

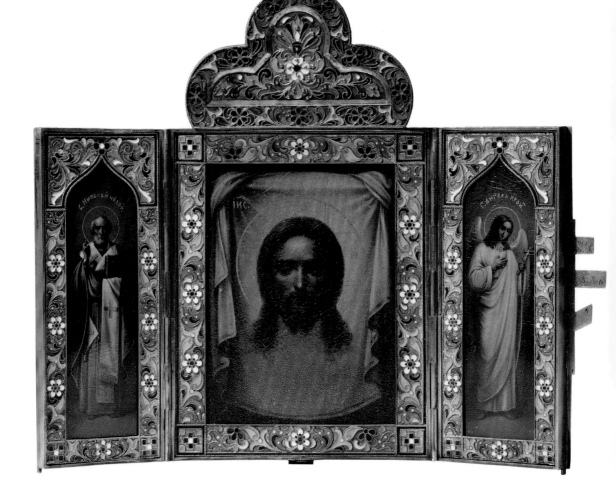

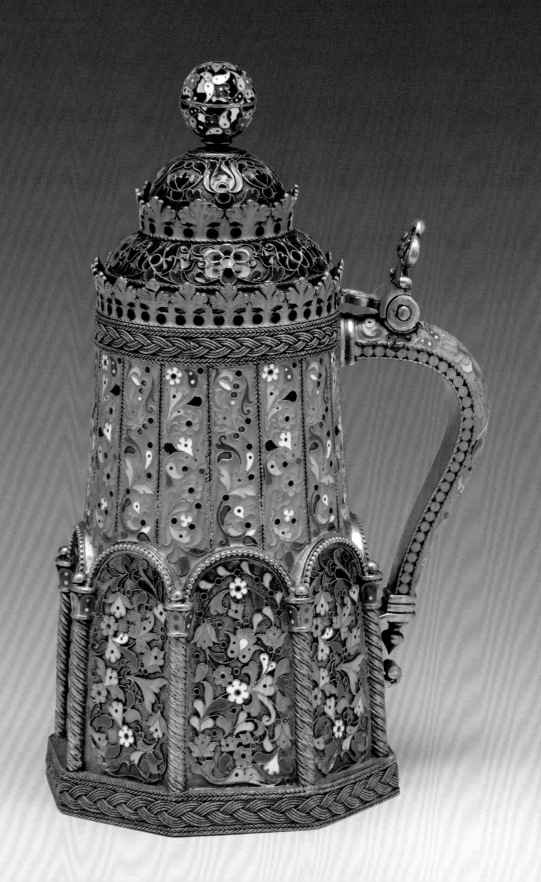

35 Tankard

Firm of Pavel Ovchinnikov (Russian, 1830–1888)
Moscow, 1891–96
Silver gilt, opaque filigree and plique-à-jour enamel
8⅛ × 5¼ × 4⅛ in. (20.8 × 13.3 × 10.5 cm)

Provenance: Leo Kaplan, New York; Jean M. Riddell, Washington, D.C., 1988;
The Walters Art Museum, 2010, gift in memory of Jean M. Riddell, 44.745

Ovchinnikov and his workshop were at the forefront of the development of the Russian Revival style, which looked to native centuries-old prototypes for inspiration. The form of this tankard, coupled with the pastel-colored enamels in arabesque floral motifs suggesting mosaic work, points to Byzantine architectural prototypes.[1]

The bottom of the tankard consists of barrel-vaulted arches terminating in semi-detached columns, resting on a braided silver-gilt base. Inside the arches is a play of negative and positive space with opaque filigree enamel floral vines applied to a matted silver-gilt "wall." Above the arches, the alternating panels of opaque sky-blue and spring-green enamel are decorated with climbing floral vines, reminiscent of the wall decorations of early Russian palaces.[2]

The two-tiered domed lid is fashioned after the sixteenth-century Tartar crown of Kazan.[3] It is worked in plique-à-jour enamel, which creates the impression of stained glass. Ovchinnikov was the first to revive this difficult process, and it became a hallmark of his firm. The bright red Russian firebird pinning down a green sea monster in the base of the tankard (fig. 36.1) is also in plique-à-jour enamel. The finial comprising a cluster of paisley enamel shapes with black dots is reminiscent of seventeenth-century Ustiug enamel work (cat. no. 7). The push piece to raise the lid echoes the crenellation of the dome.

The Ovchinnikov firm made a number of these tankards; a similar one is in the museum's collection, and a third, nearly identical example was made for Tsar Alexander III.[4]

NOTES
1 Anne Odom, "'Russkii stil': The Russian Style for Export," *The Magazine Antiques*, March 2003, 104.
2 Marvin Ross, *The Art of Karl Fabergé and His Contemporaries* (Norman, Okla., 1965), 115.
3 Anne Odom, *Russian Enamels: Kievan Rus to Fabergé* (Baltimore, Washington, D.C., and London, 1996), 120.
4 John Atzbach Antiques, email to the author, June 23, 2016.

Fig. 35.1. Cat. no. 35, detail of bottom.

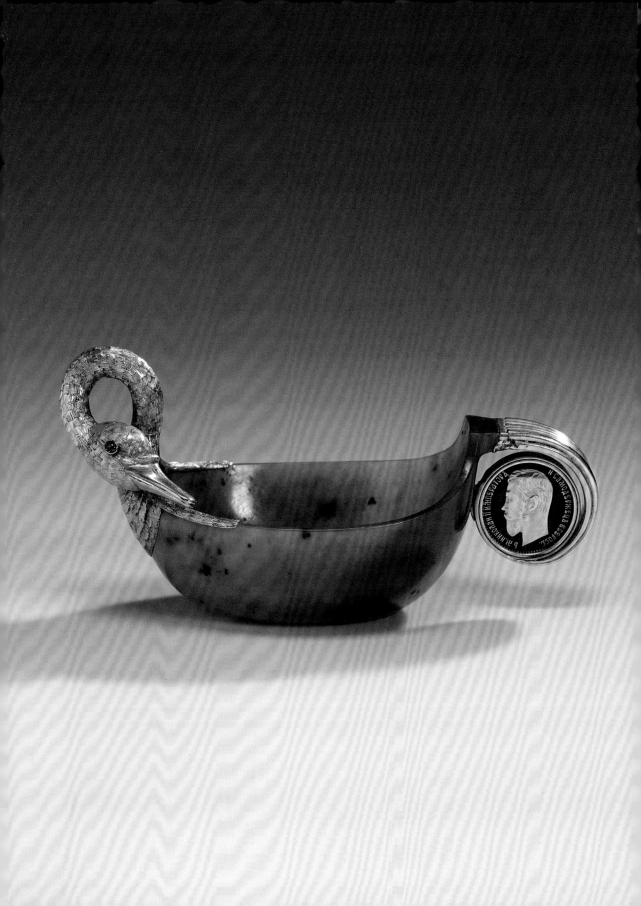

36 Swan *kovsh*

House of Fabergé, Henrik Emanuel Wigström, workmaster (Finnish, 1862–1923)
St. Petersburg, 1898–1903
Nephrite, *quatre-couleur* gold, rubies, enamel
1⁷⁄₈ × 3⁷⁄₈ × 1¾ in. (4.8 × 9.9 × 4.6 cm)

Provenance: Charles Clore sale, Sotheby's, London, October 28, 1985, lot 183; Jean M. Riddell, Washington, D.C., 1985; The Walters Art Museum, 2010, gift in memory of Jean M. Riddell, 44.974

The body of this *kovsh* is made from thinly carved nephrite. The swan's head and neck are rendered in red and green gold with exceptional attention given to the delineation of the bird's feathers. The handle is also gold, wrapped around a Russian five-ruble coin bearing the likeness of Tsar Nicholas II. The inscription on its face reads in Cyrillic, "His Imperial Majesty Nicholas Emperor, Autocrat of Russia, By the Grace of God," and on its reverse, in Cyrillic, "Five Rubles 1898." The practice of inserting coins into the surfaces of silver vessels can be traced to the seventeenth century and earlier. Here the coin is embellished with bright strawberry-red translucent enamel. The piece is marked with the initials of Henrik Wigström, workmaster at the House of Fabergé, who alongside Mikhail Perkhin oversaw the manufacture of almost all of the Imperial Easter Eggs (cat. nos. 60, 61).

Nephrite is a variant of the jade family, and was frequently selected for fine carvings as its molecular structure makes it harder than steel.

37 Letter stand

Fedor Ivanovich Rückert (Russian, 1840–1917)
Moscow, 1899–1908
Silver gilt partly in repoussé, painted filigree enamel, cabochon garnet
6½ × 5⅞ × 4⅛ in. (16.4 × 14.8 × 10.5 cm)

Provenance: Leo Kaplan, New York; Jean M. Riddell, Washington, D.C., 1985;
The Walters Art Museum, 2010, gift in memory of Jean M. Riddell, 44.869

On this letter stand, two *streltsy*, uniformed Russian guards who protected the Moscow Kremlin from the sixteenth century onward, bar a massive door with their poleaxes and sabers. It is an apt conceit: the stand was intended to guard private correspondence. The wax seal on the doorway was a typical Russian device used to prevent tampering. It may also allude to the wax used to seal letters. The cabochon garnet at the base signals that this letter stand doubled as a bell push to call an assistant. A box underneath conceals the electrical wiring.

The French-born Fedor Rückert was a premier maker of Russian Revival-style objets d'art. Historicism was in favor not only in the decorative arts, but also in painting and architecture, and these art forms fed one another. In this piece, the figures of the guards are taken from drawings preserved in *Antiquities of the Russian State* (1849–53). The volumes sparked interest in Russia's past and gave birth to the Russian Revival style. The richly decorated columns with Usolsk-style enamel flowers found parallels in Russian Revival architecture, most notably in the Imperial Museum of Russian History (now the State Historical Museum) in Moscow.

The back of the stand combines richly colored filigree enamel with gilded silver cutwork. There is an echo of the enamel floral columns on the front, with sea monsters swimming across the back rail. The reverse displays plain silver-gilt cutwork featuring two peacocks on either side of the tree of life (fig. 37.1; compare cat. no. 43). The letter stand may have been part of a larger set that would have included a pen rest, letter opener, inkwell, and lamps.

Fig. 37.1. Cat. no. 37, reverse.

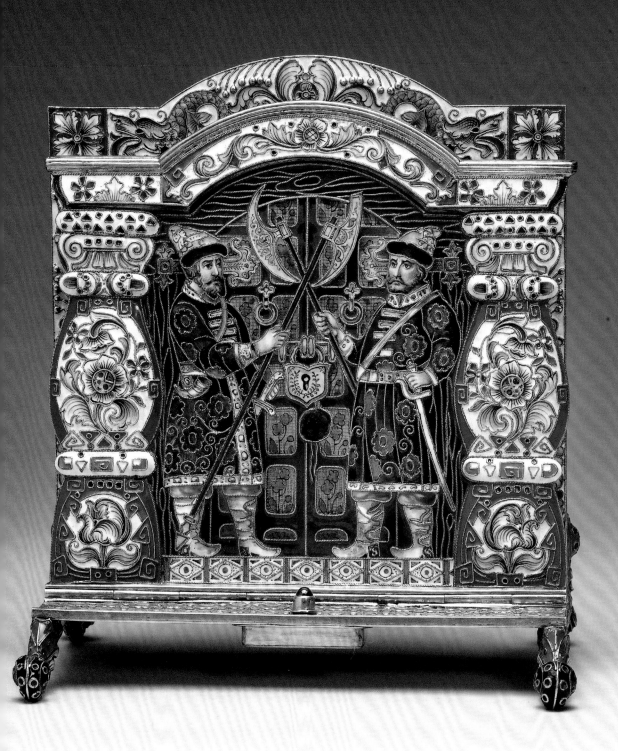

38 Cigarette case

Fedor Ivanovich Rückert (Russian, 1840–1917)
Moscow, 1899–1909
Silver gilt, painted filigree enamel, amethyst
4¼ × 2⅞ × 1⅛ in. (10.6 × 7.1 × 2.8 cm)

Provenance: Sale, Sotheby's, New York, October 22, 2002, lot 316; Jean M. Riddell
(through Leo Kaplan as agent), Washington, D.C., 2002; The Walters Art Museum, 2010,
gift in memory of Jean M. Riddell, 44.872

Snuff fell out of fashion with the vogue for cigarettes in the nineteenth century, and cigarette cases replaced snuffboxes.

This heavy silver-gilt example, which opens with a cabochon amethyst push piece, is both tactile and visually appealing in its contrasting enamel work. Two types of contrasting enamel work come together here. The first is filigree enamel, in which all the decorative shapes are formed by silver-gilt twisted bands into which various enamel colors are poured and then shaded. The second type reveals itself in the miniature enamel painting of the Great Kremlin Palace and churches for which the artist used a very fine brush. The nearly photographic view is based on period prints or photographs (fig. 38.1).

The bottom two-thirds of the case is a checkerboard of stylized flowers in deep greens, blues, and black with touches of white enamel. The dark colors of the base visually support the miniature painting. Above the picture, cascades of pink and white enamel, suggestive of snow-covered mountains, bring light to the picture of the Kremlin. The frame of the painting resolves in twisted metal curlicues that echo the edges of the case itself. The reverse of the case is a mirror image of the front, except for the miniature, which has been replaced by an enamel painting of a landscape.

The case is in the Russian Revival style, which relied on Byzantine and seventeenth-century Russian motifs and was largely free of Western influence. Fedor Rückert is best known for this type of work, which was highly popular among Muscovites from the 1880s until the revolution. This cigarette case may have been a souvenir, commemorating a visit to Moscow.

Fig. 38.1. Moscow River and the Kremlin in winter,
Moscow, ca. 1919. Keystone View Company.
Library of Congress, Washington, D.C.

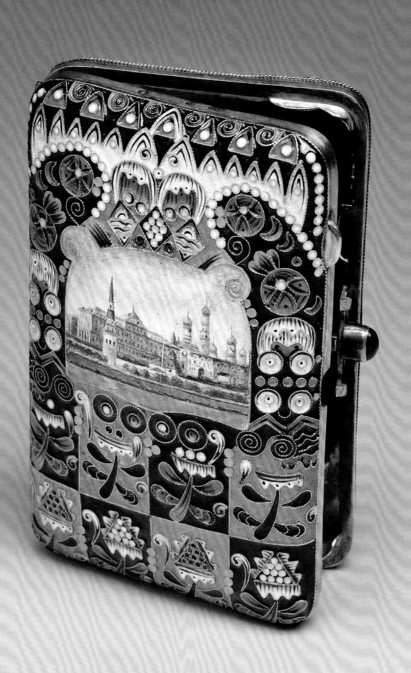

39 *Kovsh*

Attributed to Fedor Ivanovich Rückert (Russian, 1840–1917)
Moscow, 1899–1908
Silver gilt, painted filigree enamel, amethysts, citrines
2¼ × 4½ × 2¾ in. (5.6 × 11.6 × 7 cm)

Provenance: Jean M. Riddell, Washington, D.C.; The Walters Art Museum, 2010,
gift in memory of Jean M. Riddell, 44.773

This jeweled miniature *kovsh* combines ancient forms with modern style to create
a fitting early twentieth-century souvenir of Moscow. The *kovsh* comes from a
folkloric tradition: a wooden drinking cup used by peasants carved in the form
of a bird. In this miniature version, the handle is an abstract head of a bird with
an amethyst cabochon for the eye. The handle appears strikingly modern, but
is inspired by interlace patterns seen in medieval illuminated manuscripts. Its
marbleized, painted enamel work imitates semi-precious hardstones such as
agate and lapis lazuli.

The roundels feature Moscow monuments, painted *en grisaille* to suggest a
photograph. The enamelist chose two huge monuments to feature on this tiny
kovsh: the Tsar's Bell, the largest bell in the world (fig. 39.1), and the Cathedral
of Christ the Savior, the tallest Orthodox church in the world, seen from the
Great Stone Bridge. These landmarks were commonly depicted in postcards of
the same period.

Colonnettes topped by jeweled capitals separate the roundels, some of which
are painted with pastel-colored flowers in imitation of seventeenth-century
northern Russian enamels (cat. no. 11).

Fig. 39.1. Moscow: The Tsar's Bell in the
Kremlin. Late 19th-century postcard.

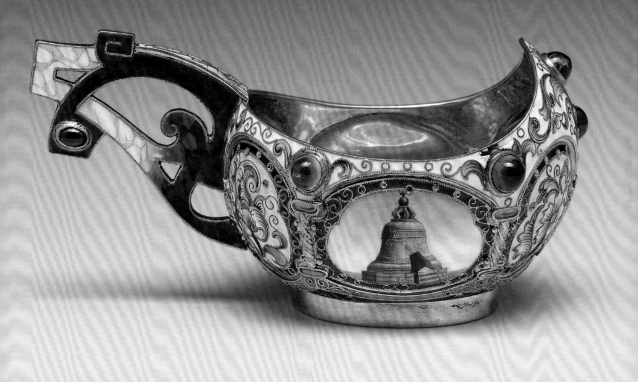

40 Vodka cup

Workshop of Pavel Ovchinnikov (Russian, 1830–1888)
Moscow, 1899–1908
Silver gilt, plique-à-jour and filigree enamel
2⅞ × 2¼ in. (7.3 × 5.5 cm)

Provenance: Jean M. Riddell, Washington, D.C.; The Walters Art Museum, 2010,
gift in memory of Jean M. Riddell, 44.775

41 Vodka cup

Theodor Nugren
St. Petersburg, 1899–1908
Silver gilt, plique-à-jour and filigree enamel
2⅝ × 1¾ in. (6.6 × 4.4 cm)

Provenance: Jean M. Riddell, Washington, D.C.; The Walters Art Museum, 2010,
gift in memory of Jean M. Riddell, 44.978

Both these vodka cups are made from plique-à-jour enamel and filigree work, employed in different styles. That on the left is decorated with a continuous aquatic scene in which appear swans, a wading stork, flying swallows, and a butterfly. The bottom reveals an abstract blossom in yellow, green, turquoise, and red enamel. The cup shows the influence of Japanese art on Russian design. Japonisme, a borrowing of Japanese aesthetics in art, was in vogue worldwide in the final decades of the nineteenth century. The cup on the right is decorated with a repeating symmetrical pattern with flowers and stylized foliage, and draws on traditional Russian designs.

Vodka, a popular drink in Russia from the sixteenth century onward, was always drunk socially. Because of the delicate nature of plique-à-jour enamel, these cups were used for special occasions such as weddings or christenings.

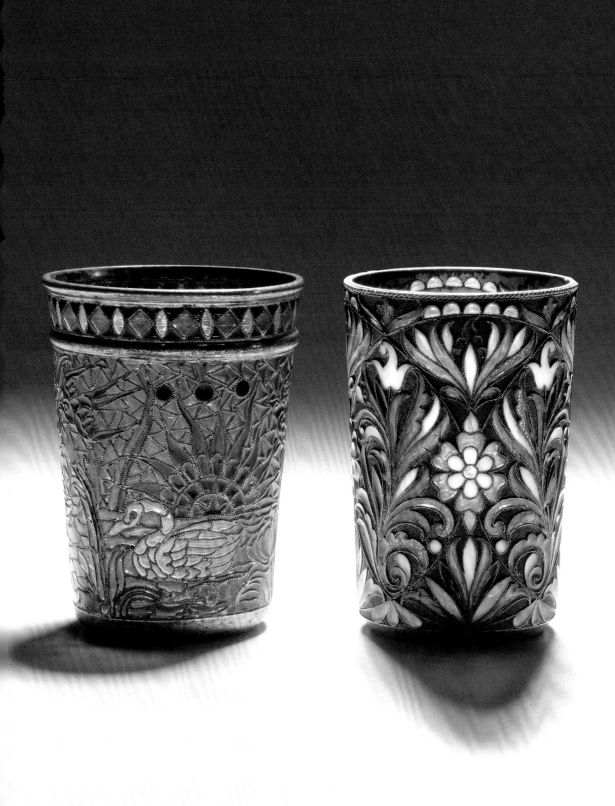

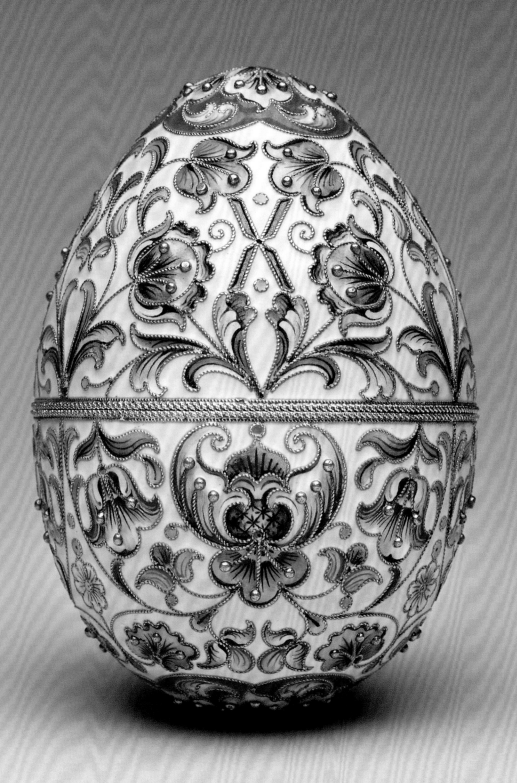

42 Easter Egg

Maria V. Semenovna (Russian, active 1896–1917)
Moscow, 1899–1908
Silver gilt, painted and filigree enamel
3¼ × 2¼ in. (8.2 × 5.8 cm)

Provenance: A La Vieille Russie, New York; Jean M. Riddell, Washington, D.C., 1977; The Walters Art Museum, 2010, gift in memory of Jean M. Riddell, 44.821

The egg, symbol of rebirth, new life, and immortality, is associated with Easter, the most important feast day in the Russian Orthodox ecclesiastical calendar. This elaborately decorated confection, covered with spring flowers, carries the Cyrillic letters "X" and "B" in red enamel in the upper quadrant. They convey the Easter greeting, "Christ is risen."

Stylistically, this late nineteenth-century egg takes inspiration from seventeenth-century techniques in its use of filigree and shaded enamel work. When compared with the gilded metal flowers and birds on the bowl with the portrait of a man (cat. no. 11), there is a similarity in the light enamel background, the shading of the flowers, and, in particular, their raised stamens. This technique of raised motifs worked in gilded silver has its origins in early metalwork.

The idea of resolving the top and bottom of the egg with different designs evokes Fabergé's decoration of the tops and bottoms of Imperial Eggs with portrait diamonds, as seen in the Rose Trellis Egg (cat. no. 61).

Maria Semenovna became active around 1890. She took over the business of her father, Vasili, and kept it going until 1917. She is known for the outstanding quality of her work, the careful fashioning of the cloisons (a network of upright metal bands), and the delicately painted enamel. She made pieces for major Moscow firms such as I. E. Morozov and Maison Boucheron.[1]

NOTE
1 Alexander von Solodkoff, *Russian Gold and Silverwork, 17th–19th Century* (New York, 1981), 52, 61, 209.

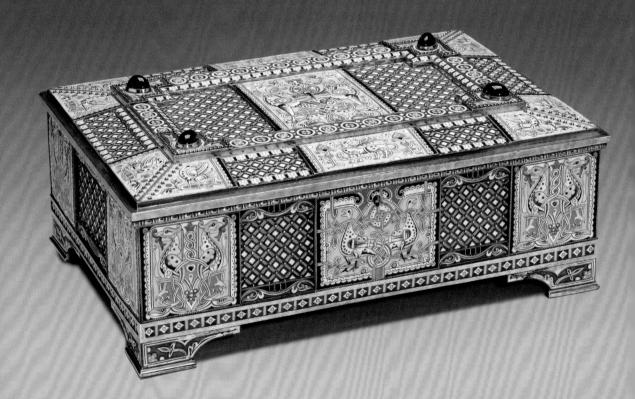

43 Casket

Firm of Pavel Ovchinnikov (Russian, 1830–1888)
Moscow, 1899–1908
Silver gilt, painted filigree enamel, granulation, amethysts
4¾ × 12¾ × 8½ in. (12.3 × 32.4 × 21.7 cm)

Provenance: Ekarerina Vikulovna and Vasili Aleksandrovich Gorbunov, Moscow; Evdokhia Vikulovna
and Sergei Vasilevich Kokorev, Moscow, by gift, 1912; Jean M. Riddell, Washington D.C.;
The Walters Art Museum, 2010, gift in memory of Jean M. Riddell, 44.755

Fig. 43.1. Addorsed bird design from
Victor de Boutovsky, *Histoire de
l'ornement russe du Xe au XVIe siècle
d'après les manuscrits* (Paris, 1870),
vol. 2, pl. 49.

NOTES

1 Paired birds flanking the tree of life
were found on Kievan Rus' jewelry
as early as AD 1000–1200. Kievan
Rus' artists borrowed these motifs
and the art of cloisonné enamel
from Byzantium. A variation is
the tree of life framed by sirens.

2 Anne Odom, *Russian Enamels:
Kievan Rus to Fabergé* (Baltimore,
Washington, D.C., and London,
1996), 124.

3 Irina V. Potkina, "Moscow's
Commercial Mosaic," in James
L. West and Iurii A. Petrov, eds.,
Merchant Moscow (Princeton, N.J.,
1998), 86.

4 Anne Odom, *Russian Silver in
America: Surviving the Melting Pot*
(Washington, D.C., and London,
2011), 169.

The form and motifs of this casket were carefully chosen to reflect its purpose as a housewarming gift. The architectonic shape borrows elements such as the lattice "windows" and tiled "roof" from the Terem Palace, a seventeenth-century Moscow residence of the tsars.

The enameled birds and beasts are often associated with manuscript illustration. The top of the box features paired peacocks framing a tree of life, suggesting the unity of the couple.[1] The paired doves decorating the center front are associated with love and concord, and the blue dots on their breasts are an ancient fertility symbol. The paired griffins protect the road to salvation and, here, the home. Many of these birds and beasts were copied from Victor de Boutovsky's *Histoire de l'ornement russe du Xe au XVIe siècle d'après les manuscrits,* published in 1870 (fig. 43.1).[2] This was a key source book in the creation of the revival style.

Inside the lid, the casket is inscribed in Cyrillic:

To your new home [Na novoceľe], to Evdokhia Vikulovna and Sergei Vasilevich Kokorev, May 1912, from Ekaterina Vikulovna and Vasili Aleksandrovich Gorbunov.

The women were sisters and descended from the founder of the Morozov textile manufactory, based in Moscow. Evdokhia's husband, Sergei, was the son of a freed serf. He had a modest upbringing but made a fortune trading in vodka. He had a lifelong passion for, and a collection of, peasant handicraft and would have understood the symbolism of this casket.[3] With its profuse use of ancient Russian forms and motifs, the casket must have been a particularly pleasing gift.

The maker, Pavel Ovchinnikov, was a freed serf who rose to the top of his profession, and won the distinction of Purveyor to the Tsars, having been granted the Imperial Warrant in 1865.[4]

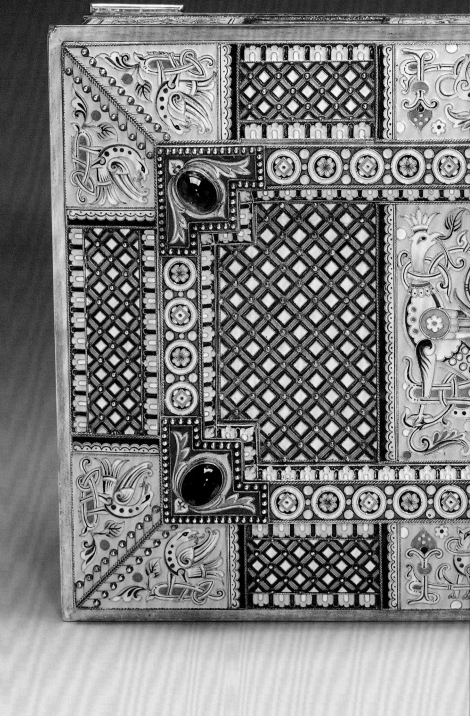

44 Mother of God icon with *oklad*

Vasili Semenov (Russian, active ca. 1869–1896)
Moscow, ca. 1889
Silver gilt, painted and filigree enamel, seed pearls, oil on wood with red silk backing
4⅞ × 3⅞ × 1 in. (12.2 × 10 × 2.6 cm)
Marks: VS in Cyrillic; St. George left

Provenance: Jean M. Riddell, Washington, D.C.; The Walters Art Museum, 2010,
gift in memory of Jean M. Riddell, 44.817

Vasili Semenov, a prominent silversmith and enamelist who exhibited at the
1867 Exposition Universelle in Paris created the *oklad*, or protective cover, for
this icon of the Virgin with the Christ Child.

The frame is enameled with shaded flowers, inspired by seventeenth-century
prototypes; the cruciform designs at the corners presage Christ's Crucifixion.
The background is lace-like filigree enamel tracery. Antique lace was widely col-
lected in the late nineteenth century and was part of the quest for historicism.
The foliate design of the frame is replicated in the Virgins' halo, surmounted by
a *kokoshnik* crown that pierces the top.

45 Kazan Mother of God icon with *oklad*

Vasili Semenov (Russian, active ca. 1869–1896)
Moscow, ca. 1889
Silver gilt, painted and filigree enamel, oil on wood with velvet backing
3¾ × 2⅞ × ⅞ in. (9.5 × 7.5 × 2.1 cm)
Marks: VS in Cyrillic; IL in Cyrillic (for Ivan Lebedkin, Moscow assay master,
active 1889–1908)

Provenance: Jean M. Riddell, Washington, D.C.; The Walters Art Museum, 2010,
gift in memory of Jean M. Riddell, 44.819

This half-length figure of the Virgin holding the Christ Child represents the
Kazan Mother of God. In the late sixteenth century, the mother of God report-
edly appeared to a young girl and instructed her to find an icon in a field near
the city of Kazan, at the confluence of the Volga and Kazanga Rivers in European
Russia. Subsequently, the icon was installed in Kazan Cathedral, and veneration
of it produced several "miracles." Our Lady of Kazan, also known as the Holy
Protectress of Russia, venerated in times of national crisis, became a popular
subject of icon painters. Both St. Petersburg and Moscow have cathedrals dedi-
cated to Our Lady of Kazan.

46 Teapot

7⅝ × 7⅜ × 3⅞ in. (10.9 × 13.2 × 7.8 cm)

47 Creamer

4⅛ × 5⅛ × 3⅛ in. (10.7 × 13.2 × 8.1 cm)

48 Sugar bowl

5½ × 6 × 4⅛ in. (14.2 × 15.2 × 10.3 cm)

49 Waste bowl

4⅞ × 5½ in. (12.2 × 13.5 cm)

Nikolai Vasilevich Alexseev
Moscow, 1899–1908
Silver gilt, filigree and painted enamel

Provenance: Sale, Sotheby's, New York, December 13, 1991, lot 71; Leo Kaplan, New York, 1991; Jean M. Riddell, Washington, D.C., 1991; The Walters Art Museum, 2010, gift in memory of Jean M. Riddell, 44.831–44.834

Tea was introduced into Russia by the Mongolians; by the late seventeenth century, the Chinese were trading tea for furs. By the late nineteenth century, tea drinking was an established part of Russian culture. One entrepreneurial family, the Perlovs, built a tea house and residence in the Chinese style on Miasnitskaia Street in Moscow (fig. 46.1). Some of the architectural detailing was brought from China to lend an air of authenticity. The tea house opened just in time for the coronation of Nicholas II in 1896, and the Perlov family was able to welcome the Chinese Regent, Lu Hung Chang, at their establishment.[1]

This tea set is in the chinoiserie taste, a decorative arts style using Chinese or pseudo-Chinese motifs, interpreted through Western eyes. It was in vogue from the mid-seventeenth century through the end of the nineteenth century. The design incorporates Chinese elements such as pagoda shapes at the bases and tops of the pieces, with finials arising from an auspicious cloud symbol. The

Fig. 46.1. The Perlov Chinese tea room on Miasnitskaia Street, Moscow.

NOTES

1 Irina V. Potkina, "Moscow's Commercial Mosaic," in James L. West and Iurii A. Petrov, eds., *Merchant Moscow* (Princeton, N.J., 1998), 37–44, fig. 2.4.

2 William Clarke, ed., "How the Dowager Empress's Jewels Survived a Revolution," in Dagmar Kajserinde, ed., *Maria Feodorovna: Empress of Russia* (Copenhagen, 1997), 334–51.

alternating enamel panels in light turquoise, with a stylized *Shòu*, or longevity symbol, and in carnelian, featuring a tea plant, add to the visual appeal. The enamel technique is strictly Russian, with filigree painted enamel characteristic of the Russian Revival style.

Little is known of the maker, Nikolai Alexeyev, although he did participate in the 1896 All-Russian Art Industry Exhibition in Nizhni Novgorod. These exhibitions were important to artisans for the opportunity to show recent work and to get a sense of commercial and artistic trends.[2]

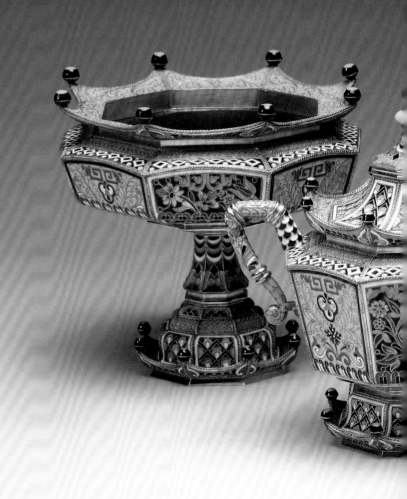

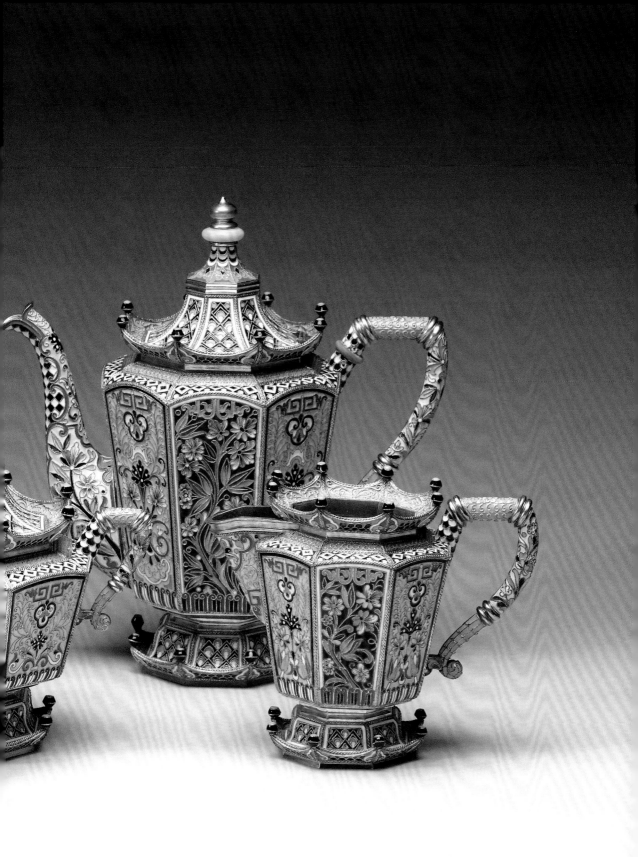

50 Pair of tazze

Imperial Glassworks
St. Petersburg, late 19th century
Purpurine, gilded bronze, colored glass
9⅜ × 7½ × 6 in. (23.8 × 19.1 × 15.3 cm)

Provenance: Alexandre Polovtsoff; Henry Walters, 1930; The Walters Art Museum, 1931,
by bequest, 47.415, 47.416

By the 1840s, European society was dining *à la russe*, with courses served sequentially rather than simultaneously, leaving the dining table free for decoration such as candelabra, flowers, and porcelains. Tazze, or footed dishes, were made in pairs. The platelike dish was a perfect surface for the presentation of fruit.

These tazze might appear to be made of carved hardstone (cat. no. 29), but in fact the material is an opaque *sang de boeuf* (blood-red) glass called purpurine, mounted on fluted gray-green glass pedestals. The red and green palette would have appealed to the Russian taste.

In the eighteenth century, purpurine was developed in the Vatican mosaic workshop in Italy, where it was known as "porporino." Tsar Nicholas I coveted this glass, remarkable for its luscious color. In the mid-1850s, he persuaded the Italian chemist Leopold Bonafede (1833–1878) to work at the Imperial Glassworks, established in 1777 to provide glassware for the court. By 1867, the Imperial Glassworks were displaying rare purpurine pieces at the Paris Exposition Universelle, and they supplied this glass to Fabergé until 1880, when the firm developed its own version.[1]

Easter, the most important holy day in the Russian Orthodox calendar, was elaborately celebrated. These tazze may have graced an Easter table. Finely crafted gilded bronze putti are perched on the edges of the bowls and hold tiny nests filled with eggs. They resemble the silver cherubs holding the 1892 Imperial Diamond Trellis Egg and the putti perched on the 1910 Imperial Colonnade Egg, which portray Imperial children. The putti on these tazze dissolve into finely chased acanthus leaves, which curl down the bowl. The gilded bronze figures and ornamentation may possibly be attributed to Julius Alexandrovich Rappoport (1851–1917), who oversaw silver production for the House of Fabergé.

NOTE

1 Karen L. Kettering, *Russian Glass at Hillwood* (Washington, D.C., 2001), 63.

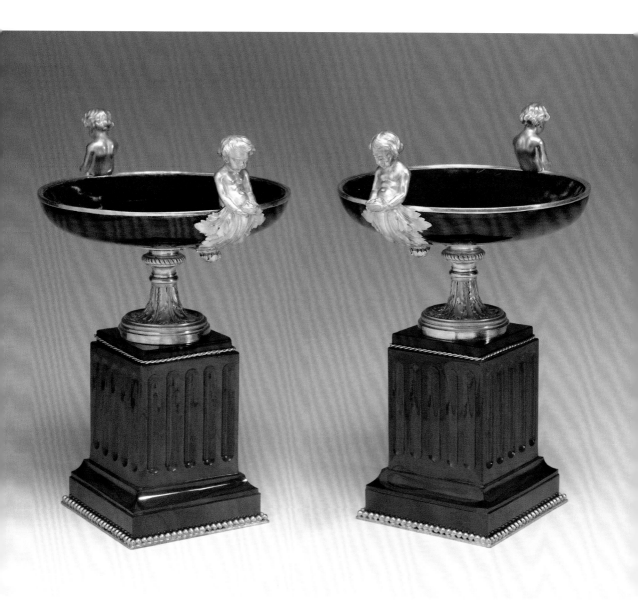

51 Oval box with monogram of Tsar Nicholas II

Peter Carl Fabergé (Russian, 1846–1920); Henrik Emanuel Wigström, workmaster
(Finnish, 1862–1923)
St. Petersburg, early 20th century
Nephrite, gold (56 *zolotnik* [14 karat]), diamonds, enamel
1¾ × 3½ × 2⅝ in. (4.4 × 9 × 6.7 cm)

Provenance: Alexandre Polovtsoff; Henry Walters, ca. 1929–30; The Walters Art Museum,
1931, by bequest, 57.1047

From the eighteenth century, presentation boxes or snuffboxes were a traditional
way for a tsar to recognize important retainers and foreign diplomats for their
service. To signify the importance of the gift, each box was personalized with a
painted miniature, the cipher of the monarch, or a state insignia.[1]

The imperial cipher of Nicholas II decorates the lid of this box. The Cyrillic
"N" surmounted by a miniature Imperial crown is worked in tiny diamonds.
Repeating ovals are found in the shape of the box, in the rose-cut diamond
frame, and in the white translucent enamel cartouche on which the cipher is
mounted. This pleasing synchronicity is attributable to Henrik Wigström, one
of Fabergé's leading workmasters, who was responsible for the creation of many
Imperial Eggs.

The highly polished box is made of nephrite, a spinach-colored jade, mined
in Russia's Lake Baikal area from the eighteenth century. This hardstone was
favored by the House of Fabergé for all sorts of fine objects. Swags of green-gold
laurel leaves, a sign of royalty, complete the design of the box.

Alexandre Polovtsoff was a connoisseur who recognized quality and under-
stood the historical importance of objects. As a purported cousin of Nicholas II,
he would have found artistic and sentimental appeal in this box.

NOTE
1 Ulla Tillander-Godenhielm,
"Brief Overview of the Russian
Imperial Award System," in *The
Era of Fabergé* (Finland: Tampere
Museums Publications 91, 2006),
140, 143.

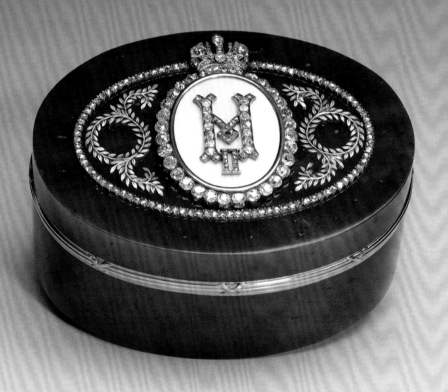

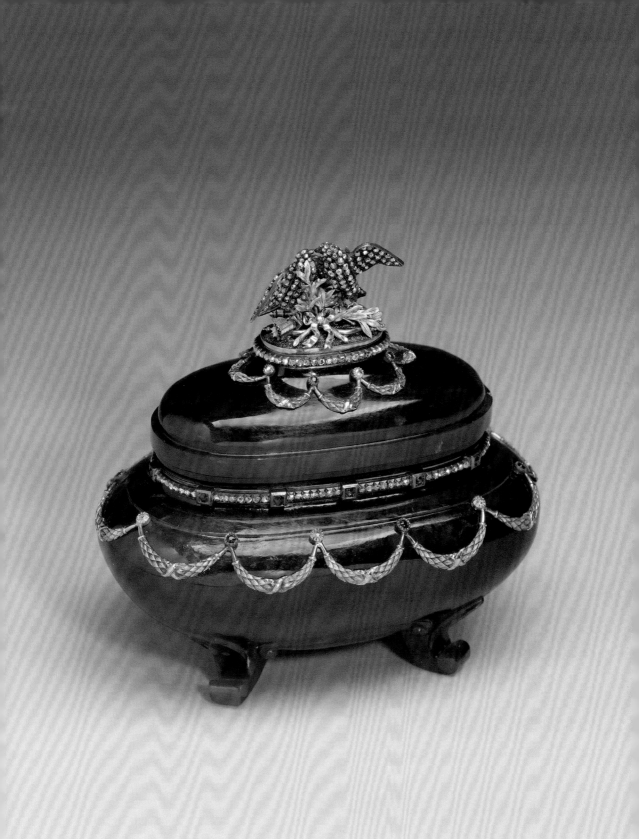

52 Urn with cover

Peter Carl Fabergé (Russian, 1846–1920)
St. Petersburg, early 20th century
Nephrite, gold, rubies, diamonds
3¾ × 3⅞ × 2½ in. (9.5 × 9.8 × 6.2 cm)

Provenance: Alexandre Polovtsoff; Henry Walters, 1929–30;
The Walters Art Museum, 1931, by bequest, 57.913

This miniature urn on turned feet is carved from nephrite, a deep green hard-stone, valued for its translucency. It was first discovered in Siberia in 1826, and additional deposits were uncovered in the 1850s. The House of Fabergé favored it for accessories, making nephrite objets d'art highly fashionable.

In many cultures, the urn shape corresponds to the world of feminine things.[1] Turtle doves, a traditional symbol of love and affection, nest on the lid (fig. 52.1). The love birds are worked in pavé-set, rose-cut diamonds and are reminiscent of those found on popular nineteenth-century jewelry such as brooches and bar pins. Their nest is a confection of Cupid's arrows and green-gold laurel branches tied with a rose-gold ribbon, symbolizing royalty, and, secondarily, fecundity.

The turtle doves emulate the embrace of the putti on the Orlov potpourri vase (cat. no. 21) and are nearly identical to the platinum turtle doves nesting on the inside of the gazebo of the 1910 Imperial Colonnade Egg. The gold swagged garlands on the cover punctuated by alternating cabochon rubies and diamonds are mirrored on the base. At the rim, the band of rose-cut diamonds accented by cabochon rubies indicates where the box opens. The urn is unmarked, which is typical of Fabergé hardstone pieces. The fine quality of the workmanship, coupled with the urn's symbolism, points to it being an Imperial commission.[2]

NOTES
1 J. E. Cirlot, *A Dictionary of Symbols* (New York, 1971), 358.
2 Walters Art Museum Online, 57.913: Urn with Cover, http://art. thewalters.org/detail/28720/urn-with-cover/ (accessed November 9, 2015).

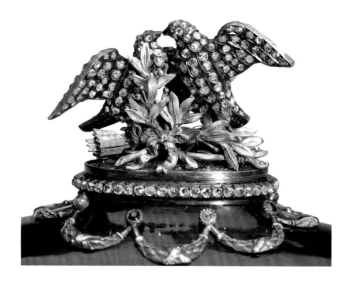

Fig. 52.1. Cat. no. 52, detail of lid.

154

53 Rhinoceros

House of Fabergé
St. Petersburg, ca. 1900
Mottled red jasper
2⅜ × 4⅝ × 1⅝ in. (6.1 × 11.8 × 4.2 cm)

54 Chimpanzee

House of Fabergé
St. Petersburg, ca. 1900
Banded agate, silver gilt, diamonds
2½ × 1⅝ × 1⅞ in. (6.4 × 4.2 × 5 cm)

55 Anteater

House of Fabergé
St. Petersburg, ca. 1900
Jasper, diamonds
1⅛ × 3½ × ¾ in. (3 × 8.7 × 2.1 cm)

56 Hippopotamus

House of Fabergé
St. Petersburg, ca. 1900
Nephrite, diamonds
1⅛ × 2 × 1¼ in. (2.9 × 5.1 × 3.1 cm)

Provenance: Henry Walters, 1900; The Walters Art Museum, 1931, by bequest,
27.480, 42.353, 42.354, 42.355

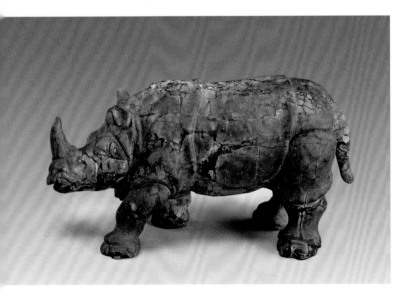
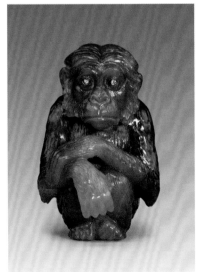

During a trip to St. Petersburg in 1900, Henry Walters purchased this group of hardstone animals at the newly opened Fabergé store. Henry's father was one of the first collectors of Asian art in America, and Henry continued to build this part of the family's collection. He would therefore have been attuned to the reference to Japanese *netsuke*s, or sash fobs, in these pieces. According to one estimate, Carl Fabergé formed a collection of more than 500 netsuke, and sometimes specific works are referenced in carvings by his workshop. Henry selected exotic animals for his menagerie: an anteater, a rhinoceros, a chimpanzee, and a hippopotamus. With the exception of the rhinoceros, these creatures all have diamond eyes. Great skill was used in selecting hardstones that sometimes mimic the markings and textures of the animals portrayed. This is particularly noticeable in the matte and coarse texture of the mottled red jasper used for the rhinoceros, and variegated browns in the banded agate used for the chimpanzee.

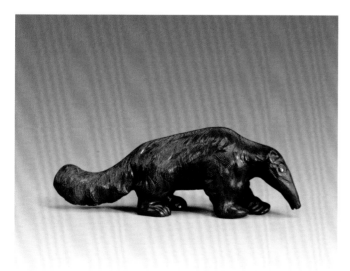
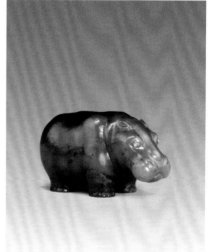

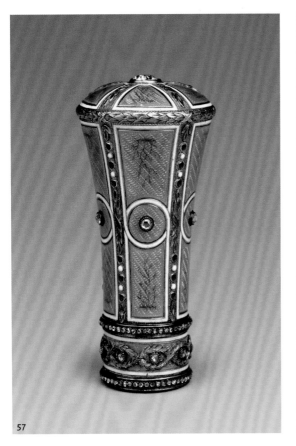

57

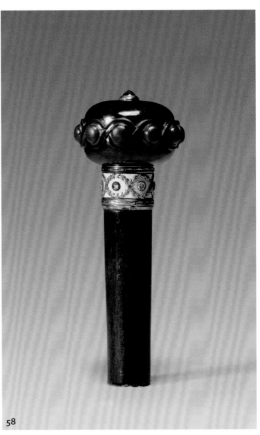

58

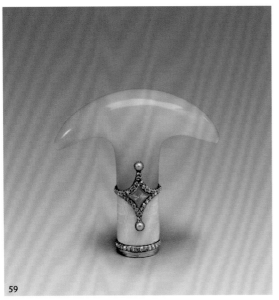

59

59 (in case)

57 Parasol handle

House of Fabergé, Mikhail Perkhin, workmaster (Russian, 1860–1903)
St. Petersburg, ca. 1900
Pink enamel on guilloché gold, diamonds
2¾ × 1½ in. (7.1 × 3.6 cm)

Provenance: Henry Walters, 1900 (purchase from the factory); Jenny Walters
(Mrs. Warren Delano III), 1900, by gift; Laura F. Delano; The Walters Art Museum,
1950, gift of Laura F. Delano, 44.621

58 Parasol handle

House of Fabergé, Mikhail Perkhin, workmaster (Russian, 1860–1903)
St. Petersburg, ca. 1900
Gold (56 *zolotnik*), guilloché enamel, diamonds, nephrite, lapis lazuli, sapphires
1¾ × 1¾ in. (4.5 × 4.5 cm)

Provenance: Henry Walters, 1900 (purchase from the factory); Jenny Walters
(Mrs. Warren Delano III), 1900, by gift; Laura F. Delano; The Walters Art Museum,
1950, gift of Laura F. Delano, 57.1841

59 Parasol handle

House of Fabergé, Mikhail Perkhin, workmaster (Russian, 1860–1903)
St. Petersburg, ca. 1900
Guilloché and *quatre-couleur* gold, jade, enamel, diamonds, pearls
2 × 2 in. (5.1 × 5.1 cm)

Provenance: Henry Walters, 1900, by purchase; Mrs. Frederick B. Adams, by gift;
Walters Art Museum, 1956, by gift, 57.1862

In the early years of the twentieth century, Henry Walters made several forays to ever broader European and Middle Eastern art-markets on board his grand steam yacht, *Narada*. In 1900, he sailed to St. Petersburg and was among the first Americans to visit the newly opened store of Carl Fabergé. Here he purchased parasol handles for his nieces, and hardstone animals for himself (cat. nos. 53–56). The three parasol handles are luxurious yet functional objects, combining enamels, gems (diamonds and sapphires), and hardstones (jade, nephrite, and lapis lazuli). Fabergé made these pieces in great variety, using different shapes and colors, as seen in the three very individualistic handles purchased by Walters. As parasols would have been carried at a range of outdoor social functions, they were the perfect place to showcase the wealth, taste, and refinement of the owners. The boxed example suggests that it was made to be fitted to a parasol of the possessor's choosing, and that it might have been used interchangeably with different sunshades.

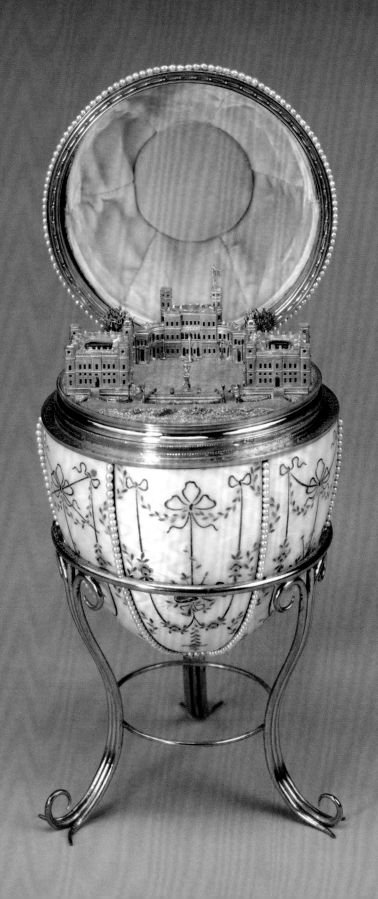

60 Gatchina Palace Egg

Peter Carl Fabergé (Russian, 1846–1920); Mikhail Evlampievich Perkhin, workmaster
(Russian, 1860–1903)
St. Petersburg, 1901
Gold, *en plein* enamel, silver gilt, portrait diamonds, rock crystal, seed pearls
5 × 3¼ in. (12.7 × 9.1 cm)

Provenance: Tsar Nicholas II, St. Petersburg; Dowager Empress Maria Feodorovna, St. Petersburg,
April 1, 1901, by gift (retained in Anichkov Palace until 1917); Alexandre Polovtsoff, Henry Walters, 1930;
The Walters Art Museum, 1931, by bequest, 44.500

Gatchina Palace bears the imprint of many Romanov tsars and empresses.
Catherine the Great's favorite, Count Grigori Grigorevich Orlov, had the palace
built on land 28 miles (45 km) south of St. Petersburg given to him by the
empress. After his death in 1783, she purchased it and presented it to her son,
Paul I. He adored conducting military maneuvers and directed that the meadow
in front of the palace be turned into a parade ground.

The palace is the central theme of this Fabergé Imperial Egg, presented
to Maria Feodorovna by her son Nicholas II for Easter 1901. Alexander III
(r. 1881–94) moved his young family to Gatchina in 1881 (fig. 61.1). The tsar's
father, Alexander II (r. 1855–81), had recently been assassinated, and his advisors
felt the family would be safer outside St. Petersburg. The Gatchina Palace Egg
commemorates the twentieth anniversary of this move and would have had
sentimental meaning to both Maria Feodorovna and Nicholas II, who grew
up largely at Gatchina. Solidifying the importance of Gatchina to the dowager
empress Maria Feodorovna is the fact that she was the patroness of Gatchina
Palace and parks as well as of the neighboring city of Gatchina.

Fig. 60.1. Tsar Alexander III of Russia (r. 1881–94)
with his wife, Maria Feodorovna, and their children,
Nicholas, Xenia, George, Michael, and Olga, St.
Petersburg, October 17, 1888.

160

The shell of the egg (fig. 60.2) is in the eighteenth-century French rococo taste. Watered white "silk" enamel panels, intersected with rows of tiny seed pearls, are engraved and painted in delicate pink, green, and white enamel with art and science trophies, an allusion to Maria's interests, suspended from garlands and bows.

The egg's surprise is the minutely detailed four-color gold replica of the palace (fig. 60.3). A miniature statue of Paul I continues to reign over the parade ground, the original monument having been erected by his son Nicholas I in honor of his father. Other finely wrought details include rock-crystal windows, tiny military cannons, the Russian flag (indicating that a member of the royal family was in residence), electric lampposts (an innovation added by Alexander III), and landscaping that includes trees and parterres. Portrait diamonds decorate the apex and base, and may once have covered enamel roundels with the date and the empress's monogram. The original invoice records that the egg cost 5,000 rubles.[1]

How this Imperial Egg came to the West is unknown. Alexandre Polovtsoff grew up with the future Nicholas II and would have been familiar with the tradition of the Fabergé Imperial Easter Eggs. He undoubtedly saw the Gatchina Palace Egg and others at the 1902 exhibition at the Von Dervis mansion in St. Petersburg and after the revolution, Polovtsoff made an inventory of the Gatchina Palace.[2] This egg was kept at the Anichkov Palace, Maria Feodorovna's St. Petersburg residence, until 1917.[3] Once the Imperial Egg was in Polovtsoff's possession, the scholar–dealer must have shown it to Henry Walters, knowing it would become a masterpiece of the Walters Art Museum.

NOTES
1 Tatiana Fabergé, Lynette G. Proler, and Valentin V. Skurlov, *The Fabergé Imperial Easter Eggs* (London, 1997), 154.
2 Ibid., 54–55.
3 Ibid., 154.

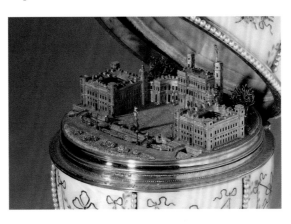

Fig. 60.3. Cat. no. 60, open

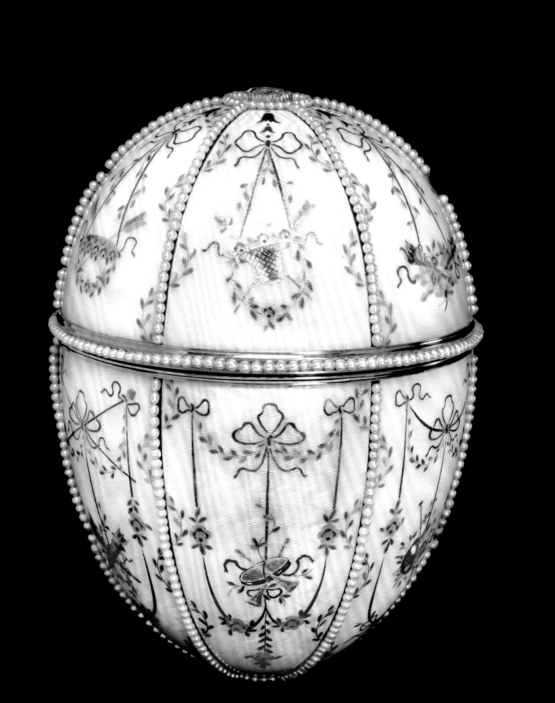

61 Rose Trellis Egg

Peter Carl Fabergé (Russian, 1846–1920); Henrik Emanuel Wigström, workmaster
(Finnish, 1862–1923)
St. Petersburg, 1907
Gold, enamel, diamonds
3 × 2¼ in. (7.7 × 5.9 cm)

Provenance: Tsar Nicholas II, Anichkov Palace, St. Petersburg, April 21, 1907, by purchase; Tsarina Alexandra Feodorovna, Anichkov Palace, St. Petersburg, April 22, 1907, by gift; Kremlin Armory, 1917 (transferred by the Kerensky government from the palace to the armory); Alexandre Polovtsoff; Henry Walters, 1930; Walters Art Museum, 1931, by bequest, 44.501

Nicholas II and Alexandra celebrated their first Easter as a married couple in 1895. In that year, Nicholas, following the tradition set by his father, gave his empress a jeweled Fabergé egg secreting a yellow enamel rosebud to celebrate the holy day, the egg being a symbol of new life. In 1907, the theme of roses, symbolic of love in the language of flowers, was taken up again. In this egg, pink roses bloom on a diamond-set trellis against a spring-green translucent enamel ground.

Empress Alexandra was fond of fresh flowers. She commissioned greenhouses that provided her favorite residence, the Alexander Palace, with flowers, even in the depths of a Russian winter. Roses had been the privilege of nobility since the time of Catherine the Great, and the pink rose decorating the Rose Trellis Egg is a miniature example of one of Alexandra's favorites: the Baronne Adolphe de Rothschild rose, first bred in France in the 1860s.[1] It is characterized by large, round

NOTE

1 Bob Atchinson, "A Romanov Passion for Flowers," http://www.alexanderpalace.org/palace/blog.html?pid=1213306016379451 (accessed December 8, 2015).

Fig. 61.1. Cat. no. 61, with impression of necklace on lined interior.

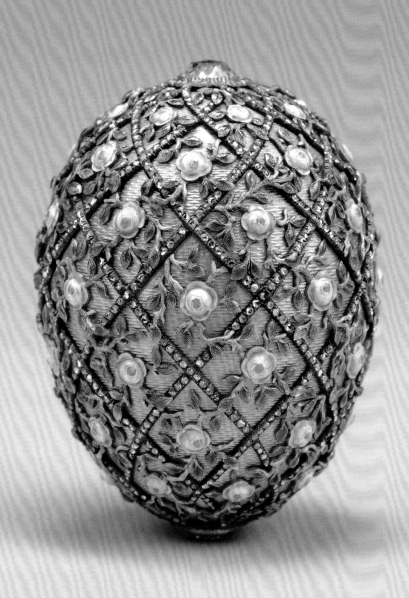

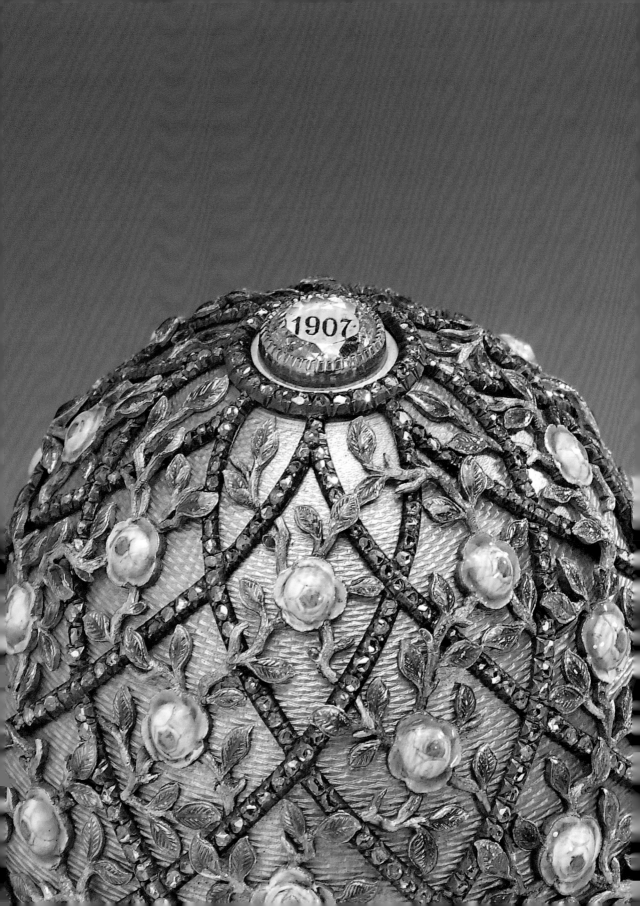

pink blossoms with shallow cupped petals. It blooms along long arching thorny branches, which require a trellis, and has a delicate scent. Keeping with Russian tradition that favors an uneven number of blossoms, the egg has forty-nine.

Many of the Imperial Eggs open up to reveal tiny surprises. In Fabergé's invoice, the 1907 surprise is described as a "diamond necklace with medallion and miniature of His Imperial Highness the Grand Duke Tsarevich Alexei Nikolaievich," now lost.[2] The bill shows that the Easter gift cost the tsar 8,300 rubles.

The Russo-Japanese War engulfed the nation in 1904–5, and there were no celebratory eggs presented in those years, thus the delay in this Imperial Egg, which commemorated the birth of the long-awaited heir in 1904. The egg is securely dated 1907 under the portrait diamond at the base; the apex holds a second portrait diamond with the date (fig. 61.2).

Henry Walters acquired this treasure from Alexandre Polovtsoff, who was possibly a distant cousin of Nicholas II. Polovtsoff's mother was purported to have been the illegitimate daughter of Tsar Nicholas I's brother Michael, and his father served as Alexander III's Secretary of State. The young Polovtsoff was present at the Alexander III's funeral and the wedding of Nicholas II and Alexandra in 1894.[3] Given his connections to the Imperial family, it is not surprising that Polovtsoff would have taken particular care in placing this Imperial treasure with an American collector who had embarked on forming a museum.

NOTES
2 Tatiana Fabergé, Lynette G. Proler, and Valentin V. Skurlov, *The Fabergé Imperial Easter Eggs* (London, 1997), 176.
3 Alexandre Polovtsoff, "Memoirs," December 1934 (unpublished), trans. Olga Savin, 7. Sincere thanks to Anne Benson for arranging for the translation and providing a copy to the author and for all her research on A. Polovtsoff.

62 Dish with images of Moscow landmarks

Fedor Ivanovich Rückert (Russian, 1840–1917) for the House of Fabergé
Moscow, ca. 1907
Silver gilt, painted filigree and *en plein* enamel, cabochon amethysts, citrines
⅞ × 6 in. (2.2 × 15.2 cm)

Provenance: Jean M. Riddell, Washington, D.C.; The Walters Art Museum, 2010, gift in memory of Jean M. Riddell, 44.896

NOTES

1 Anne Odom, *Russian Enamels: Kievan Rus to Fabergé* (Baltimore, Washington, D.C., and London, 1996), 46.

2 Anne Odom, *Russian Silver in America: Surviving the Melting Pot* (Washington, D.C., and London, 2011), 39. Rückert also worked with other firms such as Kurliukov and Marshak.

3 Irina V. Potkina, "Moscow's Commercial Mosaic," in James L. West and Iurii A. Petrov, eds., *Merchant Moscow* (Princeton, N.J., 1998), 43.

At the center of this souvenir dish is a magisterial repoussé double-headed eagle, the emblem of Imperial Russia. Famous Moscow monuments are painted in enamel *en grisaille* (in gray tones) to imitate photographs. They include the Tsar Cannon (fig. 62.1) and Bell; the Victory Arch, symbolic of victory over Napoleon; and a monument to Dmitry Pozharsky and Kuzma Minin, the Russians who repelled the Polish–Lithuanian forces in 1612 to end the "Time of Troubles," a warring period between the reign of Boris Gudonov (r. 1598–1605) and the establishment of the Romanov dynasty in 1613. Alternating with the images are brightly painted flowers in the Usolsk enamel tradition. Usolsk is the old name for the northern Russian town of Solvychegodsk, where this type of painted enamel originated in the seventeenth century.[1] Nineteenth-century enamelists looked to the past for motifs, and these baroque blossoms became a stock item (see cat. nos. 45 and 55). The blossom with the swirling petals has a distinctly Persian feeling, Persia having been a trading partner with Russia via Kiev from Russia's earliest days.

Rückert, who specialized in enamels in the Russian Revival style, regularly supplied Fabergé with this kind of work.[2] The deep red, green, and blue were a favored enamel palette, and, as in the *kovsh* (cat. no. 55), the panels are separated by miniature columns topped by jeweled capitals of cabochon citrines and amethysts. The dish is inscribed in German with the sentiment "heartfelt friendship" from L. & L. Metzl. By the last quarter of the nineteenth century, Moscow was a thriving commercial center. Advertising became an essential tool to help the merchant class grow their businesses. One of the first advertising firms was L. & E. Metzl & Co., founded in 1878.[3] This dish may have been a business gift and souvenir of Moscow from the Metzls to a German client.

Fig. 62.1. Late 19th-century postcard showing the Tsar Cannon (1586) on the grounds of the Moscow Kremlin.

63 Beaker

Firm of Pavel Ovchinnikov (Russian, 1830–1888)
Moscow, 1908–17
Silver, silver gilt, plique-à-jour enamel, metal
9⅞ × 5½ in. (25 × 13.8 cm)

Provenance: Jean M. Riddell, Washington, D.C.; The Walters Art Museum, 2010,
gift in memory of Jean M. Riddell, 44.778

Pavel Ovchinnikov used a traditional form with a revival technique in this showy Russian Revival-style beaker. Its shape imitates that of a seventeenth-century silver cup (cat. no. 16), but it is made entirely of plique-à-jour enamel. Ovchinnikov was responsible for reviving this type of enamel, and it became a hallmark of his work.

Plique-à-jour (translated from the French as "letting in daylight") is an ancient technique, known to have been used in Byzantium and in Kievan Rus', two areas linked by trade. In this beaker, tiny silver wires, which hold the enamel in place and were later gilded, are worked in many different patterns, such as the fish scales around the red enamel or circles for the blue enamel running around the rim. Transparent red enamel was known to be technically difficult to achieve.[1] The beaker was made in two sections: the base and the large flaring glass.

In 1853, Pavel Ovchinnikov, a freed serf, founded his workshop in Moscow. It included a school to train students in the arts of silversmithing and enamel work.[2] At the same time, Fedor G. Solntsev published his six-volume *Antiquities of the Russian State* (1849–53), which was instrumental in giving rise to the Russian Revival style for which Ovchinnikov was known. By the early 1880s, three hundred people worked at the Ovchinnikov factory. Works of the firm were featured at the All-Russian Exhibitions of 1865 and 1882, held in Nizhni Novgorod.

In the beaker, *kokoshnik*-shaped frames hold cartouches that recount unidentified folk tales. A figure astride a sea monster with a turtle swimming in the opposite direction, a warrior with a saber at his waist poised to shoot a bow and arrow, and a stork at sunset fill separate "windows." Butterflies and dragonflies flit among them. A butterfly, naturally attracted to the light, is forever constrained in the plique-à-jour base (fig. 63.1).

Fig. 63.1. Cat. no. 63,
detail of bottom.

NOTES

1 Alexander von Solodkoff, *Russian Gold and Silverwork, 17th–19th Century* (New York, 1981), 208.
2 Anne Odom and Jean M. Riddell, "Old Russian Style Enamels," *Apollo*, May 1986, 334.

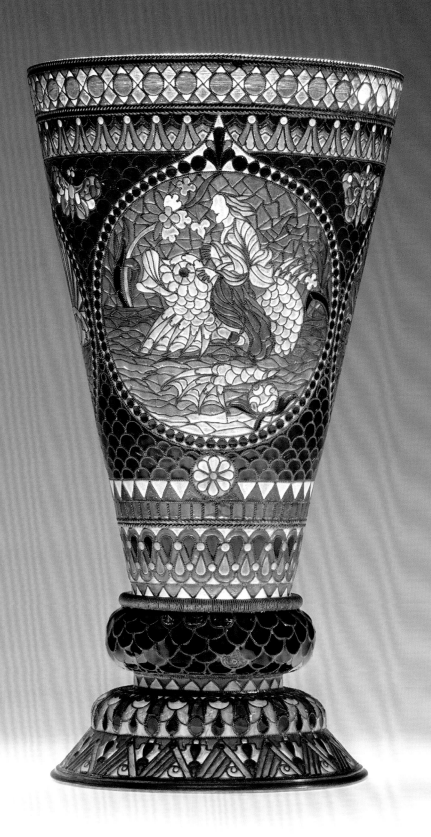

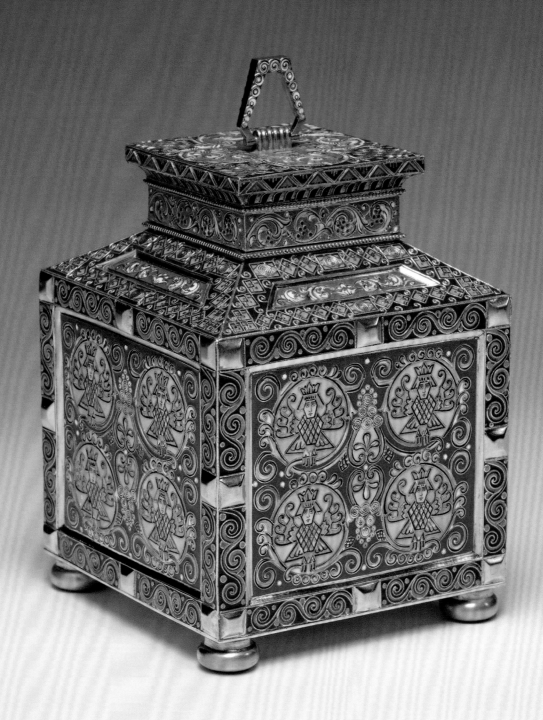

64 Tea caddy

Fedor Ivanovich Rückert (Russian, 1840–1917) for the House of Fabergé
Moscow, 1908–17
Silver gilt, filigree enamel, cork
6¼ × 4⅝ × 4⅝ in. (15.8 × 11.8 × 11.8 cm)

Provenance: A La Vieille Russie, New York; Jean M. Riddell, Washington, D.C., 1983;
The Walters Art Museum, 2010, gift in memory of Jean M. Riddell, 44.912

Tea was introduced to Russia in 1638 when the Mongolian khan sent Tsar Michael I
(r. 1613–45) a diplomatic gift of 250 pounds (113.4 kg) of tea. By the nineteenth
century, tea drinking was an integral part of the culture. The ritual of tea requires
accessories: tea sets, strainers, and canisters, or caddies, to preserve the leaves.
This example in the Russian Revival style was made by Fedor Rückert and sold
through the House of Fabergé. The design has its origins in Byzantine fabrics
that favored overall repeating motifs. Here, medallions of sirens—half-bird,
half-woman—cover the panels of the canister. Their forerunners date to the early
thirteenth century and are found in stone carvings on the Cathedral of St. George
in Yuriev-Polski.[1] Their song is one of temptation—in this instance that of tea.

 The top (fig. 65.1) is worked in a quatrefoil design, with each corner display-
ing a stylized *Camellia sinensis*, or tea plant. When the exterior lid is removed,
a second lid is revealed, which keeps the tea airtight. The second lid has a thin
parcel-gilt cutwork handle in a modern Viennese Secessionist style, affirming
that the artisans of the time were in touch with European art styles and trends.
The handle elegantly folds down to accommodate the exterior lid.

 Although small in size, the tea caddy has architectural precedents in its
stepped construction, the inset panels framed with columns punctuated by
silver-gilt studs, and the whole resting on ball feet. A miniature house, it
resembles a *teremok,* or the
residential quarters at the
top of a palace where only
women were allowed.[2] This
Russian Revival-style caddy
is a lovely conceit, celebrat-
ing women and the ritual of
taking tea.

NOTES
1 Tamara Talbot Rice, *A Concise
 History of Russian Art* (New York,
 1963), 33.
2 Anne Odom, *Russian Enamels:
 Kievan Rus to Fabergé* (Baltimore,
 Washington, D.C., and London,
 1996), 98.

Fig. 64.1. Exterior lid of cat. no.
64, showing stylized tea plant in
each corner.

65 Cigarette box with miniature of Konstantin Makovsky's *Blind Man's Buff*

Fedor Ivanovich Rückert (Russian, 1840–1917) for the House of Fabergé
Moscow, 1908–17
Silver gilt, painted filigree and matte enamel
1½ × 3⅝ × 2½ in. (3.7 × 9.3 × 6.5 cm)

Provenance: Jean M. Riddell, Washington, D.C.; The Walters Art Museum, 2010,
gift in memory of Jean M. Riddell, 44.915

"Blind Man's Buff" (buff meaning a slight push) was a popular parlor game in the late nineteenth century. The matte enamel-painted miniature on the lid of this cigarette box is an exact copy of the popular painting of the same title by Konstantin Makovsky (1839–1915). Picturesque genre paintings such as this embodied the fantasy image of "Old Russia" (fig. 65.1) embraced by the court in the costume ball of 1903 at the Winter Palace and were replicated on everything from menus to sheet music covers to items such as this cigarette box.

The Kremlin Terem Palace, the main residence of the Russian tsars in the seventeenth century, had been restored under the guidance of Fedor G. Solntsev in 1837 and became the model for the interior depicted.[1] Its arched ceiling, Dutch-style tile stove, Persian carpet, and furnishings bedecked with silver-gilt drinking cups and bowls similar to examples shown in this book (cat. nos. 8, 9, and 17) provide the setting for this playful game. All of the participants with the exception of the blindfolded person ("It" in the game) are frozen in place.

Young boys hold switches to distract "It," and a woman ducks so as not to be discovered. In the far reaches of the scene, a bench has been overturned, a child gets into mischief, and a visitor admires a baby held by her wet nurse.

The top of the enamel box forms an elaborate frame around the miniature. Characteristic of Rückert's work, rows of tiny filigree spirals in the center concentrate attention on the unfolding drama, and mountain-like shapes repeat those found in the arched ceiling. Stylized miniature *teremok* (the women's quarters in a palace) decorate the front panel; the side panels are festooned with stylized *kokoshniki*.

Fedor Rückert worked in this characteristically revivalist style and provided stock for the House of Fabergé. In 1912, Rückert and Fabergé celebrated twenty-five years of working together.[2]

Fig. 65.1. Grand Duchess Elisabeth Feodorovna in the costume of a 17th-century princess at the Costume Ball, Winter Palace, St. Petersburg, February 1903. Reproduced from *Albom kostiumirovannago bala v Zimnem Dvortsiev fevralie 1903* (*Album du bal costumé au Palais d'Hiver, février 1903*). St. Petersburg: Ekspeditsiia agotovleniiagos bumag, 1904. Library of Congress, Washington, D.C.

NOTES
1 Anne Odom, *Russian Enamels: Kievan Rus to Fabergé* (Baltimore, Washington, D.C., and London, 1996), 160.
2 Anne Odom, *Fabergé at Hillwood* (Washington, D.C., 1996), 112.

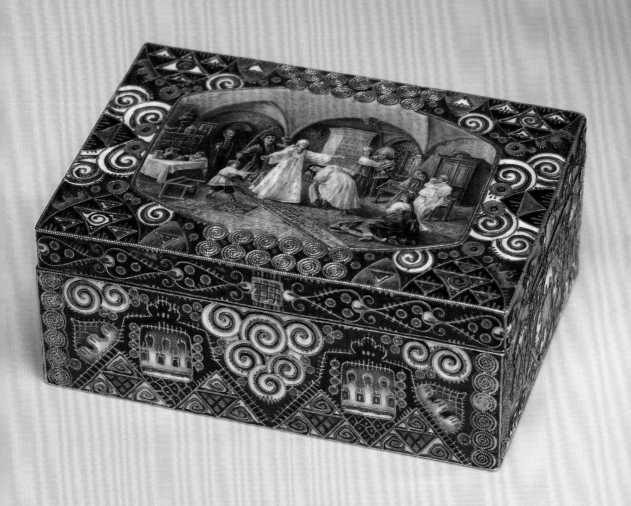

66 Box with a miniature of Viktor Vasnetsov's *Warrior at the Crossroads*

Fedor Ivanovich Rückert (Russian, 1840–1917) for the House of Fabergé
Moscow, 1908–17
Silver gilt, filigree shaded and painted matte enamel
1⅞ × 3 × 2 in. (4.3 × 7.6 × 5.1 cm)

Provenance: Jean M. Riddell, Washington, D.C.; The Walters Art Museum, 2010,
gift in memory of Jean M. Riddell, 44.917

This box is a perfect marriage of enamel work in the Russian Revival style with a miniature on its lid alluding to Kievan Rus', a medieval East Slavic state with Kiev at its center.

Warrior at the Crossroads (fig. 67.1) by Viktor Vasnetsov (1848–1926) was an immensely popular painting when it was first shown in 1882. The painting depicts the twelfth-century warrior Il'ia Muromets, a hero of Russian folk tales, on a battlefield where he and his horse mournfully survey the cost of war, symbolized by a skull and the setting sun. The warm matte tones of the painting were achieved by a technique known as "stoning" the enamel, a specialty of Rückert's.[1] His workshop had to seek permission to copy Vasnetsov's painting, and it produced several similar boxes reproducing this picture.[2]

The miniature is framed with shapes imitating the warrior's helmet. Unusual asymmetrical silver filigree work impinges on the painted surface, its abstract patterns providing both a medievalizing and a modernistic effect. Fedor Rückert may have been looking at the work of the Viennese Secessionists, a group founded in 1897, whose first president was the painter Gustav Klimt. The group produced a magazine, *Ver Sacrum*, which featured contemporary designs by its members and which Rückert may have seen. The era was alive with colliding art movements, such as Art Nouveau, Arts and Crafts, and *stil moderne*.

The box's front panel shows a ferocious griffin with a curling red tongue devouring a snake, a folkloric symbol of strength defeating adversity. Birds proliferate on the box: a string of stylized black birds flanked by two swans appears on the front panel, and on each side panel, two birds of prey.

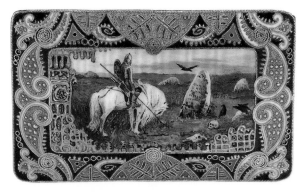

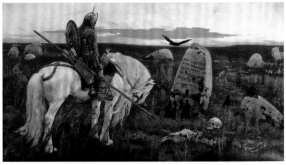

Fig. 66.1. Lid of cat. no. 66.

Fig. 66.2. Viktor Vasnetsov (Russian, 1848–1926), *Warrior at the Crossroads*, 1882. Russian State Museum, St. Petersburg.

NOTES

1 Anne Odom and Jean M. Riddell, "Old Russian Style Enamels," *Apollo*, May 1986, 336.

2 Anne Odom, "A Key to the Past: Fedor Rückert's Miniature Picture Gallery," *Apollo*, January 1993, 25.

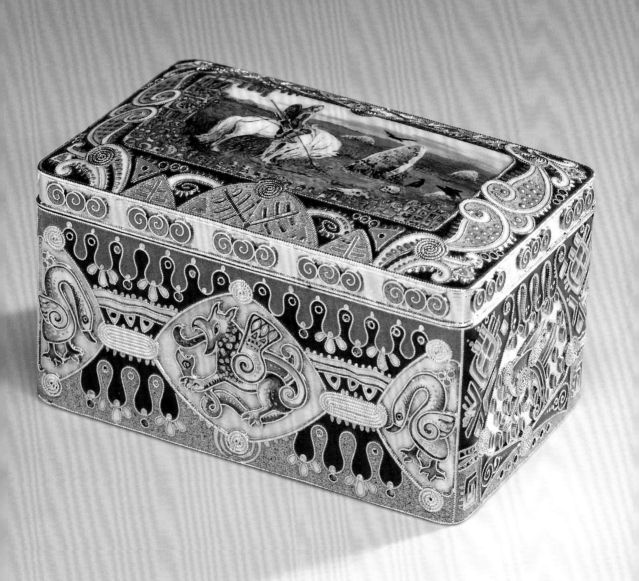

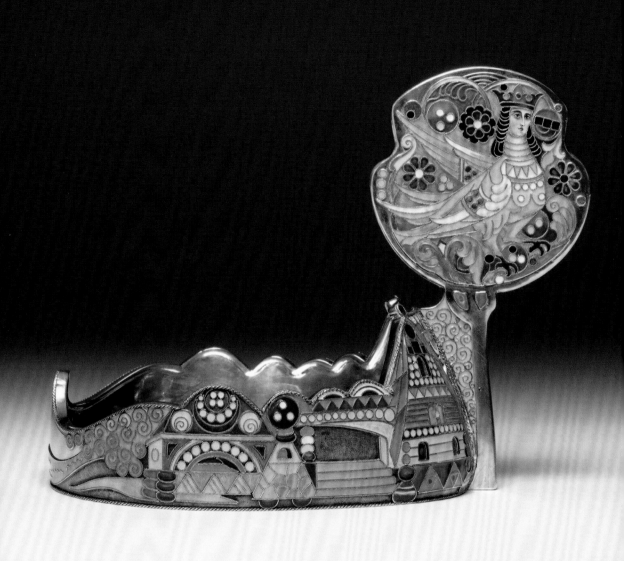

67 *Kovsh*

Firm of Ivan Khlebnikov (Russian, active 1870–1917)
Moscow, 1908–17
Silver gilt, filigree and painted enamel
5⅜ × 7⅛ × 4⅝ in. (13.6 × 18 × 11.8 cm)

Provenance: Leo Kaplan, New York; Jean M. Riddell, Washington, D.C., 1978; The Walters Art Museum, 2010, gift in memory of Jean M. Riddell, 44.798

Nikolai Rimsky-Korsakov premiered the opera *The Legend of the Invisible City of Kitezh and the Maiden Fevroniya* in St. Petersburg in 1907, and the following year in Moscow. According to legend, the city of Kitezh disappeared underwater to save itself from the Tartar invasion. In the final act of the opera, the maiden Fevroniya falls asleep in the forest and has a vision of blossoms, candles, and fairy songbirds in a tree. The mythical bird of sorrow, Alkonost, appears to tell her she must die. Her counterpart, a Sirin, a mythic bird with the head and breasts of a woman, arrives to promise her immortality. Her prince then leads her to the invisible city of Kitezh for their wedding.[1]

The Khlebnikov firm took inspiration from the opera to create this unusual decorative *kovsh*. The bird–woman perched regally in a silver-gilt flowering tree above the town of Kitezh could be interpreted as either Alkonost or the Sirin; the two lived together in the mythical underworld and shared common traits of the head of a beautiful woman and the body of a bird.

The city is laid out on the surface of the bowl like a stage set, with wooden buildings reminiscent of the medieval architecture of the town of Nizhni Novgorod, and bridges, through which water courses. The folkloric quality of the design, with its bright colors and blocklike toy architecture, mirrors the spirit of set designs by Konstantin Korovin and Apollinary Vasnetsov, who were members of the Abramtsevo Circle. This community, under the patronage of the wealthy industrialist Savva Mamontov, was committed to the resurgence of Russian folk arts, crafts, and themes.[2]

The legend was also embraced by "Old Believers," who rejected Russian Orthodoxy in the seventeenth century. The *kovsh* may have had an underlying religious meaning: a person could look away from the established Church toward another spiritual community.

NOTES
1 Anne Odom, *Russian Enamels: Kievan Rus to Fabergé* (Baltimore, Washington, D.C., and London, 1996), 144.
2 Joseph C. Bradley, "Merchant Moscow after Hours: Voluntary Associations and Leisure," in *Merchant Moscow: Images of Russia's Vanished Bourgeoisie*, ed. James L. West and Iurii A. Petrov (Princeton, N.J., 1998), 139.

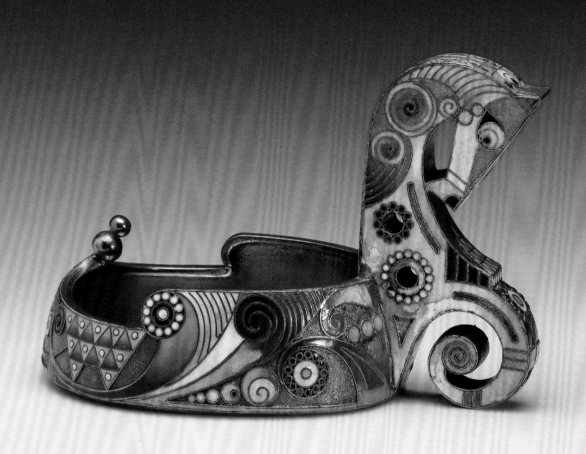

68 *Kovsh*

Firm of Ivan Khlebnikov (active 1870–1917)
Moscow, 1908–17
Silver gilt, painted filigree enamel
$3\frac{1}{4} \times 4\frac{7}{8} \times 3\frac{1}{8}$ in. (8.4 × 12.7 × 8 cm)

Provenance: Jean M. Riddell, Washington, D.C.; The Walters Art Museum, 2010, gift in memory of Jean M. Riddell, 44.797

Although originally peasant drinking cups carved of wood, by the early seventeenth century, because of their sentimental association with peasant culture, *kovshi* were crafted in fine metals as presentation gifts (cat. nos. 12, 13, and 17). In the nineteenth century, there was a revival of interest in peasant crafts and forms. Silversmiths such as Ivan Khlebnikov turned out distinctive *kovshi* in the *stil moderne*, a style that was influenced by Art Nouveau, but incorporated the modernism and solidity later found in 1920s Art Deco.

This *kovsh* is fashioned as a hippocampus or half horse, half sea creature, replacing the traditional bird form.[1] The head and hooves serve as the handle. This mythical creature appears to stride the waves, which undulate in a circular motion over the curvilinear body of the bowl and wash up on land, defined by the matted gold "sand" and chevron patterns resembling evergreens. The filigree enamel colors were chosen to suggest earth, sea, and sky. The enamel patterns in repeating circles, echoed in the circular motion of the horse's head and hooves, are inspired by aesthetics of the Vienna Secessionist movement.

The horse has a long tradition in the Nordic countries and is associated with wind, power, and speed, and subliminally with intense desires and instincts. In Roman mythology, Neptune, the god of the seas, is often depicted astride a seahorse, symbolic of his role as patron of horse racing.[2] In the Belle Epoque, horse racing was a popular sport in Russia.

NOTES
1 Tamara Talbot Rice, *A Concise History of Russian Art* (New York, 1963), 81.
2 J. E. Cirlot, *A Dictionary of Symbols* (New York, 1971), 227.

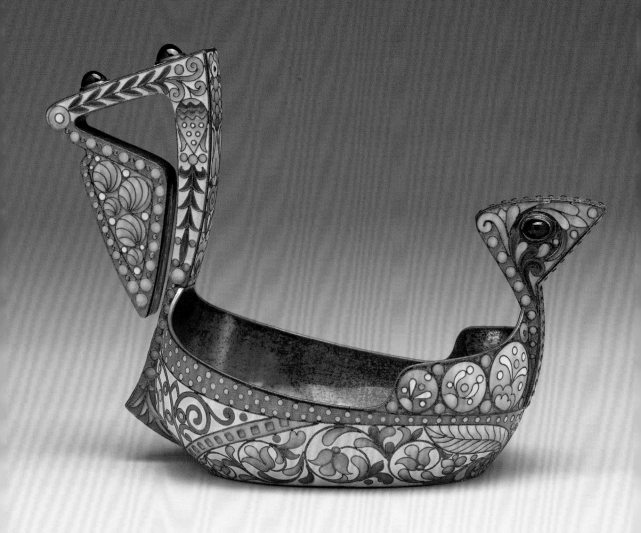

69 Bird-shaped *kovsh*

Firm of Pavel Ovchinnikov (Russian, 1830–1888)
Moscow, ca. 1910
Silver gilt, painted filigree enamel, amethysts
4¼ × 6⅜ × 2¾ in. (11.5 × 16.2 × 7.2 cm)
Inscribed (in Danish): Fra Kejserinde Maria Feodorovna til professor, dr. med, Jens Schon
2 Febr 1910

Provenance: Dowager Empress Maria Feodorovna; Jens Schon, 1910, by gift; Jean M. Riddell, Washington, D.C.; The Walters Art Museum, 2010, gift in memory of Jean M. Riddell, 44.781

With its arched neck and raised stern, this vessel seems to be moving through space, recalling the tradition that *kovshi* were patterned after swimming birds. Another tradition suggests that carvers were imitating the lines of Viking ships.[1] Other forms include the siren *kovsh* (cat. no. 67) and the *kovsh* in the shape of a hippocampus (cat. no. 68). From the seventeenth century onward, examples were made in precious metals and served as honorific gifts (cat. nos. 12, 13, and 17).

With its avian shape, pastel flowers, leaf-like forms and strawberries on the handle, and its feathering around the eyes of the bird and on its lower front body, this superb work attests to a close observation of nature. The triangular shape of the bird's head with its amethyst eye is echoed in the triangle and amethyst accents of its tail. The filigree enamel palette in light colors and the modernistic design is in keeping with the Arts and Crafts tradition of the early twentieth century.

Dowager Empress Maria Feodorovna presented this bird-shaped *kovsh* with an honorary inscription to the Danish doctor Jens Schon. She was a Danish princess by birth, and throughout her life she shared a summer villa called Hvidøre with her sister, Queen Alexandra of the United Kingdom. Following the revolution, Hvidøre became Maria's permanent residence.

Pavel Ovchinnikov died in 1888, but his four sons carried on the firm until the revolution.

NOTE
1 Anne Odom, *Russian Silver in America: Surviving the Melting Pot* (Washington, D.C., and London, 2011), 222.

70 *Kovsh* with Imperial eagle

Unknown maker
Moscow or St. Petersburg, 1911
Nephrite, silver, gold, diamonds, rubies
4⅛ × 12⅝ in. (10.5 × 32.1 cm)

Provenance: Alexandre Polovtsoff; Henry Walters, ca. 1930;
The Walters Art Museum, 1931, by bequest, 57.1076

This monumental jeweled version of a traditional drinking bowl is made of nephrite. In 1850, a source of nephrite was found in Siberia, near Irkutsk, leading to its popularity among Russian artists. The elaborate baroque-style handle has an applied coat of arms of Russia worked in gold and diamonds and inscribed May 6, 1911. In the old style (Julian) calendar May 6, 1868, was Nicholas II's birth date, and the *kovsh* may have been intended as a presentation gift for the tsar's forty-third birthday, although it was never delivered. Rather, it numbers among Henry Walters' last purchases from Alexandre Polovtsoff prior to Walters' death in 1931.

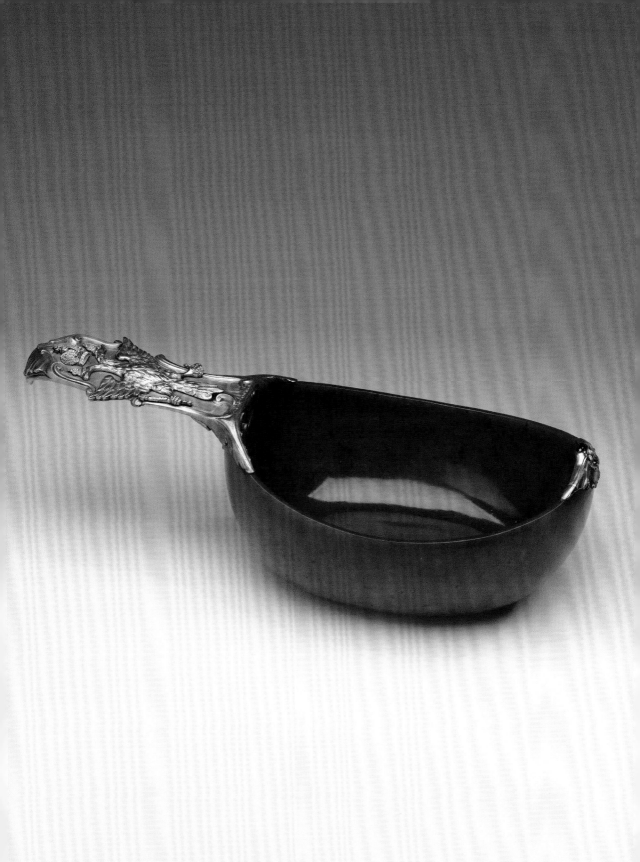

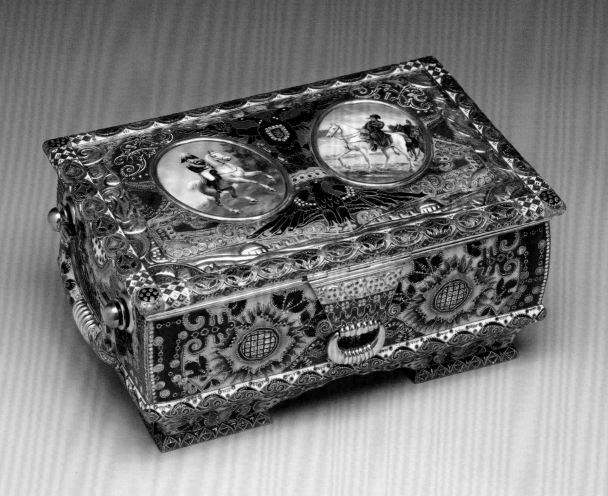

185

71 Commemorative cigar box

Fedor Ivanovich Rückert (Russian, 1840–1917)
Moscow, 1912
Parcel gilt, filigree, shaded and painted matte enamel
3¾ × 8½ × 5¼ in. (9.5 × 21.5 × 13.5 cm)

Provenance: Jean M. Riddell, Washington, D.C.; The Walters Art Museum, 2010,
gift in memory of Jean M. Riddell, 44.894

This cigar box commemorates the centennial of Russia's victory over the French emperor Napoleon I, who had set his sights on conquering Russia in June 1812, only to suffer an ignominious defeat and retreat later that year. The Russian and French emperors are identified by the elaborately scripted crowned monograms above their respective images. The enamel portrait of Napoleon, taken from Ernest Meissonier's 1864 painting (fig. 71.1), shows the beleaguered emperor trailed by his dejected generals.

In contrast, Tsar Alexander I, cropped from a painting by Franz Krüger (fig. 72.2), is pictured victorious on a prancing white horse with a chest full of medals and a plumed hat. Further proof of victory is the Russian coat of arms: the thrice-crowned double-headed eagle with St. George slaying the dragon, floating triumphantly above the eagle of the French Empire.[1] The Grande Armée of Napoleon I carried eagle standards into battle, and they were meant to be defended unto death. More than 400,000 French soldiers perished in the retreat from Moscow.

The burning of Moscow, which may have been an act of sabotage on the part of the Russians, is depicted on the lid. The walls and the guard houses of the Kremlin are molded in silver at the base, and flames and clouds of smoke lick up the sides of the box.

The magnificent filigree enamel incorporates faintly militaristic designs in the red and green chain border around the lid and the luster sunbursts on the sides, in the shape of a Russian Order, a decoration given for distinguished service to the nation. Although this box was designed to hold cigars, its pristine interior suggests that it was merely for display.

NOTE
1 Anne Odom, *Russian Enamels: Kievan Rus to Fabergé* (Baltimore, Washington, D.C., and London, 1996), 166.

Fig. 72.1. Ernest Meissonier (French, 1815–1891). *Napoleon's Retreat from Moscow*, 1864. Musée d'Orsay, Paris.

Fig. 72.2. Franz Krüger (German, 1797–1857). *Portrait of Tsar Alexander I,* 1837. State Hermitage Museum, St. Petersburg.

72 *Kovsh* with image of Tsar Michael I

Fedor Ivanovich Rückert (Russian, 1840–1917) for the House of Fabergé
Moscow, ca. 1913
Silver gilt, painted matte and filigree enamel
1⅞ × 7 × 3⅞ in. (4.9 × 17.9 × 9.9 cm)

Provenance: Sale, Sotheby Parke Bernet, November 30, 1978, lot 412; Jean M. Riddell
(through Leo Kaplan, New York, as agent), New York, Washington, D.C., 1978; The Walters Art Museum,
2010, gift in memory of Jean M. Riddell, 44.899

The tercentenary of the Romanov dynasty was celebrated in 1913 with many
official ceremonies and celebratory banquets, and precious jewelry and decora-
tive items were made as remembrances. This *kovsh* was undoubtedly created to
mark this auspicious occasion.

The first Romanov tsar, Michael I, was credited with unifying Russia fol-
lowing the Time of Troubles, a chaotic period starting in 1598 and lasting until
the establishment of the Romanov dynasty in 1613. The tsar's finely painted
portrait fills the bowl; he is depicted in sumptuous gold robes and wears the
Monomakh cap. According to legend, this cap was a gift from the Byzantine
emperor in the fifteenth century and was traditionally used in Russia to crown
the monarch. The band of sable encircling the crown is a symbol of wealth
and prosperity.

The portrait in the base bears a striking similarity to the miniature
of Tsar Michael on the Fabergé Romanov Tercentenary Egg, presented
to Empress Alexandra Feodorovna at Easter 1913. The artist, Vasili Zuiev,
was trained at the Stieglitz Institute. Nearly eighty percent of the House of
Fabergé's artisans came from this school.[1] Given the similarity of the portraits
and the fact that this *kovsh* was made for the House of Fabergé, there is a
possibility that Zuiev may also have been the miniaturist for this portrait of
the tsar.

Other details such as the abstract Romanov crest on the handle and the
Usolsk-style strawberries and flowers, representing abundance, are meant to
evoke the seventeenth century, the era of Tsar Michael. The tercentenary celebra-
tions revolved around Tsar Nicholas II and his family. Nicholas II disliked his
ancestor Peter the Great because of "his fascination for western culture and his
scorn for all pure Russian customs."[2] Peter had banned the wearing of beards to
conform to Western styles, but Nicholas II admired the pre-Petrine tsars such
as Michael and took to wearing a beard himself.

NOTES
1 Sergei M. Gontar, "Alexander III's
Reforms in the Decorative Arts,"
in *Maria Feodorovna: Empress of
Russia* (Copenhagen, 1997), 286.
2 A. A. Mosolov, *Pri dvore poslednego
imperatora* (St. Petersburg, 1992),
80, quoted in Anne Odom, *What
Became of Peter's Dream? Court
Culture in the Reign of Nicholas II*
(Vermont and Washington, D.C.,
2003), 20.

73 "OTMA" portrait diamond necklace

Russia, ca. 1914
Portrait diamonds, diamonds, gold, porcelain, watercolor, metal
First and fourth rectangular frames: approximately ⅝ × ½ in. (1.6 × 1.3 cm)
Second and third pear-shaped frames: ¾ × ½ in. (1.9 × 1.3 cm)

On loan from a private collection

The four daughters of Tsar Nicholas II and Alexandra Feodorovna—Olga, Tatiana, Maria, and Anastasia—were a tightly knit quartet who nicknamed themselves "OTMA," an acronym of the initials of their names. Their portraits, each about the size of a thumbnail, adorn this simply designed necklace, that belies the magnificence of the portrait diamonds that protect the delicate watercolor miniatures. The faceted edges of the flat-cut portrait diamonds illuminate the girls' tender faces. The surround of tiny brilliants—diamonds cut with numerous facets to maximize the light that they throw—attests to their regal status.

Empress Alexandra thought of her daughters as the couple's "little four-leaved clover … each so different in face and character,"[1] and referred to them as the "Big Pair"—Olga (b. 1895) and Tatiana (b. 1897)—and the "Little Pair"—Maria (b. 1899) and Anastasia (b. 1901).[2] Starting on the wearer's right, the jeweled miniatures are hung pendant-like in birth order.

These tiny portraits bear a resemblance to formal court photographs of the sisters from 1914 (fig. 74.1). Their grandmother the Dowager Empress Maria Feodorovna gave a ball in February 1914 to introduce the young women to society. World War I broke out in July of that year, so their "season" was short-lived.

In other photographs of the period, Olga wears her hair up, permissible for a young woman aged eighteen.[3] Tatiana, who was seventeen, had had her long hair cut in 1913 during a debilitating bout of typhoid fever. She is pictured with short hair, standing behind her sisters or alternatively sitting while they stand, perhaps out of fear of contagion. In the portrait diamond miniature, little side curls grace her cheeks, indicating her short bob.

There are various theories about the origin and dating of this necklace. The resemblance of the miniatures to the period photographs might suggest a date of ca. 1914. A more remote possibility is that the necklace may have been crafted after the 1917 revolution. Maria Feodorovna and her daughter Olga Alexandrovna and her family were forced to flee Russia, and by the early 1920s, were resettled in Denmark, Maria Feodorovna's birthplace. Aunt Olga, an accomplished watercolorist, may have painted these miniatures of her nieces on a porcelain-like material and had them fitted beneath salvaged portrait diamonds in a necklace that served as a souvenir of happier times.[4]

NOTES
1 Helen Rappaport, *The Romanov Sisters* (New York, 2014), 73.
2 Ibid., 91.
3 Karen L. Kettering, remark to Benjamin Zucker and thence to the author, 2015.
4 *The Romanov Portrait Necklace* (New York, 2012), 18.

Maria Feodorovna never publicly accepted that Nicholas, Alexandra, and their five children had perished in 1918, but Olga and Maria's other daughter, Xenia, were more accepting of this grim possibility. After ten years without a word from them, Nicholas and his family were legally presumed dead.

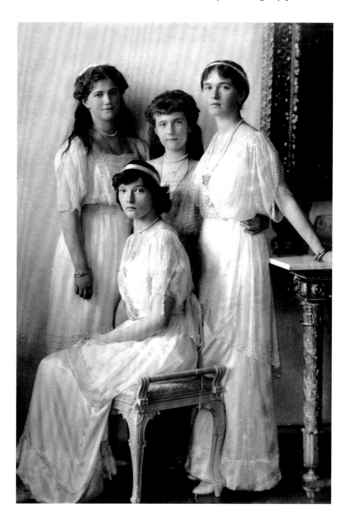

Fig. 74.1. The daughters of Tsar Nicholas II and Empress Alexandra, standing from left to right: Grand Duchesses Maria, Anastasia, and Olga; seated: Grand Duchess Tatiana. Photograph: Popperfoto/Getty Images.

Late Nineteenth- to Early Twentieth-Century Russian Enamel Artisans

WILLIAM R. JOHNSTON

Maria V. Adler

The enameled silver miniature chair by Adler illustrated in the catalogue (cat. no. 33) attests to the remarkably high mastery of technique, whether in champlevé or filigree, attained by the firm of this little-known Moscow silversmith. The example predates her recorded activity. She employed seventy-four craftsmen and held a drawing class for training apprentices.

Nikolai Vasilevich Alexseev

This firm, located on Utinskii Most in Moscow, was active from 1885 to the beginning of the twentieth century. It participated at the All-Russian Art Industry Exhibition held in Nizhni Novgorod in 1896. Among the wares shown there were salts, small *kovshi*, perfume bottles, and silver animals.

Grigori Arsenev Andreev

The Andreev firm, active in St. Petersburg from 1885 to 1898, was known for its filigree enamels and pierced silver wares.

The House of Bolin

The Bolin firm, the world's oldest jewelry house still in operation, traces its roots to the marriage in 1834 of the Swede Carl Edvard Bolin to the daughter of Andreas Roempler, a German jeweler who had settled in St. Petersburg as early as 1790.[1] Inheriting Roempler's business, Carl Edvard changed its name to Jahn and Bolin (Jahn being his brother-in-law and Roempler's partner). The firm was appointed court jeweler to Nicholas I in 1839 and, by the mid-nineteenth century, it employed over fifty artisans. Carl Edvard's brother, Henrik Conrad Bolin, opened "Shanks and Bolin, Magasin Anglais" in Moscow in 1852, with an English partner, James Stuart Shanks. The partnership failed, but Henrik Conrad continued to operate the Moscow branch manufacturing silver until his death in 1888.

Carl Edvard's son, Wilhelm James Adreevitch Bolin, opened a new branch with his cousins in St. Petersburg, known as C. E. Bolin, while maintaining the Moscow business specializing in silver. From 1912, it was listed as W. A. Bolin. A consummate entrepreneur as well as a jeweler, Wilhelm maintained offices in Paris, London, and Berlin, as well as a shop during the summer months in Bad Homburg, a spa town near Wiesbaden, Germany. With the outbreak of World War I, Wilhelm transferred the firm's resources to Stockholm. In 1916, a salesroom opened in the Swedish capital and Bolin was appointed jeweler to the Swedish court. The Russian holdings were confiscated in 1917.

Peter Carl Fabergé, St. Petersburg

At the Paris Exposition Universelle of 1900, the House of Fabergé astonished the public with its display of Imperial Easter Eggs and miniature replicas of the Russian crown jewels.[2] These were the products of its St. Petersburg headquarters, which traced its beginnings to a workshop founded in the Russian capital in 1842 by Gustav Fabergé, a descendant of French Huguenots. Gustav retired to Dresden with his family in 1860. Four years later, his eldest son, Karl Gustavovich, or Peter Carl (known as Carl; 1846–1920), returned to St. Petersburg to head the firm. He was joined in 1882 by his younger brother Agathon (1862–1895). At this time, the emphasis of the firm's production shifted from conventional jewelry to *objets de fantaisie* or bibelots such as small boxes, bonbonnières (boxes or jars for confectionary), bell pushes, and jeweled eggs. In 1882, at the Pan-Russian Industrial Exhibition in Moscow, Empress Maria Feodorovna purchased a pair of cicada-shaped gold cufflinks inspired by ancient artifacts from Kertch in the Crimea. Fabergé soon established his fame, winning numerous awards at

subsequent exhibitions, both Russian and international. Alexander III appointed him "Supplier by Special Appointment to the Imperial Court," an honor that entitled him to add the Imperial warrant to his hallmark.

Fabergé's fame rested on the superb craftsmanship and quality of the materials employed in his wares. This success was assured by the elaborate staff structure. As of 1900, the firm was located in St. Petersburg at 24 Bolshaia Morskaia Street in a building housing the offices, salesroom, workshops, design studio, reference library, and family apartment. Franz Birbaum headed the design department from 1893 to 1913; Mikhail Evlampievich Perkhin (1860–1903), followed by Henrik Emanuel Wigström (1862–1923), served as the chief workmaster supervising the overall production, and the various semi-autonomous workmasters directed their artisans and apprentices. While some workshops were housed at the Bolshaia Morskaia address, others were situated off-site. All these operations were overseen by Carl Fabergé himself. At its peak, there were over 500 employees at the St. Petersburg headquarters and dispersed among the firm's branches: Moscow (1887–1917), Kiev (1906–10), Odessa (1900–), and London (1903–15).

Among Fabergé's workmasters represented in the Walters collection is Mikhail Perkhin, who was of Russian peasant stock, had trained under Erik Kollin, Fabergé's first head workmaster, and had opened his own workshop at 16 Bolshaia Morskaia Street in 1884. Two years later, Perkhin was appointed head workmaster and, in that capacity, oversaw many of the firm's most spectacular pieces, including all but one of the Imperial Easter Eggs created before his death in 1903. Anders Nevalainen (1858–1933), a Finn, became a master goldsmith in 1885 and worked initially in the jewelry workshop

of August Holmström before heading his own shop producing wares exclusively for Fabergé. Another Finn, August Fredrik Hollming (1854–1913), moved to St. Petersburg in 1876, opened a workshop in 1880, and began to work for Fabergé. He relocated his workshop from Kazanskaya Street to the third floor of Fabergé's newly opened building in 1900. Among his specialties were small, gem-set pieces and miniature Easter Eggs. Julius Alexandrovich Rappoport (1851–1917) became a master silversmith in 1884 and opened his workshop at 65 Ekatarinskii Canal. Around 1890, he joined Fabergé's firm and provided it with silver wares until his retirement in 1909.

The House of Fabergé, Moscow (1887–1917)
To serve a broader, increasingly wealthy Russian clientele rather than just St. Petersburg's aristocratic and cosmopolitan patrons, Fabergé opened a branch in Moscow in 1887 with Allan Adreevich Bowe, a South African-born Englishman, serving as his business partner until 1906. The workshops were located at Verkhne-Bolshoi Kiselnyi Lane, House San Galli, no. 4, and Fabergé's store was on Kuznetski Most in House no. 4 of the Merchants' Society. There were two departments within the Moscow branch, one for jewelry, headed by Oskar Pihl, and the other for silver, led by Mikhail Cherpunov. With the exception of special orders, most of Fabergé's silver was produced in Moscow. In his memoirs, Franz Birbaum, the firm's head workmaster from 1893, noted that some of the Moscow branch's jewelry, gold, and enamel work were "inferior both in quality and quantity to those of St. Petersburg, but silverwork was more extensive and better organized." He observed that the Moscow work was distinguished by the predominance of the Russian style and that its defects were "redeemed by the freshness of design and cliché-free composition."[3]

Gavriil Petrovich Grachev
Gavriil Petrovich Grachev founded this firm in St. Petersburg in 1866. In 1873, his sons Mikhail and Semen renamed it Grachev Brothers, the name under which it operated until 1917. It was designated supplier to the Imperial court in 1896. Among the wares it provided to the court were silver sculptural pieces and clocks. By 1897, the firm employed sixty-six craftsmen and eleven apprentices. Among Grachev Brothers' awards were gold medals at the Paris Exposition Universelle in 1889 and Chicago's Columbian Exposition in 1893.

The Keibel Firm
In 1791, Otto Samuel Keibel (1768–1809), a native of Pasewalk, Pomerania, founded the family firm of goldsmiths in St. Petersburg. After Otto's death, his son Johann Wilhelm (1788–1862) headed the firm, which specialized in gold boxes. Many were produced as presentation pieces on the occasion of Nicholas I's coronation in 1825. Among those who trained under the direction of Johann Wilhelm Keibel in the 1830s was Gustav Fabergé, founder of the Fabergé firm (see above). Following the younger Keibel's death, the firm continued to operate until after 1910, specializing in the production of insignia.

Ivan Petrovich Khlebnikov
Ivan Khlebnikov rivaled Pavel Ovchinnikov as an early manufacturer of enameled silver in the Russian Revival style.[4] Documents show that he opened a workshop in St. Petersburg in 1867, dealing in gold and silver objects, but by 1870/71 he had opened a factory on the Shvivaya Hill in Moscow. There he manufactured a wide range of products including sculptures and silver wares engraved with peasant subjects, as well as enameled silver. His firm first showed internationally at the Vienna International Exhibition of 1873, receiving much attention for a samovar with cockerel-shaped feet and handles. Khlebnikov was designated Purveyor to the court of Grand Duke Konstantin (son of Nicholas I) in 1872 and to that of Grand Duke Vladimir Alexandrovich (son of Alexander II) five years later. In 1879, he became the purveyor ordinary to the Imperial court.

Khlebnikov's last major commission was a monumental silver pyx with sculptural elements and enameled lettering which was intended for the Cathedral of Christ the Savior in Moscow in 1880. He died the following year, leaving the shop to his sons, who, in 1888, reorganized it as a joint stock company, I. P. Khlebnikov, Sons & Co. By 1882, the firm employed over 200 workers and also maintained two art schools, one for instruction in drawing and the other in sculpting, with about 75 students. The firm is known to have employed external workmasters who sometimes added their own marks to their works.

At the Paris Exposition Universelle in 1900, Khlebnikov's exhibits attracted an international clientele. The firm's decorative works are noted for their distinctive whimsical character.

Orest Fedorovich Kurliukov
Kurliukov, an art dealer and silversmith, originally worked for the Khlebnikov firm. In 1884, he opened his own factory. At the turn of the century, Kurliukov adopted for his silver vessels a version of the Art Nouveau style characterized by restrained, curvilinear designs, which may have been inspired by Viennese rather than more curvaceous French prototypes. He was known for tea services, cigarette cases, and Chinese-inspired tea caddies. Kurliukov joined a silver artel, or co-operative, in 1916.

Antip Ivanovich Kuzmichev
Kuzmichev's manufactory can be traced in Moscow back to 1856. By 1897, ninety-three workers and fifteen apprentices were employed. Its products included vestments, oklads, and various utensils, especially spoons. Since so much of his work was exported to America, where it was sold through Tiffany & Co., Kuzmichev's enamels became more familiar in America than in his native land. His wares often represent tours de force of enameling in their range of techniques. His firm began to produce plique-à-jour enamel at about the same time as did Pavel Ovchinnikov's.

Josef Abramovich Marshak
In 1878, Josef Abramovich Marshak opened a silver workshop in Podil, a district in Kiev, but soon moved to a more fashionable address at 4 Kreschatyk Street. His shop was on the ground floor and the upper two floors were devoted to the factory. By 1897, he employed as many as seventy-two workers. From 1904 to 1917, a retail shop was attached to the factory. Marshak exhibited internationally, winning acclaim for the quality of his wares, particularly jewelry. In the early twentieth century, in addition to his own pieces, Marshak sold the products of other workshops including those of Ivan Britsyn and Fedor Rückert.

Israel Rukhomovsky (1860–1936), the well-known forger, trained in Marshak's manufactory. In the early 1890s, this gifted goldsmith created the notorious fake "Scythian" gold tiara that was acquired by the Louvre, Paris, in 1906.

Dimitri Ivanovich Orlov

Dimitri Orlov established his silver and gold manufactory in Moscow in 1840 and by 1865 he employed thirty-five workers and ten students. His firm closed in 1872.

Pavel Ovchinnikov

The most influential manufactory in Moscow's silver trade during the last quarter of the nineteenth century was that of Pavel Ovchinnikov. Its products ranged from enameled silver decorative wares, to plate, and to sculpture. The firm pioneered the Russian Revival style and was largely responsible for introducing the filigree and the plique-à-jour techniques of enameling to the Moscow silver trade.

The founder, Pavel Akimovich Ovchnnikov (1830–1888), formerly a serf on the vast estates of Serge Volonsky, migrated to Moscow where he apprenticed with a brother, A. Ovchinnikov, before opening a workshop in 1851. Within two years, his firm was well established. Ovchinnikov furthered his reputation in 1865 by winning a gold medal for his enameled wares at the All-Russian Exhibition of Industries and Crafts held in Moscow. That year, he also received the title of "Supplier to Tsarevich Alexander Alexandrovich" (later Alexander III). Numerous international awards followed, including a silver medal for a sculpture at the Paris Exposition Universelle in 1867. Three years later, he exhibited enameled silver liturgical objects executed in the Russo-Byzantine style at the Russian Industrial Exhibition in St. Petersburg. At the Vienna International Exhibition in 1873, he was awarded the title of Purveyor Ordinary to King Victor Emmanuel of Italy. As business grew, Ovchinnikov opened a branch in St. Petersburg, which flourished from 1873 until 1915. Additional recognition came in 1881 when he was awarded the title of "Court Supplier" (the Imperial warrant). By then, Ovchinnikov employed a staff of 300. The following year, at the All-Russian International Art Exhibition, he was presented with another silver medal, this time for his vocational school which offered 130 apprentices training over a five- or six-year period. Though the school specialized in gold and silver wares, it also provided more general courses including those in singing and gymnastics.

Following his death in 1888, Pavel's sons assumed control of the firm: the Moscow office was headed by Alexander Ovchinnikov, while Mikhail Ovchinnikov was in charge of efforts in St. Petersburg. The family business continued to flourish, receiving honorable mentions at the international exhibitions in Chicago in 1893 and in Paris in 1900.

Pavel Ovchinnikov's earliest enamels were in the champlevé technique executed in the highest grade of silver, 91 *zolotniks* (94.79 of 100 parts silver as opposed to sterling silver at 92.5 parts), suggesting that they may have been intended for export. For decorative motifs and shapes, Ovchinnikov drew on ethnological publications as well as Russian *kustar* or folk arts, particularly embroidered textiles. By the late 1880s, however, his production was dominated by painted filigree enamel wares with floral designs in the seventeenth-century style of the town of Usolsk. The earliest example of Ovchinnikov's use of plique-à-jour enamel in the Walters' collection is dated 1884. His firm would become associated with this technique, particularly in the late 1890s when it was also in vogue in France and Norway.

Grigori Grigorevich Pankratiev

Little is known of this St. Petersburg silver manufactory other than that it was active from 1874 until 1908.

Andrei Mikhailovich Postnikov

Postnikov's firm is said to have opened as a silver workshop in Moscow in 1836, but by 1868 it had become a factory producing various objects in gold, silver, and bronze.[5] Within three years, it employed sixty-three workers and twenty-four apprentices. Postnikov opened a school attached to his manufactory with forty-seven students in 1870. In 1877, he was appointed court jeweler. The last reference to Postnikov was in 1898.

Fedor Ivanovich Rückert

Little was known of Fedor Rückert's background and family until Tatiana N. Muntian of the Kremlin Armory Museum interviewed his descendants.[6] Friedrich Mauritz Rückert (1840–1917), as he was originally named, was taken at the age of fourteen from his native Alsace-Lorraine to Moscow. His first marriage, a few years later, resulted in a family of two daughters and a son, and his second produced six more children. After the death of his second wife, he married a third time at the age of sixty-five.

Rückert's early career as a silversmith is not documented. However, a silver and enamel cup from 1912, commemorating his twenty-five-year association with the firm of Carl Fabergé, confirms that Rückert was practicing his art from 1887.[7] Initially, he employed filigree enamel decorated with Usolsk-type tulip blossoms, creating works which are scarcely discernible from those of contemporaries, particularly Pavel Ovchinnikov, with whom he might have trained. Subsequently, he worked both as an independent silversmith, employing his five sons, and as a supplier for Fabergé and other firms, among them Ovchinnikov and Kurliukov (see above). His wares bore both his own mark and that of the retailer, though in the case of works supplied to Fabergé, Rückert's mark was often overstamped, rendering it almost indiscernible. Rückert's workshop was located on the first floor of the family's large house at 23/3 Vorontsovskaya Street. Rückert's descendants recall that, in addition to his sons, he hired a number of apprentices who lived in the neighborhood. It has been estimated, however, that Rückert had as many as forty employees, which would explain the firm's large output.[8] Frustratingly little information is available regarding the roles of the individuals in the enterprise. In 1899, the eldest son, Pavel Rückert (1883–1926), was enrolled in the Stroganov Institute for Technical Drawing (see below) in Moscow where he may have been briefly joined by his brother Feodor Rückert (1888–1942).

Around 1908, perhaps as a result of his sons' exposure at the Stroganov Institute to international artistic developments, particularly Art Nouveau and Austrian Secessionism, Rückert altered his style, adopting such decorative elements as sunflowers, cloudberries, pine trees, and owls derived from Russian folk art traditions in woodwork and textiles. His colors grew darker and he often used black in his designs. His wire filigree also changed: no longer was it limited to separating fields of color, but it took on a decorative role of its own. At this time, Rückert also began to incorporate in his works miniatures replicating paintings by such then-popular artists as Konstantin Makovsky (1839–1915) and Viktor Vasnetsov (1848–1926). Although the combination of richly patterned filigree decoration and meticulously painted miniatures may appear incongruous, the two elements were united through their harmonious color schemes.

In some of Rückert's production, his decorative motifs become more abstract and the colors muted in response to a similar major shift in fashion also discernible in the *kustar* crafts.[9] Probably contributing to this change was the introduction in major cities of electric lighting, which might have made the vivid colors associated with Russian Revivalism seem harsh.

Fedor Rückert and the House of Fabergé (1887–1917)

By opening a branch in Moscow in 1887 (see above), Fabergé sought to compete with Pavel Ovchinnikov and other local firms in producing silver wares, jewelry, and enamels executed in the Russian Revival style. Initially, Fabergé retailed the wares of other silversmiths, but eventually, under the direction of Agathon Fabergé, Carl's younger and perhaps more artistically gifted brother, the Moscow branch produced its own cloisonné and filigree enamels.

From the outset, a relationship was established with Fedor Rückert, whose workshop undoubtedly provided silver wares enameled with Russian Revival motifs not unlike those of major competitors. The most significant products of the Fabergé–Rückert collaboration, however, were the silver boxes and *kovshi* enameled with Russian Revival and *stil moderne* decoration and set with miniatures replicating popular paintings. Most of these date from around 1908 and

later.[10] Little has been documented of the operations of Rückert's workshop other than that it employed family members and a few outsiders. Although many Fabergé pieces bear Rückert's mark, either alone or overstamped with the House of Fabergé mark and the Imperial warrant, others are unmarked but are in a distinctly Rückert style. These are often attributed to his workshop or said to have been executed in the *stil moderne* by Fabergé's own employees, who might have trained under Rückert.

Vasili Semenov

Vasili Semenov established his silver factory in Moscow in 1852 and by 1873 he employed forty workers. He first showed his wares in Paris at the Exposition Universelle in 1867, and in St. Petersburg in 1870 he received a silver medal for his niello pieces. His products were regarded as being of exceptional technical quality. In 1896, his daughter Maria (see below) inherited the firm.

Maria V. Semenovna

Mariia Semenovna inherited her father's workshop in 1896. It remained in operation until 1917, employing at one time approximately one hundred workmen, including silversmiths and enamelers. Her wares have been described as exhibiting a distinctive delicacy in their floral designs and pastel colors. Among the decorative motifs found on her shop's wares are filigree wire spirals and short

strands of twisted wire terminating in raised pellets.

Stroganov Institute

Baron Sergei Grigorievich Stroganov (1794–1882) founded the Stroganov Institute in Moscow in 1825 to provide training in the decorative and applied arts.[11] He was descended from a venerable aristocratic family long known for its patronage of the arts.

In 1843, the school fell under government control and, in 1860, it was renamed the Stroganov Institute for Technical Drawing. In 1901, it received the patronage of Grand Duchess Elizabeth Feodorovna, Empress Alexandra's elder sister, and adopted the title "Imperial" to become the Imperial Stroganov Institute. Its mark was *I. S. Y.* with the double-headed eagle (a symbol reserved for suppliers to the court who had been in business for at least fifty years). In the early twentieth century, the institute was instrumental in promoting the Russian Revival style, Art Nouveau, and *stil moderne*. Its enamel workshop opened in 1902 and, over the course of eight years of training, students were thoroughly grounded in the techniques of enameling and metalworking. Among the institute's enameled wares are pieces commemorating the Romanov Tercentenary in 1913. Today, the institute operates as the Stroganov Moscow State University for Arts and Industry.

Notes

Headnote

Russian naming conventions and the fact that both Alexandre Alexandrovich Polovtsoff (1867–1944) and his father, State Secretary Alexander Alexandrovich Polovtsov (1832–1909), were authors of influential books have led to frequent confusion. Russian texts tend to refer to them as Polovtsov the elder and Polovtsov the younger. To avoid confusion, this book uses the French spelling (Polovtsoff) for the younger man, who was resident in France when he knew Walters, and retains the traditional Russian spelling for his father.

Introduction

1　During the 1890s large numbers of Russian-Jewish immigrants arrived and were processed through the Locust Point terminal in the port of Baltimore. These immigrants helped to create the substantial Polish and Russian community still present in East Baltimore. Samuel Joseph, *Jewish Immigration to the United States: From 1881 to 1910* (New York: Arno Press, 1914; repr. 1969), 159.

2　William R. Johnston, *William and Henry Walters: The Reticent Collectors* (Baltimore: Johns Hopkins University Press, 1999), 119.

3　Her story was one of adventure marked by both good fortune and the tragedies of World War I and the Russian Revolution. She met the Russian prince Mikhail Cantacuzène-Speransky while traveling with her mother in Rome in 1898. After a brief courtship, the couple married in Newport, Rhode Island, on September 22, 1899. Julia Dent Grant Cantacuzène-Speransky went on to write a history of the last years of the Russian Empire, *Revolutionary Days: Recollections of Romanoffs and Bolsheviki, 1914–1917* (New York: Charles Scribner's Sons, 1919). The Cantacuzène-Speranskys received a notable array of gifts from friends including the Joneses and the Delanos. Among these gifts were Russian icons, decorative objects, and European and American treasures, Johnston,

Reticent Collectors (note 2), 119. Henry Walters' gift to them was passage aboard the *Narada* from Newport to New York City as the first leg of their honeymoon excursion.

4　They are now in the Walters Art Museum, accessioned as nos. 42.353, 42.354, 42.355, 27.480, 44.621, 57.1841 and 57.1862.

5　The Easter Eggs that had been gifts between Tsar Alexander III and Maria Feodorovna and between Tsar Nicholas II and Alexandra Feodorovna were displayed at the St. Petersburg Von Dervis Mansion in 1902.

6　Recounted in the contemporary Stieglitz Museum's history: www.stieglitzmuseum.ru/en/museum.htm (accessed October 4, 2016).

7　Johnston, *Reticent Collectors* (note 2), 94.

8　www.stieglitzmuseum.ru/en/museum.htm (accessed October 4, 2016).

9　The Revolution of 1905 that swept through St. Petersburg following the defeat of the Russian Army by the Japanese forces in the Far East led to many changes in the system of Russian state rule. Among them was the decision to close public educational institutions that were perceived as a threat to society. Abraham Ascher, *The Revolution of 1905: Russia in Disarray* (Stanford: Stanford University Press, 1994), 194.

10　Robert C. Williams, *Dumping Oils: Soviet Art Sales and Soviet-American Relations 1928–1933*, Woodrow Wilson International Center Colloquium, May 25, 1977, 10.

11　Will Lowes and Christel Ludewig McCanless, *Fabergé Eggs: A Retrospective Encyclopedia* (Lanham, Maryland: Scarecrow Press, 2001).

12　At the time of the arrival of this egg with Henry's caretaker in Baltimore, one of these tiny seed pearls had fallen out. The receipt describes this missing pearl, but mentions nothing of the Imperial history of the object.

13　The whereabouts of the surprise that once rested inside this egg are unknown.

Chapter One

I am grateful to Benjamin Zucker and Margaret Kelly Trombly for their generous sharing of research, most especially for a typescript copy of Alexandre Polovtsoff's memoirs ("Vospminaniia") at Yale University, Beinecke Rare Book & Manuscript Library, Ms. 403, Box 5, Folder 2. The State Archive of the Russian Federation in Moscow holds another copy of Polovtsoff's memoirs (GARF Fond 5881, op. 1, d. 118). Excerpts were also published in the Paris émigré journal *Vozrozhdenie* as A. A. Polovtsov, "Vospominaniia," *Vozrozhdenie*, 1949, no. I. I would like to extend my thanks also to Galina Vlasova, chief curator of the Stieglitz Museum, for acquainting me with the museum's history and collections during a visit in 2014.

1　For an overview, see Jonathan Meyer, *Great Exhibitions: London, New York, Paris, Philadelphia, 1851–1900* (Woodbridge, Suffolk: Antique Collectors' Club, 2006), and Catherine L. Futter et al, *Inventing the Modern World: Decorative Arts at the World's Fairs, 1851–1939* (New York: Skira, 2012).

2　William Johnston, "Henry Walters: America's First Collector of Russian Art," *Pinakoteka*, 22/23, 2006, 190–96.

3　*Russkii biograficheskii slovar'* … 25 vols. (St. Petersburg: Izd. Imp. Russkago Istoricheskago Ob-va, 1896–1918; repr. New York: Kraus, 1962). In addition to P. A. Zaianchkovskii's introduction to his diaries, published as *Dnevnik gosudarstvennogo sekretaria* (Moscow: Nauka, 1966), see S. A. Nikitin, "Aleksandr Aleksandrovich Polovtsov," *Voprosy istorii*, July 2008, no. 7, 39–54.

4　Polovtsoff, "Vospminaniia," 19–20.

5　I. G. Etoeva, "Portrety Ekateriny II raboty M.-A. Kollo," *Ermitazhnye chteniia pamiati V. F. Levinsona-Lessinga*, 1999, 38–41, and M. Beker, "Mari Kollo v Peterburge," *Pinakoteka*, 2001, no. 13–14, 186–91.

6　Olga Stieglitz, *Die Stieglitz aus Arolsen: Texte, Bilder, Dokumente* (Stadt Arolsen: Museum, 2003), and V. A. Vasil'ev, *Triumf i tragediia Barona* (St. Petersburg: Politekhnika-servis, 2013).

7 Boris V. Ananich and Sergei G. Beliaev, "St. Petersburg: Banking Center of the Russian Empire," in *Commerce in Russian Urban Culture, 1861–1914*, ed. William Craft Brumfield, Boris Ananich, and Yuri Petrov (Washington, D.C.: Woodrow Wilson Center Press, 2001), 10–13. In his portrait by Petr Sokolov, Stieglitz is shown holding a note signed "Rothschild" confirming a loan of [?] million pounds sterling. This was most likely part of the complex financing of 1843 for which Nicholas I awarded him a gold snuffbox with the emperor's cipher in diamonds.

8 Polovtsoff, "Vospominaniia," 25.

9 Galina Vlasova, "Khudozhnik i promyshlennost," *Nashe nasledie*, 77, 2006, 15–16. Stable URL, accessed December 31, 2015: http://www. nasledie-rus.ru/podshivka/7705.php and "Humboldt and the Generous Dream of Stieglitz," in Tatiana F. Fabergé, Eric-Alain Kohler, and Valentin V. Skurlov, *Fabergé: A Comprehensive Reference Book* (Geneva: Éditions Slatkine, 2012), 331–32.

10 N. A. Koveshnikova, "Promyshlennoe razvitie i khudozhestvenno-promyshlennoe obrazovanie v Rossii v XIX nach. XX veka," *Sibirskii pedagogicheskii zhurnal*, 2010, no. 8, 198.

11 Polovtsoff, "Vospominaniia," 27.

12 A. A. Polovtsov, *Dnevnik gosudarstvennogo sekretaria*, 2 vols. (Moscow: Tsentropoligraf, 2005), 1:146–47, 187; 2:247.

13 Kuzma Petrov-Vodkin, *Prostrantsvo Evklida* (Moscow: Azbuka, 2000), 378–79.

14 Galina Vlasova, "Shkola khudozhestvennogo masterstva," *Nashe nasledie*, 77, 2006, 16–20. Stable URL, accessed December 31, 2015: http://www. nasledie-rus.ru/podshivka/7706.php.

15 Galina Prokhorenko, "Muzei – uchebnaia programa i nagliadnoe posobie," *Nashe nasledie*, 77, 2006, 21–23. Stable URL, accessed December 31, 2015: http://www. nasledie-rus.ru/podshivka/7707.php.

16 A report in *Nedelia stroitelia* in 1882 quoted in G. A. Vlasova, *Uchilishche Barona A. L. Shtiglitsa. Shkola masterstva* (Moscow: Izd. Moskovskoi shkoly akvareli Sergeia Andriaki, 2004), 7.

17 Polovtsoff, "Vospominaniia," 28.

18 Galina Prokhorenko, "Uchebnoe prostrantsvo novogo tipa," *Nashe nasledie*, 2006, no. 79/80, 137–43. Stable URL, accessed December 31, 2015: http://www. nasledie-rus.ru/podshivka/7919.php.

19 L. G. Antokolskii, "Khudozhestvenno-promyshlennyi muzei barona Shtiglitsa," *Iskusstvo i khudozhestvennaia promyshlennost'*, 1899, no. 7, 867–73.

20 Tamara Rappe, "Zapadnoevropeiskoe prikladnoe iskusstvo v muzee Uchilishcha barona Shtiglitsa," *Nashe nasledie*, 2006,

no. 77, 29–35. Stable URL, accessed December 31, 2015: http://www.nasledie-rus.ru/podshivka/7709.php.

21 Polovtsoff, "Vospominaniia," 26.

22 N. P. Kondakov, *Histoire et monuments des émaux byzantins* (Frankfurt am Main: [August Osterrieth], 1892).

23 Polovtsoff, "Vospominaniia," 26.

24 Ibid., 25.

25 See *Collection de M. A. Polovtsoff: Catalogue des très importants bijoux, colliers de perles fines, riche diadème, rivières, broches enrichis de perles, brillants, rubis, émeraudes … Tableaux anciens & modernes, oeuvres de Daubigny; Diaz, Greuze, Isabey …* (Paris: Galerie Georges Petit, 1909).

26 *Catalogue des objets d'art et d'ameublement: Tableaux, dessins, estampes, principalement du XVIIIe siècle. Sculptures. Bronzes d'ameublement du XVIIIe siècle. Orfèvrerie Tapisseries anciennes des XVIe, XVIIe et XVIIIe siècles … appartenant à divers Amateurs et provenant en partie de la collection de Mr. Polovtsoff. Vente à Paris le 27 Mai 1910* (Paris, 1910); and *Catalogue de livres et estampes relatifs à l'architecture, à l'ornementation, à la décoration intérieure, cérémonies, orfèvrerie, bijouterie, dentelles, manuscrits, livres illustrés. provenant de la bibliothèque de M. A. Polovtsoff. Première partie, dont la vente aura lieu du 14 au 16 Novembre 1910* (Paris: Henri Leclerc, 1910). The Walters Suchtelen Hours (Ms. W.176) appeared in the latter sale.

27 Francis W. Wcislo, *Tales of Imperial Russia: The Life and Times of Sergei Witte, 1849–1915* (Oxford: Oxford University Press, 2011), 126.

28 For other graduates or instructors of the Stieglitz Institute who worked for Fabergé, see Fabergé, Kohler, and Skurlov, *Fabergé: A Comprehensive Reference Book*, 124, 142, 176–77, 179, 188, 190–92, 194, 206–7, 215, 222–23, 227, 242, 247, 255, 261, 265–66, 271, 273, 277, 290, and 293.

29 Galina Prokhorenko, "Muzei posle revoliutsii," *Nashe nasledie*, 2006, no. 79/80. Stable URL, accessed December 31, 2015: http://www.nasledie-rus.ru/podshivka/7922.php.

30 S. K., "Sobranie russkago farfora v muzee Barona Shtiglitsa," *Stolitsa i usad'ba*, July 1, 1915, no. 36–37, 28–29; E. Kh. Vestfalen, *Putevoditel' po I filialu (b. Muzei Shtiglitsa)* (Leningrad: Izd. Ermitazha, 1929); T. M. Moiseeva, "Etnograficheskie kollektsii muzeia Tsentral'nogo uchilishcha tekhnicheskogo risovaniia barona Shtiglitsa," *Kunstkamera*, 1995, no. 8–9, 153–61; G. Vlasova and G. Prokhorenko, *Muzei barona Shtiglitsa proshloe i nastoiashchee* (St. Petersburg: Sezar,

1996); T. V. Rappe, *Zapadnoevropeiskoe prikladnoe iskusstvo XVI–XVIII vekov iz sobraniia Ermitazha* (St. Petersburg: Slaviia, 1996); Mariia Men'shikova, "Iskusstvo Kitaia v kollektsiiakh Polovtsovykh," *Nashe nasledie*, 2006, no. 79/80. Stable URL, accessed December 31, 2015: http://www.nasledie-rus.ru/podshivka/7920.php.

31 While the staff of the Walters Art Museum has not definitively established that Henry Walters acquired the Ador potpourri vase from Polovtsoff, Polovtsoff's extensive connections to members of the Orlov-Davydov family suggest that he certainly participated at the very least as an adviser on the acquisition. Polovtsoff and Orlov-Davydov worked together on the 1935 Exhibition of Russian Art in London.

Chapter Two

1 Polovtsov wrote about his childhood, career, and adventures up to the revolution of 1917 in his memoirs (December 1934). A typescript copy of the memoirs ("Vospminaniia") is at Yale University, Beinecke Rare Book & Manuscript Library, Ms. 403, Box 5, Folder 2, together with a translation (by D. Routledge), from which the quotations herein are taken. The State Archive of the Russian Federation in Moscow holds another copy of Polovtsoff's memoirs (GARF Fond 5881, op. 1, d. 118).

2 A. A. Polovtsov, *Dnevnik gosudarstvennogo sekretaria* (*Diary of a Secretary of State*), 2 vols. (Moscow: Izdatel'stvo Nauka, 2005); Oleg Neverov and Emmanuel Ducamp, *Great Private Collections of Imperial Russia* (New York and St. Petersburg: Vendome Press and State Hermitage Museum, 2004), 146–53. For the sale, see *Collection de M. A. Polovtsoff: Catalogue des très importants bijoux, colliers de perles fines, riche diadème, rivières, broches enrichis de perles, brillants, rubis, émeraudes. … Tableaux anciens & modernes, oeuvres de Daubigny; Diaz, Greuze, Isabey. …* (Paris: Galerie Georges Petit, 1909).

3 Marquis de Breteuil, *Journal Secret, 1887–1889*, ed. Dominique Paoli (Paris: Mercure de France, 2007), 184.

4 Polovtsoff memoirs (note 1), typescript, p. 72.

5 Sofia, Polovtsoff's first wife, subsequently engaged in liberal political interests and women's causes, notably the Russian Society for the Protection of Women in 1900, leading to her appointment, in May 1917, to the Provisional Government as Assistant Minister for State Welfare, and in July as Assistant Minister for Education. Put on trial and imprisoned

by the Bolsheviks, she went into exile with Nicolai Ivanovich Astrov in 1920, and remained with him until his death in 1934, supporting émigrés and refugee relief in Geneva and New York.

6 Sofka Skipwith, *Sofka: The Autobiography of a Princess* (London: Hart-Davis, 1968), 31.

7 Anonymous, *The Russian Diary of an Englishman, Petrograd, 1915–1917* (London: Heinemann, 1919), 70.

8 Gustave Schlumberger, *Mes souvenirs, 1844–1928*, 2 vols. (Paris: Plon, 1934), 2:242, notes that "[Polovtsoff] has just written a curious book on the state of the museums and of the collections of the Russian palaces" ("il vient d'écrire un livre curieux sur l'état des musées et des collections des palais russes"). The reference is to Alexandre Polovtsoff, *Les trésors d'art en Russie sous le régime bolcheviste* (Paris: Société française d'imprimerie et de librairie, 1919). An excellent résumé of Polovtsoff's achievement at Pavlovsk is given in Suzanne Massie, *Pavlovsk: The Life of a Russian Palace* (Boston: Little, Brown, 1990), 130–61.

9 Alexandre Polovtsoff, *Les trésors d'art en Russie sous le régime bolcheviste* (Paris: Société française d'imprimerie et de librairie, 1919), 58–59. The text is digitized at https://ia800506.us.archive.org/33/items/lestresorsdartenoopolo/lestresorsdartenoopolo.pdf

10 Ibid., 47.

11 Ibid., 42.

12 Ibid., 37.

13 Ibid., 38.

14 Ibid., 40.

15 For instance, he discovered that a pair of candelabra with ingenious fittings (apparently modern), inventoried in 1802, had been acquired in Paris in 1782. Polovtsoff, *Les trésors d'art en Russie* (note 9), 84.

16 A. Polovtsoff [letter to the editor], "Salvage of Works of Art in Russia," *Burlington Magazine*, 34, no. 193, April 1919, 160–61 at 161.

17 Polovtsoff, *Les trésors d'art en Russie* (note 9), 91.

18 Ibid., 69.

19 Schlumberger, *Mes souvenirs* (note 8), 2:331–32.

20 "Ainsi, mélangés, affamés, déguisés, colonels de la garde, professeurs, femmes de la noblesse, prostituées, artistes improvisés, tziganes célèbres venaient livrer tantôt d'une âme violente et sincère, tantôt avec un cabotinage frelaté aux couples assomés de bruit, de lumière et de champagne, le souffle barbare, désespéré et parfois sublime que la Russie sans limites et sans forme a déposé dans ses chants, ses danses et dans le coeur de ses pires enfants." Joseph Kessel, *Nuits de princes* (Paris: Éditions de France, 1927), 139; English trans., Jack Kahane, *Princes of the Night* (New York: Macauley, 1928), 141.

21 George Orwell, *Down and Out in Paris and London* (New York and London: Harper Brothers, 1933; repr. Boston: Houghton Mifflin, 2010).

22 Ibid.

23 A. Polovtsoff, *The Land of Timur: Recollections of Russian Turkestan* (London: Methuen & Co., 1932), 20.

24 A. Polovtsoff, "A Persian Carpet of the 16th Century," *Burlington Magazine*, 36, no. 196, July 1919, 17–19.

25 N. Semyonova and N. V. Iljine, *Selling Russia's Treasures: The Soviet Trade in Nationalized Art, 1917–1938* (London and New York: Abbeville Press, 2013).

26 Semyonova and Iljine, *Selling Russia's Treasures* (note 25), 74 and n. 17.

27 Information kindly given by Alexander von Solodkoff, who owns the Russian manuscript diary of Léon Grinberg.

28 Lord Herbert and Lady Zia Wernher, introduction, *Catalogue of the Exhibition of Russian Art, 1 Belgrave Square, London, SW1, 4 June–13 July 1935*, 2nd edition (London: Oliver Burridge, 1935), 6–7.

29 Manuscript in Rheims Cathedral Library, superseded by Bibliothèque municipale de Reims, Ms. 255.

Chapter Three

1 Anne Louise Germaine de Staël-Holstein, *Ten Years' Exile: Memoirs of That Interesting Period of the Life of the Baroness De Staël-Holstein, Written by Herself, during the Years 1810, 1811, 1812, and 1813, and Now First Published from the Original Manuscript, by Her Son* (London: Treuttel & Würtz, 1821), 316, 329.

2 Edward Gibbon, *The Decline and Fall of the Roman Empire*, 3: *The History of the Empire from A.D. 1185 to A.D. 1453* (London: W. Strahan and T. Cadell, 1781), chap. 32.

3 Richard Chancellor (d. 1556), quoted by Olga Dmitrieva, "From Whitehall to the Kremlin: The Diplomacy and Political Culture of the English and Russian Courts," in *Treasures of the Royal Courts: Tudors, Stuarts and Russian Tsars*, ed. Olga Dimitrieva and Tessa Murdoch, exh. cat., London: Victoria and Albert Museum (London: V&A Publishing, 2013), 13, n. 21.

4 *Britannia and Muscovy: English Silver at the Court of the Tsars*, ed. Olga Dmitrieva and Natalya Abramova, exh. cat., New Haven: Yale Center for British Art; London: The Gilbert Collection (New Haven and London: Yale University Press, 2006), 185.

5 Jérémie Pauzié, ed. Mélany Draveny, *Edition critique introduite et commentée du mémoire de Jérémie Pauzié, joaillier à la cour de Russie de 1730 à 1763* (Geneva: [s.n.], 2004).

6 Alexander von Solodkoff, *Russian Gold and Silverwork, 17th–19th Century* (New York: Rizzoli, 1981), 201–5 and 202, n. 2, quoting Jérémie Pauzié, *Mémoires* [published in Russian in *Russkaya Starina*, 1, 1870, 131–54] and Claudius Fontain-Borgel, *Notes sur Jérémie Pauzié: Joaillier attaché à la cour impériale de Russie* (Geneva, 1889).

7 Attributed to Louis-David Duval, as is the cornucopia hairpin (signed). The flowers are represented as in full bloom, as in bud, or closed, and the stems are tied with a ribbon.

8 For the crown, see Solodkoff, *Russian Gold and Silverwork* (note 6), 203, n. 6. For the spinel acquired in Beijing in 1676 by the Russian ambassador Nicolae Milescu Spathary, see Papi, 36.

9 I. G. Georgi (1794), quoted by Olga Kostiuk, "Catherine the Great's Jewellery Collection," in *Catherine the Great and Gustave III*, ed. Magnus Olausson, exh. cat., Stockholm: Nationalmuseum (Stockholm: Nationalmuseum, 1998), 539.

10 Leopold Pfisterer was engaged by Prince Dimitri Michailovitch Golitsyn, Russian ambassador to Vienna in 1763, who signed a six-year contract but remained in St. Petersburg for thirty-four more years.

11 George Fox, "History of Rundell, Bridge and Rundell," unpublished manuscript, ca. 1843, in the Baker Library, Harvard University School of Business, Cambridge, Massachusetts, Ms. 597, F792 [photostat copy, Victoria and Albert Museum, London], 13.

12 Diana Scarisbrick, "Portrait Diamonds," in Diana Scarisbrick, *Portrait Jewels: Opulence and Intimacy from the Medici to the Romanovs* (London: Thames & Hudson, 2011), 320–42.

13 *Memoirs of Madame Vigée Lebrun*, trans. Lytton Strachey (London: Grant Richards, 1904), 98.

14 Ulla Tillander-Godenhielm, *Jewels from Imperial St. Petersburg* (St. Petersburg: Liki Rossii, 2012), 31–57, lists the jewels in the marriage caskets of the daughters of Paul I.

15 Tillander-Godenhielm, *Jewels from Imperial St. Petersburg* (note 14), 28–29 and 44–45, and, for the spray of lilies, 34.

16 Christian Müller, *Tableau de Pétersbourg, ou lettres sur la Russie écrites en 1810, 1811, 1812* (Paris: Treuttel et Wurtz, 1814), 353ff. See Solodkoff, *Russian Gold and Silverwork* (note 6), 80: "diadem of

leaves surrounds the head like a crown, each leaf consists of a single large brilliant in an *à jour* setting of wonderfully fine work by which each is surrounded with smaller stones composing the base of the leaf. Over the forehead the diamonds and leaves become larger and the ends of the stalks are joined by a fabulous sapphire."

17 Sophie de Choiseul-Gauffier, *Réminiscences sur Alexandre Ier et sur l'empereur Napoléon I* (Paris: E. Dentu, 1862), 348.

18 Cornélie de Wassenaer, *A Visit to St. Petersburg, 1824–1825*, ed. and trans. Igor Vinogradoff (Wilby, Norwich: Michael Russell, 1994), 45.

19 Marquis of Londonderry, *Recollections of a Tour in the North of Europe, 1836–1837* (London: R. Bentley, 1838), 115; and Alexandre Dumas, *Le maître d'armes* (Paris, 1840), English trans. John Butler, *Memoirs of a Maître d'armes; or, Eighteen Months at St. Petersburg* (London: Longman, 1857).

20 Frances Anne Vane Londonderry, *Russian Journal of Lady Londonderry, 1836–1837* (London: J. Murray, 1973), 83 and 203.

21 Claude de Grève, ed., *Le voyage en Russie: Anthologie des voyageurs français aux XVIIIe et XIXe siècles* (Paris: Robert Laffont, 1990), 1051, n. 3 (Victor d'Arlincourt at Peterhof in 1843).

22 Arsène Houssaye, *Les confessions: souvenirs d'un demi-siècle, 1830–1880*, 6 vols. (Paris: E. Dentu, 1885–1891), 286.

23 Sydney W. Jackman and Hella Haasse, eds., *A Stranger in The Hague: The Letters of Queen Sophie of the Netherlands to Lady Malet, 1842–1877* (Durham, N.C.: Duke University Press, 1989), 160.

24 Diana Mandache, ed., *Dearest Missy: The Correspondence between Marie, Grand Duchess of Russia, Duchess of Edinburgh and of Saxe-Coburg and Gotha, and her daughter, Marie, Crown Princess of Romania, 1879–1900* (Falköping: Rosvall, 2011), 239.

25 Stefano Papi, *Jewels of the Romanovs: Family and Court* (New York: Thames & Hudson, 2010), 59.

26 Ibid., 50–51, 52, 54–55, 62–63.

27 Ibid., 300–01.

28 De Grève, *Le voyage en Russie* (note 21), 479.

29 Eugène Fontenay, *Les bijoux anciens et modernes* (Paris: Société d'encouragement pour la propagation des livres d'art, 1887), 423–24 and n. 1 (author's translation): Russian jewelry is characterized by straightforward design leaving no room for fantasy. The objective is the impeccable execution of a motif whose charm and effect derives from the contrast between a grand outline with the refinement of smaller details. The

method is to surround the central point—a ruby, sapphire, or emerald—usually en cabochon—or a pearl with a line of diamonds. These are linked by a few solitaires to a frame of geometric, round, oval, square-shape or cut-out Byzantine style. Then the gaps left open are filled with rose diamond details, masterpieces of setting. … The craftsman takes his needle-thin file to the hatching prepared in advance so as to bite more gently and corrects the outlines, putting in place strips of metal as thin and slender as an engraver's burin. Finally, since our polishing sticks are too rough for him, he uses a mutton bone powder to rub over his setting, knowing that in this way the silver will shine like soft moonlight, and show off the brilliance of a fine diamond as well as the incomparable finesse of the setting.

30 Maurice Paléologue, *An Ambassador's Memoirs*, 3 vols. (London: Hutchison and Co., 1923–25), 1:14.

31 *The Queen: The Lady's Newspaper and Court Chronicle*, May 11, 1878, 343.

32 The firm was founded by Carl Edvard Bolin. His younger brother, Henrik Conrad, in association with Jahn, was appointed court jeweler, and then after his death in 1888 was succeeded by his son, who showed a wreath of diamond and emerald leaves, branches of ruby currants drooping from diamond leaves, and two sprays of convolvuli at the Great Exhibition held in London in 1851. Famous jewels created by Bolin include the pearl drop and diamond tiara (1841) subsequently owned by the Duchess of Marlborough, the ruby and diamond parure of the Duchess of Edinburgh (1874), the interlaced circle tiara of the Grand Duchess Vladimir (1874), the diamond and emerald tiara of the Grand Duchess Serge, the Colombian emerald necklace of Empress Alexandra Feodorovna, and her pearl and diamond parure. Magdalena Ribbing, *Jewellery and Silver for Tsars, Queens and Others* (St. Petersburg: W. Bolin, 2000), records the history of Bolin over 200 years.

33 Mandache, *Dearest Missy* (note 24), 429: "French jewels are simply inconceivably beautiful. As I know Boucheron he took us aside and showed us some of his wonders—enchanted to see my friend."

34 Géza von Habsburg and Marina Lopato, *Fabergé: Imperial Jeweller* (Washington, D.C.: Fabergé Arts Foundation, 1993) 444–61 (Birbaum memoirs).

35 Wilfried Zeisler, *L'objet d'art et de luxe français en Russie, 1881–1917: Fournisseurs, clients, collections et influences* (Paris: Mare & Martin Arts, 2014).

36 Alexander Yevgengevich Fersman, *Russia's Treasure of Diamonds and Precious Stones* (Moscow: Narodnyi kommissariat finansov, 1925).

Late Nineteenth- to Early Twentieth–Century Russian Enamel Artisans

1 A major source for Bolin is Christian Bolin, "Bolin, St. Petersburg Jewelers and Moscow Silversmiths," in Geza von Habsburg et al., *Fabergé: Imperial Craftsman and His World* (London: Booth-Clibborn Editions, 2000), 318–19.

2 In his numerous publications, Dr. Geza von Habsburg has provided thorough accounts of the history of the House of Fabergé reflecting the most current research. Of particular interest has been his *Fabergé: Imperial Craftsman and His World*.

3 "The Memoirs of Franz Birbaum," 1919, published in Geza von Habsburg and M. N. Lopato, *Fabergé: Imperial Jeweller* (St. Petersburg: State Hermitage Museum, 1993), 446–60.

4 For the Khlebnikov firm, see Tatiana Muntian, *Russian Silver of the Centuries (Sixteenth–Early Twentieth)* (St. Petersburg: Slavia, 2004), 170–83 and 194–95.

5 For Postnikov, see G. G. Smorodinova and B. L. Ulyanova in Gerard Hill, ed., *Fabergé and the Russian Master Goldsmiths* (New York: Wings Books, 1989), 40.

6 Tatiana N. Muntian, "Fedor Ivanovich Ruckert," in von Habsburg et al., *Fabergé: Imperial Craftsman and His World* (note 1), 80–81.

7 *Fabergé: A Loan Exhibition for the Benefit of the Cooper-Hewitt Museum, The Smithsonian's National Museum of Design* (New York: A La Vieille Russie, 1983), 42 (no. 55).

8 Hill, *Fabergé and the Russian Master Goldsmiths* (note 5), 41.

9 Princess Maria Tenisheva complained in 1898 that the weavers at her textile workshops at Smoelensk had to be paid bonuses to use the more stylish colors rather than the more traditional palette. Quoted by Orlando Figes in *Natasha's Dance: A Cultural History of Russia* (New York: Metropolitan Books, 2003), 267.

10 Some of the Rückert–Fabergé pieces from the Riddell Collection are stamped with the *kokoshnik* mark of 1896/9–1908 and others with the post-1908 mark.

11 Much of this information was taken from Michel Kamidian and Valentin Skurlov, "Russian Enamel at the Beginning of the Twentieth Century," in von Habsburg et al., *Fabergé: Imperial Craftsman and His World* (note 1), 64–65.

Bibliography

Manuscript Sources

Notes, manuscripts, and typescript copies of the writings of Alexandre Polovtsoff are held by the Manuscripts and Archives Division of Sterling Memorial Library, Yale University, New Haven, Connecticut, call number MS 403 (Alexandre Polovtsoff Papers). Finding aid link (with brief description): http://hdl.handle.net/10079/fa/mssa.ms.0403 (accessed October 4, 2016).

Memoirs

Polovtsoff, Pierre.
 Glory and Downfall: Reminiscences of a Russian General Staff Officer.
 London: G. Bell, 1935.
Skipwith, Sofka (*née* Sofia Dolgoruky).
 Sofka: The Autobiography of a Princess.
 London: Hart-Davis, 1968.
Talbot Rice, Tamara.
 Tamara: Memoirs of St. Petersburg, Paris, Oxford and Byzantium, ed. Elizabeth Talbot. London: J. Murray, 1996.
Zinovieff, Sofka.
 Red Princess: A Revolutionary Life.
 London: Granta, 2007.

Published Works by Alexandre Polovtsoff

The Call of the Siren: Today and Yesterday.
 London: Selwyn & Blount, 1939.
Favoris de Catherine la Grande.
 Paris: Plon, 1909 (English edition as
 The Favourites of Catherine the Great
 [London: Herbert Jenkins Ltd., 1940]).
"An Historical Survey."
 In *Russian Art: An Introduction*,
 ed. David Talbot Rice, 9–21.
 London: Gurney and Jackson, 1935.
The Land of Timur: Recollections of Russian Turkestan. London: Methuen & Co., 1932.
Russian Exhibition Gossip.
 London: O. Burridge, 1935.
Très importants bijoux, colliers de perisfines [auction catalog]. Paris: Galérie Georges Petit, 1909.
Les trésors d'art en Russie sous le régime bolcheviste. Paris: Société française d'imprimerie et de librairie, 1919 [trans. Donald Cameron as *Treasures of Art in Russia under the Bolshevik Regime.* London: Routledge, 1970]. French edition digitized at https://ia800506.us.archive.org/33/items/lestresorsdartenoopolo/lestresorsdartenoopolo.pdf (accessed November 11, 2016)

Secondary Sources

Bowlt, John E.
 Moscow and St. Petersburg, 1900–1920: Art, Life, and Culture of the Russian Silver Age. New York: Vendome Press, 2008.
—. *The Silver Age: Russian Art of the Early Twentieth Century and the "World of Art" Group*, ORP Studies in Russian Art History. Newtonville, Mass.: Oriental Research Partners, 1979.
Brumfield, William.
 "The Decorative Arts in Russian Architecture, 1900–1907." *The Journal of Decorative and Propaganda Arts, 1875–1945* (1987): 12–27.
Chenevière, Antoine.
 Russian Furniture: The Golden Age 1780–1840. New York: Vendome Press, 1988.
Fabergé, Tatiana, Lynette G. Proler, and Valentin V. Skirlov.
 The Fabergé Imperial Easter Eggs.
 London: Christie, Manson and Woods, 1997.
Fersman, Alexander Yevgengevich.
 Drevnosti Rossiskago gosudarstva, izdannyi'a' po Vysochaishemu poveli'e'ni [Russia's treasure of diamonds and precious stones] (Moscow: Narodnyi kommissariat finansov, 1925).
Figes, Orlando.
 Natasha's Dance: A Cultural History of Russia. New York: Metropolitan Books, 2002.
Habsburg, Géza von.
 Fabergé: Hofjuwelier der Zaren.
 Munich: Hirmer, 1986.
—. *Fabergé Revealed at the Virginia Museum of Fine Arts.* New York: Skira Rizzoli, 2011.
Habsburg, Géza von, with contributions by Alexander von Solodkoff and Robert Bianchi. *Fabergé: Imperial Craftsman and His World.*
 London: Booth-Clibborn, 2000.

Habsburg, Géza von, and Marina Lopato.
 Fabergé: Imperial Jeweller. St. Petersburg: State Hermitage Museum, 1993.
Habsburg-Lothringen, Géza von, and Alexander von Solodkoff. *Fabergé, Court Jeweler to the Tsars.* New York: Rizzoli, 1979.
Hawley, Henry.
 Fabergé and His Contemporaries: The India Early Minshall Collection of the Cleveland Museum of Art. Cleveland, Ohio: Cleveland Museum of Art, 1967.
Hill, Gerard, ed.
 Fabergé and the Russian Master Goldsmiths. New York: Universe, 1989.
Hilton, Alison.
 Russian Folk Art. Bloomington: Indiana University Press, 1995.
Johnston, William R.
 William and Henry Walters: The Reticent Collectors. Baltimore: Johns Hopkins University Press, 1999.
Kirin, Asen.
 Exuberance of Meaning: The Art Patronage of Catherine the Great (1762–1796). Athens: Georgia Museum of Art, 2013.
Kozyrev, K.
 Baron Stieglitz Museum: the Past and the Present. St Petersburg: Sezar, 1994.
Kudriavtseva, Tamara Vasil'evna.
 Russian Imperial Porcelain.
 St Petersburg: Slavia, 2003.
Massie, Suzanne.
 Pavlovsk: The Life of a Russian Palace. Boston: Little Brown, 1990.
Mavrodina, N.M.
 Iskusstvo Ekaterinburgskikii Kamnerezov.
 St Petersburg: Izdatel'stvo Gosudarstvennogo Ėrmitazha, 2000
Odom, Anne.
 The Art of the Russian North.
 Washington, D.C.: Hillwood Museum and Gardens, 2001.

—."Decorative Arts of the Russian North: Western Imagery in Provincial Cities." In *The Art of the Russian North*. Washington, D.C.: Hillwood Museum and Gardens, 2001.

—. *Fabergé at Hillwood*. Washington, D.C.: Hillwood Museum and Gardens, 1996.

—. *Hillwood: Thirty Years of Collecting, 1977–2007*. Washington, D.C.: Hillwood Museum and Gardens, 2007.

—."A Key to the Past: Fedor Rückert's Miniature Picture Gallery." *Apollo*, January 1993, 22–27.

—. "A Revolution in Russian Design: Solntsev and the Decorative Arts." In Cynthia Hyla Whittaker, ed. *Visualizing Russia: Fedor Solntsev and Crafting a National Past*. Leiden and Boston: Brill, 2010.

—. *Russian Enamels: Kievan Rus to Fabergé*. Baltimore and London: Walters Art Gallery and Philip Wilson Publishers, 1996.

—. *Russian Silver in America: Surviving the Melting Pot*. Washington, D.C., and London: Hillwood Museum and Gardens, and D. Giles Ltd., 2011.

—. *What Became of Peter's Dream? Court Culture in the Reign of Nicholas II*. Middlebury, Vt.: Middlebury College Museum of Art, and Washington, D.C.: Hillwood Museum and Gardens, 2003.

Odom, Anne, with Jean M. Riddell. "Old Russian-Style Enamels." *Apollo*, May 1986, 332–37.

Odom, Anne, and Wendy R. Salmond. *Treasures into Tractors: the Selling of Russia's Cultural Heritage, 1918–1938*. Washington, D.C.: Hillwood Estate, Museum & Gardens; and Seattle: University of Washington Press, 2009.

Papi, Stefano. *Jewels of the Romanovs: Family and Court*. New York: Thames & Hudson, 2010.

Rappaport, Helen. *The Romanov Sisters: The Lost Lives of the Daughters of Nicholas and Alexandra*. New York: St. Martin's Press, 2014.

Ross, Marvin Chauncey. *The Art of Karl Fabergé and His Contemporaries*. Norman: University of Oklahoma Press, 1965.

Salmond, Wendy. *Arts and Crafts in Late Imperial Russia: Reviving the Kustar Industries, 1870–1917*. New York and Cambridge: Cambridge University Press, 1996.

—."The Solomenko Embroidery Workshops." *Journal of Decorative and Propaganda Arts* 5 (1987): 126–43.

Scarisbrick, Diana. *Portrait Jewels: Opulence and Intimacy from the Medici to the Romanovs*. London: Thames & Hudson, 2011.

—."Regal Ornaments: Six Centuries of Diamond Jewelry." In *The Nature of Diamonds*, ed. George Harlow, 142–63. Cambridge: Cambridge University Press, 1998.

Solodkoff, Alexander von. *Russian Gold and Silverwork, 17th–19th Century*. New York: Rizzoli, 1981.

Splendeurs de Russie: Mille ans d'orfeverie. Paris: Musée du Petit Palais, 1993.

Talbot Rice, Tamara. *Russian Art*. West Drayton, Middlesex, 1949.

Talbot Rice, Tamara. *A Concise History of Russian Art*. New York: Frederick A. Praeger Inc., 1963.

Tillander-Godenhielm, Ulla. *Fabergé: ja hänen suomalaiset mestarinsa*. Helsinki, 2008.

Verdier, Philippe, ed. *Russian Art: Icons and Decorative Objects from the Origin to the Twentieth Century*. Baltimore: The Walters Art Gallery, 1959.

Watts, Geoffrey. *Russian Silversmiths' Hallmarks, 1700 to 1917*. Bath: Gemini Publications, 2006.

West, James L, and Iurii A. Petrov, eds. *Merchant Moscow: Images of Russia's Vanished Bourgeoisie*. Princeton: Princeton University Press, 1998.

Whittaker, Cynthia Hyla, ed. *Visualizing Russia, Fedor Solntsev and Crafting a National Past*. Leiden and Boston: Brill, 2010.

Williams, Hadyn, ed. *Enamels of the World, 1700–2000: The Khalili Collections*. London: The Khalili Family Trust, 2009.

Picture Credits

Stieglitz-Polovtsov family tree

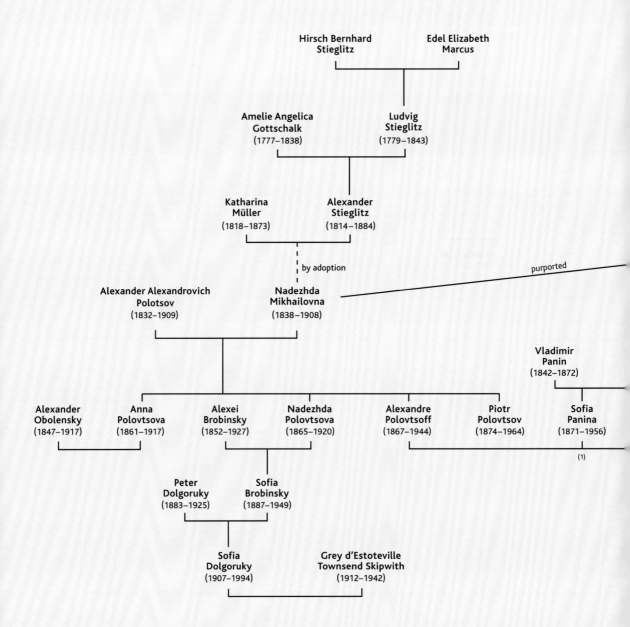

Hirsch Bernhard Stieglitz — Edel Elizabeth Marcus

Amelie Angelica Gottschalk (1777–1838) — Ludvig Stieglitz (1779–1843)

Katharina Müller (1818–1873) — Alexander Stieglitz (1814–1884)

by adoption

purported

Alexander Alexandrovich Polotsov (1832–1909) — Nadezhda Mikhailovna (1838–1908)

Vladimir Panin (1842–1872)

Alexander Obolensky (1847–1917) — Anna Polovtsova (1861–1917)

Alexei Brobinsky (1852–1927) — Nadezhda Polovtsova (1865–1920)

Alexandre Polovtsoff (1867–1944)

Piotr Polovtsov (1874–1964)

Sofia Panina (1871–1956)

(1)

Peter Dolgoruky (1883–1925) — Sofia Brobinsky (1887–1949)

Sofia Dolgoruky (1907–1994) — Grey d'Estoteville Townsend Skipwith (1912–1942)

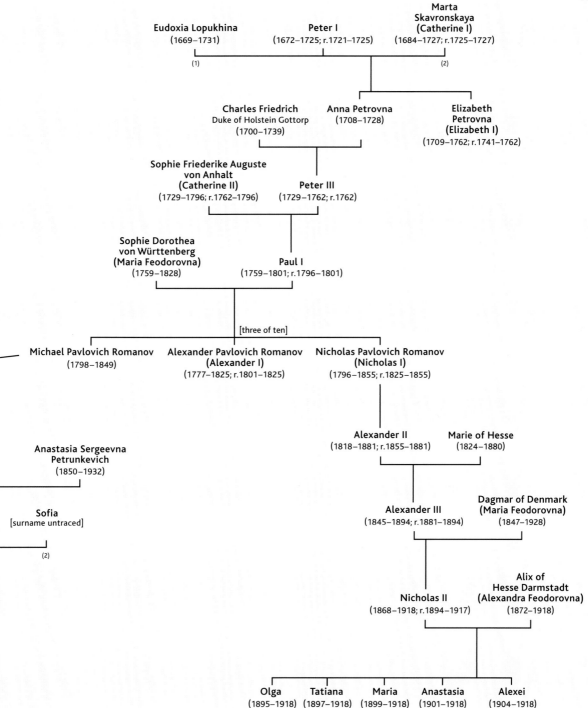

Eudoxia Lopukhina
(1669–1731)

Peter I
(1672–1725; r.1721–1725)

Marta
Skavronskaya
(Catherine I)
(1684–1727; r.1725–1727)

(1)

(2)

Charles Friedrich
Duke of Holstein Gottorp
(1700–1739)

Anna Petrovna
(1708–1728)

Elizabeth
Petrovna
(Elizabeth I)
(1709–1762; r.1741–1762)

Sophie Friederike Auguste
von Anhalt
(Catherine II)
(1729–1796; r.1762–1796)

Peter III
(1729–1762; r.1762)

Sophie Dorothea
von Württenberg
(Maria Feodorovna)
(1759–1828)

Paul I
(1759–1801; r.1796–1801)

[three of ten]

Michael Pavlovich Romanov
(1798–1849)

Alexander Pavlovich Romanov
(Alexander I)
(1777–1825; r.1801–1825)

Nicholas Pavlovich Romanov
(Nicholas I)
(1796–1855; r.1825–1855)

Alexander II
(1818–1881; r.1855–1881)

Marie of Hesse
(1824–1880)

Anastasia Sergeevna
Petrunkevich
(1850–1932)

Alexander III
(1845–1894; r.1881–1894)

Dagmar of Denmark
(Maria Feodorovna)
(1847–1928)

Sofia
[surname untraced]

(2)

Nicholas II
(1868–1918; r.1894–1917)

Alix of
Hesse Darmstadt
(Alexandra Feodorovna)
(1872–1918)

Olga
(1895–1918)

Tatiana
(1897–1918)

Maria
(1899–1918)

Anastasia
(1901–1918)

Alexei
(1904–1918)

Glossary

Aigrette
A hair ornament made from, or in the form of, feathers.

Basse-taille
A technique in which metal, typically gold or silver, is engraved, etched, or carved in low relief, and the surface covered with transparent or translucent enamel.

Briolette
A faceted pear-shaped or oval gemstone.

Cabochon
An unfaceted, polished, flat-bottomed convex stone.

Champlevé
A technique in which a metal surface is carved out, leaving shallow troughs that are filled with enamels.

Cloisonné
A technique in which thin, flat metal strips are soldered to a metal ground and the resulting chambers, or cloisons, filled with enamels.

Collier d'esclave
Literally, "slave's necklace": a choker, often composed of three or more chains.

En camaïeu
A design composed in shades of a single color.

En grisaille
A design composed in shades of gray.

En plein
Enamel applied in broad swaths rather than in segmented compartments.

Filigree enamel
A technique, similar to cloisonné, in which a design of thin wires or beads is soldered to a metal base and the interstices filled with enamel.

Guilloché
Transparent enamel applied over a patterned ground; the pattern is produced by mechanical techniques, such as lathe or engine turning.

Niello
A decorative metalwork technique in which incised designs are filled with black copper, silver, or lead sulfides.

Parure
A matching set of jewelry intended to be worn together.

Pavé
Literally "paved": gemstones, typically diamonds, set closely together.

Plique-à-jour
An enameling technique in which designs are formed of thin metal wires without a backing and the cells filled with translucent or transparent enamel. The result resembles stained glass.

Portrait diamonds
Flat-cut diamonds that are used as protective covers for hand-painted miniatures set in jewelry. The diamonds are faceted on the edges to throw additional light onto these tiny portraits.

Quatre-couleur
Designs composed of gold alloys of different colors.

Repoussé
A metalworking technique in which designs are hammered out from the object's reverse; it is distinguished from chasing, in which designs are worked into the metal from the front.

Rivière
A string of gemstones of the same variety.

Surtout de table
An elaborate table centerpiece.

Verre églomisé
Reverse-painted glass on which a thin metal foil (typically gold or silver) has been applied.

RUSSIAN TERMS

Bokal
A trumpet-shaped goblet.

Bratina
A large spherical drinking bowl or loving cup for *kvass* (a fermented drink made from rye) or wine.

Endova
A spherical pouring vessel.

Izba
A peasant house fabricated from wood with detailed carving along the rooftop and window frames.

Kokoshnik
An elaborate, often jeweled, crest-shaped headdress worn by married women.

Kolt
A headdress worn by women, consisting of pairs of ornaments suspended from the temples on decorative chains.

Kovsh
A boat-shaped drinking vessel originally for mead, *kvass*, or beer; by the late nineteenth century it was largely a presentation piece rather than a functional item.

Oklad
A metal cover for the painted surface of icons, pierced to leave visible the face and hands of the depicted religious figure.

Teremok
The stepped-back upper floors of a palace or noble house reserved for women.

Index

Page numbers in *italic* refer to the illustrations